A Skeptic's Guide to Arts in the Church

A SKEPTIC'S GUIDE
to ARTS IN THE CHURCH

Ruminations on Twenty Reservations

Edited by
Mark Coppenger

WIPF & STOCK · Eugene, Oregon

A SKEPTIC'S GUIDE TO ARTS IN THE CHURCH
Ruminations on Twenty Reservations

Wipf & Stock
An Imprint of Wipf and Stock Publishers
199 W. 8th Ave., Suite 3
Eugene, OR 97401

www.wipfandstock.com

PAPERBACK ISBN: 978-1-5326-4913-4
HARDCOVER ISBN: 978-1-5326-4914-1
EBOOK ISBN: 978-1-5326-4915-8

Manufactured in the U.S.A. 08/30/18

Contents

Preface

THE IDEA FOR THIS book grew out of an aesthetics course I taught jointly with my colleague, Joe Crider, the Ernest and Mildred Hogan Professor of Church Music and Worship, and the Executive Director of Southern Seminary's Institute for Biblical Worship. We'd both served for a good many years in church and academic positions, and we were able to compare notes and share war stories regarding the role of arts in the church. This being a seminary course, discussion turned naturally and repeatedly to ecclesiastical matters, though we also surveyed more generic aesthetic issues.

What struck me especially was the give-and-take nature of our time together, not only with each other, but also with the M.Div. students. We got into the nooks and crannies of ministry, granting right along that there were real issues in play and that both the gainsayers and the enthusiasts deserved a respectful hearing.

Being the philosopher in the group, I couldn't help thinking of the Socratic model, the dialogical approach to sorting things out. And while Socrates began dialogues with such "What is it" questions as "What is justice?" (*Republic*), "What is love?" (*Symposium*), and "What is knowledge?" (*Theaetetus*), I focused on what might be beneficial for or dangerous to the life of the church. And the ideas came tumbling, with an eventual working list of twenty questions.

That was 2012, and in the intervening years, I've bounced those questions off a variety of students (and a Chicago gallery owner), and a range of interlocutors have answered the call. You'll meet twenty-two of them in this book. (In this connection, I've asked them to write longer-than-usual bio notes, which you'll find under "Contributors" in the back.) And, of course, we invite you to pick up on our discussion in your own classrooms, cohorts, or mind. We've just opened the conversation, and we feel sure you have something to add.

Introduction

REGARDING ARTS IN THE church, you typically find books and articles of two sorts. The first bemoans the way that entertainment and theologically-illicit, suspect, distracting, or extraneous artistic elements have weakened or diluted the power of the preached gospel and holiness. Some suggest that artists are inclined to lead us to see how close we can fly to the flame of cultural relevance without being burned.

On the other hand, a burgeoning literature indicts the church for marginalizing or demeaning the arts, or, in a more irenic voice, suggests that the church needs to take its arts-vitamins for health's sake. Some of the writing has a martyr's cast to it, complaining that gifts are not taken seriously, that there seems to be little or no place for artists to exercise their callings.

So, we have, in a sense, dueling publications—Martyrs vs. Watchdogs; Zealots vs. Philistines; Iconophiles vs. Iconoclasts. This book, however, takes both "sides" seriously, and so can be irritating, even appalling, to the disputing parties. It frustrates one side by suggesting that there are legitimate concerns, and the other side by arguing that many of those concerns can be mitigated or extenuated.

Of course, we've been at it for centuries, and evangelicals of one stamp or another have a long and arguably understandable tradition of resistance to and wariness over the arts—the Calvinists have followed the restrictive regulative principle ("If it's not prescribed, it's illicit"); the Westminster Divines repudiated icons; Timothy Dwight called actors "the offal of society"; for decades, Wheaton College forbade its professors to attend movies. But then the "normative principle" ("If it's not proscribed, it's licit"), associated with Luther, has helped open the door to a range of Sunday morning fare, from puppets, to mini-dramas, to interpretive dance. We don't see evangelical iconoclasts sacking cathedrals. Neither is inquisitional persecution visited upon of those reluctant to genuflect before an image of the Blessed

Virgin Mary. But we do criticize and marginalize, exclude and preclude, berate and supplicate in the name of orthodoxy and orthopraxy.

Music had enjoyed long-standing esteem and representation in the services of the church. Indeed, you could say that Christianity (as opposed to Islam, Buddhism, Hinduism, etc.) is the "singing faith," with virtually every genre in play, from Gregorian chants, to oratorios, to hymns, to gospel songs (whether black or white Southern), to (gulp) rap. We sing our hymns bluegrass or Sacred Harp. Our choirs deliver anthems and cantatas, or dress up like shepherds and magi to perform *Amahl and the Night Visitors*. We work with hymnbooks or words-only, big-screen projections, sing to the accompaniment of pipe organ or djembe. We sally forth *a cappella*, antiphonal, or in rounds. You name the style, we do the style.

The visual and plastic arts have not fared so well. Yes, we see stained-glass windows, tasteful carpet selections, some banners, and occasional baptistery art, but we've kept strong focus on the spoken word. And despite complaints from Christian painters, thespians, sculptors, and their fans, few churches have been willing to turn their auditoriums into sanctified theaters and galleries.

Much of the opposition concerns particulars. Many hold that if painters would hew closer to Rembrandt, Sallman, or Kinkade, than to Klee, Dali, or Rothko (and quit marshalling pretentious jargon to underscore their profundity), then they might get a better welcome. And if they'd only keep better company or had a higher threshold of appreciation. ("Are you really that impressed with John Cage and Andy Warhol?"; "Did you know when you signed on as a theater major, you'd be called on to say all those vile things in David Mamet's *Glengarry Glen Ross*?")

Maybe Hans Rookmaaker and Francis Schaeffer were right, that 17th-century Dutch art was a crowning achievement and that abstract expressionism was a signpost on the road to the "death of culture." Or maybe Jonathan Anderson and William Dyrness are right to push back against this notion and claim spiritual depth in the abstract.

Thus, the discourse hums (or rages) along, and so it is represented and extended in this book, where the parties are taken seriously, but not so seriously as to acquiesce to whatever the contrary fellow might be saying.

You will see the various contributors to the dialogues identified by their last names.

Introduction

Dan Addington	Benjamin Edwards	Andrew Walker
Ann Ahrens	Will Farris	Mark Warnock
Daniel Blackaby	Amanda Jenkins	Harrison Watters
Christ Bolt	Matthew Raley	Matthew Westerholm
Ryan Brandt	Richard Reichert	Paul Wilkinson
Daniel Cabal	Timothy Scott	Eric Williamson
Stephen DeKuyper	Na Young Seo	
Joseph Dittman	Richard Stark	

In the back, you'll find bio sketches written by the subjects. I asked them to follow my lead in giving informal descriptions of their backgrounds, accounts of their lives, including their work in the arts and their study of aesthetics. You'll see a wide range of experiences and perspectives so that you might more readily identify with them. And you'll get to know them by their voices, which I've sought to preserve with a light edit.

Game on.

1

Doesn't the Use of Visual Art Risk Violating the Second Commandment?

Coppenger: At a meeting on the campus of Samford University, several of the conferees expressed their dismay at the new Beeson Divinity School chapel. It was lavish and striking, with images of "saints" from church history, including martyrs. Beeson posts a 360-degree tour of the chapel on their website, and it certainly stands out among SBC venues I've seen.

I have to say, I was a little taken aback by the seriousness of the critics' digs, but it prompted me to review my take on the Decalogue's prohibition against images.

Around the time of the Beeson visit, I'd done a feature on baptistery art in the *Southern Baptist Celebrator*, and another on banner ministry. Were these transgressive, or were they kosher so long as no representation of God the Father, the Son Jesus, or the Holy Spirit was on them?

And what of my visit to Chartres cathedral, where I admired the *Jesse Tree* stained glass window? And how about the time when I, as a kid, saw *The Robe* at a drive-in, thanks to my dad, a Bible prof, who took the family to see it? Were we slumming, upsetting God?

Kosher and Ferraris

Addington: Kosher! Great choice of words, since we are talking about Jewish law specific to their living in a time and among countries that were rife

with graven idol worship. Did the banner-ministry church serve kosher hot dogs at fellowship picnics? This has much more to do with the relationship of emancipated Christians (there is no other kind, by the way) to Jewish Old Testament law than it does with any ideas about art.

Coppenger: So how should we read that passage?

Addington: First, Exodus 20:4 ("You shall not make for yourself a carved image, or any likeness of anything that is in heaven above, or that is in the earth beneath, or that is in the water under the earth") seems to forbid all representational artwork. By the way, this is why Muslims welcome geometric decoration and ornamentation, a form of visual art to be sure, in their places of worship, but forbid any use of naturalistic imagery of any kind. I'd like to think that as Christians, we operate in a different theological place from Muslims, as well as Orthodox Jews.

Verse 5 then clarifies and contextualizes verse 4: "You shall not bow down to them or serve them." This is the whole point; it's not an arbitrary command. Verse 4 says, "Make *for yourself.*" This has to do with a *personal use.* And what *is* that use? Verse 5 says it's, "*To bow down and serve.*"

It's hard for us Western, modern folks to get this. We laugh and shake our head when Edward G. Robinson (in The *Ten Commandments*) convinces the Hebrews and even Moses to go along with the golden calf idea. It's not our deal, but it was a *big deal* back then, and God was trying to move his people to a new place. So the command is *very* culturally specific. In twenty-first century, Western civilization, among educated people, and in the Western evangelical church, idol worship is not about worshiping a calf or a crucifix or an icon. We, in this church, understand that other "idols" have replaced those idols; that basically, an idol is *anything* that seduces our eyes from Christ, that becomes an object of worship that puts God second or worse, e.g., sex, fashion, money, fame, success . . . even church work or denominational positions. (We would be better to prohibit Ferraris from our church parking lots than icons on our altars.)

Deuteronomy says we should not bow down to nature—the sun and the stars. But Luther asked rhetorically, when discussing iconoclasm, whether we should pull these heavenly bodies from the sky. And note that, in Exodus 25:18–22, God actually commands that certain images be made, two cherubim to be carved and placed on the Mercy Seat. God also

commanded that a bronze serpent be sculpted, even though he *knew* it would later become an object of worship!

Remember the Catacombs

Seo. Across church history, the visual arts have always been embroiled in controversy, and that's understandable. Throughout scripture, God warns against idolatry, and even Aaron, whom God chose as the helper for Moses, committed this sin by fashioning a golden calf. So, we might ask whether visual images have special, enticing power to draw believers to worship them?

I don't think so. Idolatry starts with the human desire for autonomy. But we also wish to worship something, so we proceed to make beautiful things with our hands, objects which can satisfy our religious interest while preserving our supposed right to have things our own way.

I believe that art is unavoidable instinct of human beings, a gift from God. God used it in the tabernacle, and early Christians, who suffered from severe persecution, expressed their faith on the walls of clandestine worship places. And, in spite of various iconoclastic movements, many Christians, including Protestants, have retained visual beauty in their liturgical settings.

Surely, beautiful art reflects the presence of God in many ways. And even though human beings can misuse any of God's gifts, there is no reason to reject the use of the gift of art in worship.

"Holy" Idols

Westerholm: In his biblical survey of idolatry (*We Become What We Worship*), G. K. Beale notes how the Jewish leaders of Jesus' day placed their confidence in the Temple as a sign that they were God's people. Beale argues they turned the Temple itself into an idol. Idolatry doesn't limit itself to objects of pagan origin. Beale also tracks the ways that Jesus uses the terminology of idolatry from the Old Testament to condemn those who "loved the glory that comes from man more than the glory that comes from God" (Jn 12:43). It seems idolatry doesn't limit itself to visual imagery.

Coppenger: Good point, that appreciation for even the "Holy Temple" could be unseemly. In that connection, it strikes me that talk of the "Holy

Land" can get us in trouble. While I'm a huge supporter of Israel, and I've enjoyed, beginning in 1966, a half dozen trips to the nation, I want to insist that whatever land the believer stands upon is "holy land." When I witness on a doorstep in Detroit, that moment and that place are as sanctified as the deck of a boat on the Sea of Galilee, where Christian tourists are singing hymns. (Yes, I'm echoing Luther a bit in dismissing the distinction between sacred and secular vocations.)

The point is, we need to be very careful about attributing magic or special grace or surpassing sustenance to physical things, whether icons, cars, buildings, bishops, or land. The power is in The Way, The Truth, and the Life, not in the The Stuff, the Setting, or the Style.

Westerholm: To put it another way, idolatry isn't ontological; it's ethical. That is, idolatry is not a function of *what* an object is, but a description of *how* something is (mis)used.

Burning Bush and Descending Dove

Bolt: Scripture contains no clear prohibition against visual art in worship. Rather, Scripture prescribes the use of visual art in worship, describes God anthropomorphically by appeal to various physical features, and posits God's self-revelation in physical form on multiple occasions.

The Second Commandment does not forbid worshiping God or making images and likenesses, but it does forbid worship of false gods through their images and likenesses. The law of God is good if it is used lawfully (1 Timothy 1:8), but the Second Commandment of Exodus 20:4 is sandwiched between verses 3 and 5 for a reason. The First Commandment says not to worship other gods than God, and perhaps the Second Commandment is like unto it: Do not worship other gods than God through their images or likenesses. The Second Commandment does not prohibit the production of all images and likenesses, since such images and likenesses are used in God-sanctioned worship throughout the Old Testament, especially in the temple. Rather, one must not bow down and serve them. The distinction between using visual arts in worship and worshipping visual arts is plain.

The Second Commandment is so far off from addressing particular practices in Christian art that one wonders why it was ever used as a proof text in the first place. Not even the Reformers agreed on the place of this passage in that discussion. But if this text is not at the center of the debate,

what text would be? Would we not expect to find such a serious prohibition clearly stated in Scripture?

Of course, we do not know what God looks like. God is spirit. And as creatures—sinful ones—we are prone to recreate God in our image. That would be a huge problem, were it not for the fact that God has revealed himself to us through physical categories in his redemptive Word. When God reveals himself to us in something that is creaturely, we need not shrink back from it. Not only does God use anthropomorphism to tell us what he is like; God appears in various physical, creaturely forms throughout the Old Testament. For example, God appears to Moses in a burning bush. Certainly, Moses was not in sin when he saw the bush, or imagined the bush, or described the bush in writing. God also reveals himself in physical, creaturely forms in the New Testament. For example, at the baptism of Jesus, the Spirit descends in the physical form of a dove. Again, John the Baptist was not in sin when he saw the dove, or imagined the dove, and Luke was not in sin when he described the dove in writing. Nor are we in sin when we read about the bush and the dove, imagine the bush and the dove, or create images of the bush and the dove. We are merely picturing God as he intended for us to picture him.

Some may object that the bush or the dove do not picture God as he is. Yet God is the one who revealed himself through these means. So also, some may object that the bush or the dove do not communicate all there is to know about God. Of course, this objection would apply to any literary description of God as well. Not only do manmade theological descriptions of God fall far short of communicating all there is to know about God, no one text of Scripture communicates all there is to know about God.

We do not know exactly what Jesus looked like, so our "pictures" of him are guesses. Of course, we do not know what many other figures of history looked like either, and yet we still make images and likenesses of them. Jesus would have looked just like other men from his place and time, and not stood out as God in virtue of his physical appearance. But this leads to one last concern, which is that if we are not making images and likenesses of Christ to worship them, and if there is nothing in particular that stands out about Jesus in terms of physical appearance, then why are we making images and likenesses of him at all? In a way, artists are the ones to answer this question, not by way of theological and philosophical thought on the question, but through producing their art.

Coppenger: I'm neither an artist nor the son of an artist, but I can give one reason for making visual images of the Lord—to tell a gospel story. One of these hangs on our wall at home, a print of Christ raising Lazarus, as it appears among the Giotto frescoes in Padua's Arena Chapel. Offset by cobalt blue, the chapel's many panels depict the life of Christ (the adoration of the magi; the flight to Egypt; Judas's betrayal with a kiss, etc.). It makes for one of the most stunning and gratifying interiors in the world.

That print has been the source of great encouragement to me through the years as we've negotiated a range of upsets and reversals, for it reminds me that Jesus rescues us from ruin, even beyond "the eleventh hour." Indeed, as with Lazarus, he showed up powerfully in "the thirteenth hour." Lazarus was already dead, but no matter. Christ's timing was, and is, perfect. And to suggest that this image does me spiritual harm, that it promotes idolatry rather than thankfulness to Christ . . . I just don't buy it.

I should also mention the helpfulness of the Bible-storying scarf, made available through our International Mission Board. I've supplied a number of them, upon request, to a minister who works with Middle Eastern internationals in Nashville. And a version of this cloth was useful (and not harmful) in our work with international students in Evanston.

Generational Shift and New Songs

Coppenger: Joe Crider, my colleague at Southern, speaks apppreciatively of a sermon Dr. Deron Spoo preached at First Baptist Church, Tulsa—one about the snake Moses fashioned for display on a pole in Numbers 21. In its day, people looked to it and were healed. But later on, they started to worship it, and Hezekiah had it destroyed. Spoo's application: "What one generation considered an enhancement in worship, the next can consider a hindrance."

Addington: That was a *great* example!

Warnock: This could be the reason for the command to "Sing unto the Lord a new song"; artistic elements in worship have a tendency to wear out, and they need from time to time to be renewed or replaced. After you've heard a song thirty-five times, it fails to have the same force. Of course, some become classics, which contain cultural memory that gets renewed in different contexts. For instance, a classic like *Amazing Grace* has

a freshly renewed strength when sung at a 9/11 memorial service or at your mother's funeral. The context renews it. The principle stands, however, that artistic expressions wear out. Just think about church décor. I grew up in the 1970s in a church with pew coverings and carpet that were (surprise!) red-like-the-blood-of-Jesus.

The prohibition against idols prevents us from placing limits upon our ideas of God, certainly, but perhaps it also prevents us from placing limits on our experiences of God. Thus, the church needs artists to continually contribute fresh material for the life of the church.

Tap Water

Cabal: There are places on earth where you should avoid tap water for concern over stomach problems, so you drink bottled water. But you severely and pointlessly limit yourself if you always refuse to drink tap water. And, of course, if you insist on sticking to bottled water, you'll miss out on, for instance, apple cider, hot cocoa, lemonade, milk shakes, orange juice, and coconut milk.

Yes, there are risks, but they depend more or less on how visual the culture's idolatry is. I have seen the *Jesus Film* being shown to Muslims who are explicitly forbidden to even look at pictures of their prophet Mohammed, yet I've never seen the Muslims tempted to bow down to the television. Technically, people could worship a banner as well, but I doubt it.

Perhaps one follow-up question to consider is, "How does visual art cause non-believers at the service to respond?" Do non-believers worship the visual art or think Christians are worshipping it? Or, instead, could the visual art help them to worship the Risen Christ?

Coppenger: I once got as sick as a dog using tap water to brush my teeth at a fine Cairo hotel, while the Egyptians could have drunk the stuff all day long. Their gut was armored against it. Similarly, I think that, thanks to the Reformation, most Protestants are fairly immune to art-idolatry. (And no, I'm not saying that a stained-glass window featuring Jesus is, *per se*, a toxic microbe.) But the Catholics are not so fortunate.

I think, for instance, of the collection of objects stacked around the "image of Mary" that emerged on the concrete face of the I-94, Fullerton underpass in Chicago. Salt and the elements combined to stain the wall, and devotees sprang into action. I remember driving through there weekly

to teach an extension class for Southern and, so, witness a curious collection of candles, photos, ribbons, and even a papal flag. They had to rope off the wall to keep people from touching it. One of the Catholic priests with whom we met in the Southern Baptist/Roman Catholic conversations in the late 1990s spoke tenderly of such manifestations of "folk Catholicism," but it strikes me they're indulging a spiritually-dangerous form of magical thinking.

To risk straining the analogy, let me just add that most Evangelicals have gotten their shots against such infection, but theological booster shots aren't gratuitous.

Filling the Vacuum

Westerholm: I think it's important to remember that church attenders have to look at something. The better question is, "Do the observables of our churches produce throughtful interactions with the essential nature of our faith?" By forbidding the arts, Christians do not establish the primacy of the Word. Rather, Christians doom themselves to thoughtlessly decorated church buildings.

Coppenger: Good point. And I suppose a word from Aristotle (*Nicomachean Ethics*) on not underdoing or overdoing it would be in order. On the one hand, I find the interior(s) of Jerusalem's Church of the Holy Sepulchre to be a mess. On the other, I wouldn't want our church to resemble the inside of a massive concrete, unadorned culvert. Maybe a Zen master could worship delightedly through the years in a seamless expanse of gray, but I think a healthy Christian would get an itch for imagery.

Farris: I personally am more blessed by worship in a cathedral than in a stark, whitewashed church, but God uses any venue whatever to allow the Spirit to work.

Coppenger: Indeed. But I wonder if some venues are better attuned to different spiritual activities. I remember my surprised-by-awe reaction to Gaudi's *Sagrada Familia* cathedral interior in Barcelona. I was expecting to have an interesting aesthetic response to a quirky piece of architecture, and it proved spiritually compelling. A very worshipful place, I think. But I'm not sure it would be so good for an old-time revival meeting, which I love,

but which many hold in contempt today. As I recall, you don't need any distractions, however glorious, from the gut-wrenching work of repentance under the convicting word of the preacher. I remember a little cracker-box church I once supplied as a preacher in seminary; you could almost touch the back row from the pulpit. It wasn't pretty, but not everything spiritually-needful in a service is pretty. Ask John the Baptist. Similarly, a splintery, wooden bench on a bare-concrete floor in a corrugated-roofed "tabernacle" at youth camp is just right for getting this tough, tearful job done. In a basilica, your mind could easily wander from the uncomfortable task at hand, particularly since cathedrals are not known for take-no-prisoners expository preaching.

Ordinances

Stark: Many traditions reject the use of any images out of fear that the images might be worshiped; nevertheless, these traditions must deal with the fact that even the New Testament mandates the use of certain images in worship—namely, the ordinances. Yet, while these ordinances have been abused, we still rightly practice them. Now, I am by no means placing all images on the same level as the ordinances. I am only suggesting that the abuse of something in worship does not mean we must remove it altogether. Every time I baptize someone, I tell the congregation that baptism is symbolic—an "outward sign of an inward change"—and I am careful to explain that baptism holds no salvific powers. Similarly, ministers must be careful in explaining the Lord's Supper. How often has this physical reminder of Christ's passion been abused throughout church history? How easy would it be to worship this image since it is "the body and blood" of Christ? Again, I am not suggesting that man-made images should play anywhere near the important role that the ordinances play. I am only saying that the obedient practice of the ordinances in our churches suggests that we can utilize physical forms without falling into idolatry.

Luther and Cranach

Stark: On another note, the iconoclastic tradition that we associate with the Reformation was a response to the rampant abuse of images in Catholicism at the time. Nevertheless, while the more Calvinistic strands of the Reformation went the more iconoclastic route, one must not forget that Luther

allowed for the use of images in the church and was himself a good friend of the artist Cranach, who, in his paintings and altarpieces, gave visual expression to Luther's theology and teaching.

Coppenger: Speaking of partnerships, I was gratified with a Coppenger-Addington partnership at Evanston Baptist Church. When I decided to take on the daunting task of preaching through Revelation, I asked Dan (who is party to this dialogue) to bring us a drawing in connection with each week's text. The pay was modest but the work was great. We simply took out push pins and mounted them on wallboard to the side. Some were pen and ink, others encaustic, still others with water color and even gold leaf. They picked up on the strong biblical imagery, whether frog, horse, cubic city, or smoke. I thought they were a gratifying addition, as they are now to my dining room in Nashville, where they hang framed and available for prompting talk of Christ with dinner guests.

The Incarnation

Stark: Of course, in dealing with the issue of the Second Commandment, one must not forget to bring in the second person of the Trinity: Christ. The Second Commandment prohibits putting God in physical form, but the second person of the Trinity takes on physical form and becomes one of us. The Second Commandment prevents us from making God too small. The second person of the Trinity makes himself "small" on our behalf. The Incarnation changes everything. What was once invisible has now become visible. What was once Spirit has now taken on flesh. What was once unrepresentable is now representable because God has seen fit to tabernacle among us. In other words, putting God in physical form would be problematic because, among other reasons, one cannot limit God to something finite—and we do not even know what God looks like. Nevertheless, depicting the Incarnate Christ in physical form is possible because he took on the flesh of a man—and we do know what a man looks like.

Thus, while the Second Commandment should give us great pause in utilizing images in a worship setting, the larger context of Scripture seems to suggest that the purpose of this commandment was to avoid idolatry—not to avoid art.

Bosch and the Catechism

Coppenger: Now and then in ministry, I get a surprise rebuke from a Christian who's found illicit something I thought was harmless, even salutary. For a bioethics conference, I fashioned a parody of C.S. Lewis's *Screwtape Letters*, one designed to criticize Dr. Kervorkian. I called it *Hemlock Letters*. The problem, as one of my fellow speakers told me between sessions, was that it required me to "put on the mind of Satan." When I objected that C.S. Lewis had done it, the answer was simply that Lewis had blown it too.

And then there was the time that a Christian publication asked me to select five paintings that depicted aspects of the gospel, and I chose, among others, Hieronymus Bosch's *Christ Carrying the Cross*, an image that captures the venality of the crowd surrounding him on his trek to Calvary. Word came back that I needed to go with paintings that didn't picture Jesus, and I wasn't sure whether this reflected the conviction of the publisher or his reluctance to provoke a certain audience. Whichever it was, I found the concern odd.

I mentioned my puzzlement to some colleagues, and one said it was part of the Westminster Larger Catechism (Q109), which condemns "the making any representation of God, of all or of any of the three persons, either inwardly in our mind, or outwardly in any kind of image or likeness of any creature whatsoever." Wow! (And to think my preacher dad and missionary-society-president mother had once given me an illustrated children's Bible, and our Sunday School walls featured Jesus-story prints produced by our denomination publishing house.)

Of course, Jesus is not a "creature," but he came in the form of one, in our likeness. So is the prohibition simply against picturing Jesus as an animal, say as a lamb, as with Zubaran's *Angus Dei?* Or does it mean that the baby Jesus in Fra Angelico's *The Adoration of the Magi* (or home manger scenes) is out of bounds?

Either way, I have to say that, as much as I appreciate Westminster, citing it as the trump card leaves me cold, for the same doctrinal document prescribes infant baptism (Q166), which, to my Baptist mind, is unbiblical. I think the publisher who disallowed my Bosch was throwing the baby (no pun intended) out with the Catholic bath. And the concern that a physical depiction of Christ could not represent his full deity would seem to legislate as much against the incarnation itself as against a painting. All sorts of people saw Jesus in his day without noticing his divinity. He didn't

have a halo or speak in some sort of heavenly tongue. So was that, in itself, misleading?

Buddhism vs. Heart Piercing

Dittman: Dr. Crider once wrote of the danger that people might "equate an emotionally-charged response (to an artistically catalyzed prompt) with a spiritual experience." But I would add a caveat, that we not assert that the emotions can be divorced from spiritual response. (For how else could we describe "pierced to the heart," except by admitting an emotional experience?) Rather we habitually distrust the origins of emotions (knowing that the heart is deceitful above all things), and the danger he suggests must exist in the misappropriation of worship to the creature in neglect of the Creator, who alone is worthy of all worship.

Undoubtedly, a spiritual experience will never transpire without some degree of emotional reality. Demonstrate this spiritual experience devoid of emotion, and the consequence will resemble some vapid, Buddhistic trance. But too often it is our default folly to demonize emotion while simultaneously urging zealous spiritual response. Can we presume to divide the spirit from the soul? When we curtail the emotion, we suppress the imagination, we snuff out the flame of the Spirit.

Emotion is birthed within the human spirit, which, while existing under God's sovereignty, has nevertheless been endowed with individuality and with freedom to rebel; thus, our challenge includes the winning of souls, the discipling of rebellious spirits, the cultivation of emotions which must cease to serve our own wicked desires and begin to serve the peerless will of the Creator whose nature can neither be contained nor fully expressed in mere works of art.

Crider correctly asserted that idolatry occurs when an individual or a congregation erroneously attributes godlike agency to lifeless objects, and he points to visual worship aids as a possible cause. I cannot wholly disagree; however, in the chemical equation of church worship, idolatry can be as much the product of corrupted reagents as of misused catalysts. Therefore, the solution which prevents idolatry, introduces a measured dose of artistry while diligently attending to the purity of its congregants.

Artistic means must be employed to quicken the imagination. The secular authorities and agents tell a compelling story, subtly corrupting our congregants and turning their attentions to the things and ways of this

fleeting world, while the ways of God fall into disuse and ill repute. Scriptures tell us that the world perishes. Even so, as testifiers of the faith, we must employ what few talents we have been given (in the uncertain times we have been given), investing these talents in worship, in evangelism, and in all Kingdom work in hopes of earning a righteous return by the Spirit of God. Whether through the splendor of visual aids, the exuberance of music, or the conviction of preaching, the people will benefit from wisely-apportioned artistry in service to the simplicity, sufficiency, and necessity of Christ's gospel: his life, his death, and his resurrection.

Coppenger: You're right that the secular authorities play a powerful tune, beguiling us with bogus stories and cheap emotions. I think of the high production values of such films as the pro-abortion *Cider House Rules* and the pro-fornication *Pleasantville*. How in the world do you compete with those? Well, two things: We really do have gifted artists and filmmakers in the camp, and God engineers great collaborations and fundings in church history; but also, God is pleased to glorify Himself and rescue people by means of the spoken gospel from unsophisticated messengers.

I recall a career day at a Tennessee Baptist school in the 1990s. As a PR staffer at the SBC Executive Committee, I was on a panel in front of the communications majors. During the Q&A, a student asked me why we didn't make great ads like the Mormons did, and I explained that each of those ending with the superimposed words, "The Church of Jesus Christ of Latter Day Saints," costs about $400,000, with particular help from a Mormon-friendly Madison Avenue agency, Bonneville Associates. Our SBC video budget, in turn, was $25,000, which didn't get you far. (We did win the Shoestring Award from the Religious Public Relations Council for a $750, 15-second ad we made from old footage plus a voiceover.) Besides, I added, "Mormons don't have the Holy Spirit, so they have to rely on such things to make headway."

To my surprise, a hand shot up, and a Mormon girl said, in a tremulous voice, that they did, too, have the Holy Spirit. I didn't think Mormons were enrolled there, and I didn't expect the inviting faculty to be appalled at my insensitivity, but I stuck by my observation. Great art is wonderful, but not necessary to advance the gospel.

The Pagan Context

Ahrens: Allen Ross, in his book, *Recalling the Hope of Glory*, writes that one of the primary reasons for the prohibition of images of God is that it would essentially confine God to a particular place that housed that image. Additionally, God would then be reduced in rank to be equal with other pagan gods who were represented in images.

Coppenger: This, indeed, provides context for the commandment, but I think we need to be careful about too much contextualizing. When I see feminist interpreters discount Paul's teaching against women pastors, saying that these were just localized attempts to counter passing church problems instead of the counsel of lasting authority, I have to say that 1 Timothy 2:14 ties the teaching to Eve and not just to whatever was going on in the Hellenistic/Roman world of that day. I don't think that's what you're doing here, but we always need to be careful about explaining away uncomfortable passages by tying them to distant contexts.

God's Love of the Visual

Ahrens: An additional point arising from this question: "Why all the beauty around us in creation?" It seems God loves the visual. It seems reasonable to conclude that since we are made in God's image, we also appreciate the visual.

Coppenger: Again, a nice point, but a word of caution. God also favors the execution of justice (cf. Rom 7), but we don't want to bring judicial sentencing, incarceration, or capital punishment (Gn 9) into the worship service.

Mental Images and Play-Doh

Williamson: When the preacher says, "With heads bowed and eyes closed," if mental pictures arise in our thoughts, are they sinful? What are we left with when we disregard any form of art representing God?

It reminds me of a time from my youth group days. The youth minister asked us to use Play-Doh to express our thoughts about God. Looking around, I noticed several had the talent of sculpting. Aside from crosses, others made rocks or foundations. The advanced recreated roses and other

beautiful representations from nature. In my cleverness, I didn't make anything. I proclaimed that God was infinitely beyond the clay. The minister rolled his eyes, "Gimme a break!" The others were able to express their faith in a manner that signified God; they created forms so that God would be praised. They were not creating images to be worshipped. They were expressing their worship through their talents. There's an important distinction between the subject and expression of worship.

One-ism vs. Two-ism

Edwards: I wonder if this prohibition flows from an important distinction between the biblical worldview and most other religions/cultures. Peter Jones points to the difference between "One-ism" and "Two-ism." Most cultures think there is a kind of continuity between different realms, including nature, humanity, and the divine. For example, Hindus worship idols, but they do so because they believe the god that they are worshiping has become identified with that idol. That's why they feed them, dress them, wake them up, fan flies off them, etc. There is no ultimate distinction between the idol and the god. But the Christian God is holy and transcendent, completely distinct from the creation. That's why it was so wrong for Aaron (and later Jeroboam) to make a calf to worship God, as if God was somehow identified with that calf. But the Ark of the Covenant was simply a place where God was "seated." God was distinct from the Ark. So our use of images in worship would need to maintain a clear distinction between the image and God.

English, Korean, or Ugandan Jesus?

Coppenger: One of the objections to portrayals of Jesus notes our tendency to paint him in our own image. Sallman's *Head of Christ*, which hung in many churches (and even in the Bible department building of my alma mater), brings to mind someone you might well find surfing off the coast of California in the 1960s. Then there are the black and Asian nativity scenes you find in different ethnic fellowships. Doesn't this battle of the images show the folly in trying to portray Jesus in the first place, and couldn't the choice of one over the other support some sort of ecclesiastical chauvinism, suggesting that one group is closer to the Lord than another?

Farris: I'd suggest that we need to remain true to reality in such portrayals. Jesus was Jewish, coming down from the line of David, with all the anthropological attributes that go with that. Of course, there's a bit of latitude in physical characteristics (Byzantine, Semitic, Near Eastern, Arabic, etc.), but certainly not room for the blue-eyed Western look, Afro look, Eskimo look, etc.

Coppenger: In preparation for an Evangelical Theological Society paper on icons, I visited a couple of Orthodox churches and spoke to their priests. In one, while we were surveying the paintings throughout the building, I asked him what he thought of, say, a Japanese icon of Jesus or Mary. I thought he'd say that a good one needed to hew closely to a Rublev look, as with *The Virgin of Vladimir*, or to one of the *Christ Pantacrator* standards. He surprised me by saying it didn't matter since the point was not realistic portrayal but the reality beyond the image—that the Mary of the *Magnificat* was Jesus' virginal mother and that Christ was, indeed, the Lord Almighty. I knew the Orthodox said they didn't dwell on the image, but rather looked through it, as if it were a window to the reality outside this world, but I'd never heard it applied this way to a conflicting diversity of ethic portrayals.

The Critic's Biblical/Theological Competence

Williamson: Waldemar Januszczak's documentary on the Impressionists is a good example of a basic misunderstanding of the Second Commandment. While he may be a good art critic (formerly of *The Guardian*), he makes a poor theologian. In this documentary, he discusses Camille Pissarro's background. He associates Pissarro's Jewish roots with Impressionism's radical departure from convention. He states that Pissarro's heritage did more than simply frown on art; Judaism forbade art.

Januszczak believes that this is why there were no great Jewish artists before Pissarro. I'll pass on his claim that there were no great Jewish artists before Pissarro, but he's wrong to connect it with a doctrinal issue. Januszczak cites the Second Commandment, but he only reads through the first clause: "That's why there's no paintings or sculptures in synagogues." It's ironic that Januszczak is standing in a synagogue on the island of St. Thomas, Pissarro's birthplace. Behind him are highly ornate images and representations of flora and fauna in gold and silver. He goes on to comment that Pissarro drew all the time, "whether he was supposed to or not."

The film shows Pissarro's early sketches. Januszczak says that the sketches are "still and quiet." Then he remarks, "Don't let this quietude fool you. Powerful sins are being committed here." Again, a celebrated art critic but a poor theologian.

This underscores the necessity of philosophical and theological adroitness in art criticism. A basic reading of Exodus shows the artistic and representational nature of the tabernacle. The representation of flowers and blossoms betrays Januszczak's assessment of Judaism. In 35:32, Bezalel is called to "design artistic designs, to work in gold, in silver, and in bronze." In verse 33, his work is called an "artistic craft." Other workers in the tabernacle are identified as "craftsmen, designers, embroiderers, and weavers" (Ex 35:35). Ultimately, "They are craftsmen in all the work and artistic designers."

Januszczak's example shows us two things: first, we should always be critical of critics and experts; his mischaracterization of the Second Commandment misinforms his unquestioning and deferential audience; second, we should be vigilant against proof-texting. (This reminds me of Ron Nash's humorously using Psalms 14:1 to show that the Bible denies God's existence.)

2

And What About the "Regulative Principle"?

Coppenger: Why can't we just stay with the apostolic model—the preaching of the Word, the breaking of bread, praying, singing psalms, hymns, and spirit songs? Do we really need (or have the warrant for) the cultivation of puppets, clowning, dramas, etc. in worship?

Addington: That's a loaded question. Many churches have, in fact, attempted to "get back to the roots," and it always looks different. I mean, how far do we take that, and how confident are we that we actually know what those churches really looked like? By the way, I don't need puppets in worship. I *really* don't. But if I ever saw something like that puppet piece based on Revelation that Mark and I saw at a secular venue in Chicago, if I ever saw that in a church, worship service or no, that would really be a gift—a treasured moment when elements and principles of my faith came alive for me in a brand new way. I can't quantify how that makes me a better Christian, but it doesn't make me a worse Christian! If it deepens my faith somehow, even my understanding of God, his world, or the people he created, and it asks me to evangelize, then it is profitable.

Coppenger: That was, indeed, an amazing puppet show, featuring, in other acts, an underwater hotel and the discharge of a .45 caliber pistol (with blanks) against a projected movie background. But back to the one in question. It was based on the account of the woman and the dragon in

Revelation 12. And this wasn't a cute Bert-and-Ernie operation, popping up from behind pipe and drape. It was a handsomely crafted set of figures, large and small.

Afterwards I talked to the man about maybe coming back to Chicago, perhaps to do something for our Baptist Collegiate Ministry group on the Northwestern University campus. And it was not at all unthinkable that we might use him in an Evanston Baptist Church service. We just never got around to it, especially given the finances of a church plant.

Stirs Up More Snakes Than You Can Kill

Westerholm: I have read hundreds (maybe thousands?) of pages about the regulatory principle. And I am less convinced than ever that the regulative and Hooker principles are useful topics to discuss, because both of the principles are highly-contested concepts with a lot of disagreement regarding definitions and applications (e.g., the email debate between Darryl Hart and John Frame, published at frame-poythress.org).

Three topics can illustrate the quagmire: First, should churches forbid or prescribe vestments? People who answered "forbid" and people who answered "prescribe" *both* claimed the Hooker principle. (For instance, there was a signal debate between the anti-vestment John Hooper and the pro-vestment Nicholas Ridley.) Second, should churches ban or authorize instruments for corporate worship? The pro-a capella and the pro-orchestra/organs/guitars sides all claim that the regulative principle authorizes their conclusion. And, third, consider the topic of appropriate songs for congregational singing. Some observers of the regulatory principle allow for songs of human composure (hymns and even praise choruses); some allow for all biblical texts to be sung (including canticles); and others insist on exclusive psalmody. But even *within* those regulatory-principled proponents of exclusive psalmody, there is more disagreement on what the practice should sound like. Should we sing metrical psalms or chant them unmetered? Are we allowed to paraphrase the Psalm into the vernacular or follow a more wooden translation? And if we insist on being *biblical*, ought we be chanting our psalms in *English*?

My point is this: As monolithic as these principles read (and as inflexible as their practitioners seem), the concepts provide more questions than answers to these conversations.

Coppenger: And one of those questions is that of self-referential inconsistency. (One of our doctoral students, Denny Kuhn, brought this up in our discussion.) If we're allowed to do only those things prescribed explicitly by scripture, what about the regulative principle itself? Where does the Bible stipulate that it's the exclusive standard?

Good for Grounding

Stark: How about business meetings, bulletins, and baby dedications? And I wonder where Ezekiel and his crazy, laying-siege-to-a-brick drama would fit into all of this—or for that matter, David's scandalous dance moves! But seriously, I appreciate the regulative principle in that it helps to keep us grounded and intentional in all we do in worship. I certainly do not want worship services to be a free-for-all, but I think that is what most fear would happen if we had artistic elements in worship. Moreover, we have all seen art used in emotionally manipulative ways in worship services ("Watch what happens when I turn on this black light!")—and we have all been to churches that put on a great show but barely mention the name of Jesus or read any Scripture. I think the regulative principle keeps us focused by having us ask the right questions: Is what I am doing and portraying biblical? Does it move people's affections toward Jesus or does it put the focus somewhere else? Are we putting on a good show or are we cultivating worship? Are we faithfully instructing people on the ways of God or are we just creating a nice hipster (or traditional) atmosphere? But these questions are just as relevant to those who do not engage the arts as they are to those who do.

Coppenger: You speak of the "emotionally manipulative" technique of turning on a black light to illuminate something as yet unnoticed on the canvas. Let me push back a little. I well remember Wheaton College's Karl Steele and his presentation to Belmont Heights Baptist Church in Nashville, during my grad school days. He worked with a big canvas, sketching a scene from the Garden of Gethsemane as he described the crucifixion and burial of the Lord. And yes, indeed, at the prime moment, he flipped some switch and the upright Christ appeared in the tomb entrance, risen from the grave.

I can't remember feeling used or compromised. Nor did I feel an impulse to defend the gospel against Steele's "manipulative" treatment. It was

a feel-good moment (and also a think-well moment), but not something to be embarrassed about in a worship service.

I remember just as well Karl's place in the art department at Wheaton when I landed in the philosophy department in the 1970s. He'd come on the faculty in the 1940s or 1950s and was something of a relic in the midst of artists more in tune with the gallery culture of the day. Still, I never found reason to disparage his ministry of childlike wonder at the unfolding of Bible stories.

I once heard that a Christian leader evaluated worship music with the question, "If the Apostle Paul is seated on the platform, is he smiling?" I'm not confident in saying that he would be frowning if Steele flipped the black-light switch to show the risen Savior.

Prescriptive or Restrictive?

Bolt: The regulative principle of worship (RPW) does not tell us what *not* to do, but what to *do*. Regardless of the position a Christian takes on this issue, all should concede that the worship prescribed by Scripture is true, good, and beautiful. We certainly do not want to find ourselves calling the worship described in Scripture, or the worship of the early church, "restrictive," with a negative connotation, do we? An aversion to the apparent restrictiveness of the RPW with respect to *quantity* of art forms allowed in worship should not affect our understanding of the *quality* of those art forms that are allowed in worship.

For example, the aesthetic value of Mennonites singing hymns without instruments, or smaller Reformed churches singing the Psalms, or even the formal public reading of Scripture is not diminished just because other practices might be forbidden. Ancient, Catholic, and Reformed liturgical practices are trendy again, and part of the reason may be that they are extremely appealing in terms of their apparent scriptural, ecclesial, and aesthetic quality. So, the RPW does not of necessity restrict the aesthetic or artistic quality of our worship, but it obviously precludes some elements others might want to include in worship. Contrasting this chapter on the RPW with the chapter on talent show judges might also yield some insights into the practical value of the RPW.

Campbellite Scruples

Coppenger: Matt brought up acapella strictures, and I remember my first exposure to Restorationist parameters. My high school band director led music at a Church of Christ, and one of our tenor sax players, a member there, schooled me in their reasons for shunning instruments in their services. I remember his reliance on Amos 6:1, 5, which speaks of the woe that falls on those "at ease in Zion" who follow David in crafting and playing musical instruments. These were the "no creed but the Bible" people, but it struck me that their hermeneutic and application were more acrobatic than exegetical at this point. And I couldn't figure out why they drew lines where they did outlawing pianos but using printed hymnbooks with Western harmonies.

On the other hand, I think there is prudential wisdom in limiting drama, film clips, etc., for they can become the tail that wags the dog. It's often said that we don't so much own our houses as they own us, what with mortgages and upkeep. The same could be said for a church that must, every week, feed the theatrical beast. This week's clip from *Downton Abbey* must be matched or bettered by one from *Chariots of Fire* or *Trip to Bountiful* (not to mention cooler scenes from old *Seinfeld* or *Friends* episodes). The pastor can lose confidence in the power of the preached Word and come to think that he has to stir the pot with thespian spices.

David Gordon from Grove City College spoke to this at Southern in his Mullins Lectures. He talked about the audacity, even "foolishness," of preaching (1 Cor 1:21) as God's chief means of presenting the gospel. After all, the culture has a generous buffet of charming alternatives, whether philosophical dialogue, drama, or poetry. But the Lord chose the prosaic, "ordinary" track of speaking scriptural propositions without irony and ambiguity. Yes, the speaker may be uninspiring in look, demeanor, and rhetorical skill, but the power is in the message, not in the channel.

Put up against the simple spoken word, a film clip or painting can be like crack cocaine. Just think of the courtroom scene is *A Few Good Men*, where Jack Nicholson shouts, "You want the truth! You can't handle the truth!" Or the Christmas home scene at the end *It's a Wonderful Life*, when Jimmy Stewart walks into the full light of his neighbors' love. You could show those for purpose of illustration, but they're so powerful that the people might stay buzzed throughout the service, missing much of what you had to say in the sermon.

Still, I think there can be a place for this. And I appeal to what I call the "prophetic principle" (or "prophetic-means principle"). It's not the same as Luther's normative principle, which says it's licit if it's not forbidden. I think this latter approach is too loose, since there are weird means the biblical writers never thought to disparage. For instance, I'm not persuaded that releasing the smell of rotten eggs (hydrogen sulfide) into the hall as an illustration of the stinkiness of sin is a good approach.

Rather, I think there is place for contemporary versions of the biblical approaches used to convey truth, whether Ezekiel's little dramas, Jesus' drawing in the sand and inviting little children to gather around him, or John the Baptist's wearing rough clothing. They were powerful in Bible times and can be so today.

As for dance, I'm very guarded. I have no doubt that those involved in interpretive dance can be edified, exulting in the way their expressive movement points them toward God. And yes, there are encouragements to dance in the Old Testament (Psalm 150). But the physicality can be a problem. I remember back around 1980 when I was asked to speak in two arts-week chapels at Trinity. The first day, a lovely woman in tights came on stage to do a graceful take on some biblical theme. Unfortunately, her figure and movements were more likely to lead the men to an unholy place in their hearts rather than to the throne room of God. I'm sure her heart was pure, but, alas, instead of a surge of piety, we men had an episode of scopophilia. Better if she had reserved this worship for the privacy of her home.

That being said, I should say a good word for a recent instance of "worship dance" I saw in a church where I preached in Southeast Asia. While the choir and congregation sang worship songs, five young women, chastely dressed, moved with the music, striking tambourines in unison. It wasn't at all offensive, but rather it added to the cheer of the moment, a counterpart to the darkness of the region's Islamist orientation.

Dance is not my cup of tea, but I don't think it's the bowl of hemlock some would have us think it to be in worship.

3

Don't We Risk Taking the Wrong Side in the Struggle for Primacy of the Word Over the Image?

Coppenger: My Baptist preacher father-in-law once gave me tips about hiring church staff. He told me that I'd always want to kill my youth director, so I shouldn't hope for anything different. (They're always walking the edge in one way or another.) As for education directors, if, when one comes into your office, he straightens all the certificates on your wall before sitting down, that's your man. (You need someone with a keen eye and heart for detail, whether parking-space size or the cleanliness of toys in the nursery.) As for music ministers, "They're all prima donnas, and they'd take the whole service for themselves if they could. You have to fight to protect space for the sermon."

Unfair on all counts, I'm sure (and he spoke with a good measure of humor, for he appreciated his staff), but there is something of a point there—that apart from the art of literature, the artist/musician is not as big on words and propositions as the pastor. Yet he must work with words, those in the pages of Scripture. John 1:1 says, "In the beginning was the Word"—and not the image or the chord. And doctrine is essentially a matter of propositions, not typically the artists' "love language."

As powerful as the image of the *Pieta* might be, we need the words to make sense of it. Why's the woman sorrowing? Who's in her lap? Is he asleep or dead? Whichever it might be, so what?

So again, it's important to keep insisting that the propositional aspect is essential, indeed, primary.

Gregory the Great and Images for the Illiterate

Addington: My touchstone for many of these questions seems to be Protestant history and the unseemly (but perhaps necessary) residue of the Reformation. It's ironic that the *Pieta* would be name-checked above as an example of how incomprehensible images can be without words. This sculpture was created when images *were* the word, and the actual words were both incomprehensible and unavailable to the common population. Our current state of literacy may be bad, but it isn't *that* bad. It suggests to me that this fear of the battle between word and image may be exaggerated. Battle or not, the church service ain't never gonna lean that far towards image again, thanks to Luther and Guttenberg. I don't see it as a conflict, though. I think the church is a great place to see word and image come together.

Coppenger: I think you're working off the classic quote attributed to seventh-century Pope Gregory the Great: "To adore a depiction is one thing; to learn a lesson through the story depicted is another. Writing sets out truth to the literate, while a picture sets it out to those who cannot read but can see." Of course, through the ages of church history, there have been illiterate believers, including countless children, who've been aided by Bible story pictures. Still, most who are illiterate understand the spoken language and so can learn aurally, in any number of settings, about Noah's Ark, Elijah on Mount Carmel, and the stoning of Stephen. But back to the *Pieta*, the one by Michelangelo in the Vatican's St. Peter's Basilica. People of that day, circa 1500, were generally able to pick up on what was being said by preachers. Yes, the Latin Mass could have been a challenge to even some Italians, but there was plenty of very clear preaching going on in the region. This was 900 years after the death of Gregory the Great, and the Dominican friar Savonarola, a contemporary of Michelangelo, was stirring things up big time in Florence. The sculptor's point (apart from satisfying his patron) was not to compensate for the citizens' illiteracy, but to touch the hearts of the faithful, who knew perfectly well who Mary was and who that was lying unconscious in her lap. (Actually, what they *thought* they knew about Mary in this episode may well have not been the case; the Bible doesn't encourage

us to think she held the Lord's crucified and dead body; this notion is likely an outworking of Catholic Marian devotion, which tends to run beyond the counsel of scripture.)

"Using" the Arts

Addington: Instead of framing the issue as a "this against that" question, we should, of course, work to reconcile the two to the glory of God. We talk about "using" the arts in the church a lot, but that misses the point. The more we try to "use" the arts, the less we engage in the unique way that the arts get to the truth. God created this ability to create and touch hearts through the act of creating, not as a pastime, but as an expression of whom we come from. I honestly don't think that the psalmist ever said, "I hope that my use of poetic forms helps make this text more evocative." I imagine it was less calculated, even less cynical, and more honest than that. And so it is today. There should be an artfulness to all our expression in the church service. That doesn't mean "artifice." It means sensitivity and conscious-ness. Sensitivity to the hearts of our congregations. A consciousness of our responsibility as those who help facilitate corporate worship. You think a loud or aggressively distorted song might not be right for a congregation? A screaming preacher's words might not be right either. Paul knew his audi-ence, and adjusted accordingly. He was an artful preacher.

Coppenger: I appreciate your talk of artfulness in terms knowing your audience. We're not just up there expressing ourselves for our own grati-fication (or we shouldn't be). So, I'm a little puzzled by impatience with evocation.

It seems to me we're trading one "this against that" for another. Some pretty tough words in play, at least as they're deployed here—'using,' 'cal-culated,' 'cynical,' and 'artifice.' For starters, I'm spoken of as being "used" all the time, and I'm not offended by it, e.g., "Mark, we're trying to figure out what Kant was up to, and we could *use* your expertise here"; "Hey, have you got a moment? I could *use* a hand in moving this furniture." These are words of honor, on the order of, "We really need some help here, and we think you have what it takes help us succeed."

Of course, if we're just asking musicians to provide some unmemora-ble, background, mood music as we slosh around on stage between speak-ing events, then yes, that's off-putting. But I don't think that's what's at issue

here. And I don't get why a poet goes slumming when he carefully orders his thoughts and feelings according to patterns of rhyme or, in the case of Hebrew poetry, parallelism/chiasm. For instance, when David says, "The heavens declare the glory of God, and the firmament showeth his handiwork," he's constraining himself to repeat in new words what he said in the first proposition. After saying the thing about the heavens, he might have been distracted by the flight of a hummingbird and waxed poetic on the wonder. But he stuck with the heavens/firmament theme to do justice to the "double-down" protocol, which was more evocative in this cultural context.

The same with "artful" preaching, which tailors itself not only to the truth but also to the attention spans, felt and unfelt needs, familiar associations, etc. of the congregation. So, the preacher and musician can be happy to be "used" of God in this way.

Let's Play a Game

Coppenger: By the way, I can appreciate the artistry of drama within a sermon. For instance, in a message on the call to evangelize, one denominational worker pulled two volunteers from the audience and place them on opposite sides of the pulpit down front. He then had each one of them go out into the crowd and grab one other person, bringing him or her to their station. The congregants were to clap and cheer as they did so. These two original "volunteers" represented soul winners, each one winning one. (But that explanation would come at the end.)

In the second round, one repeated his actions, selecting one other person from the crowd, while his original fetchee clapped his hands along with the assembly. But on the other side, both the original witness and his convert went out to bring someone back. In short order, we had three people standing on the left and four on the right. Then, in successive rounds, the contrasting bunches grew from 4:8, 5:16, and 6:32. One was growing numerically, the other exponentially. The point was that the evangelistic task was not just work for the hired, professional pastor, but rather for all who were saved, each reaching others in turn. That's how healthy churches grow.

The whole thing took 10–15 minutes, with a lot of hubbub and laughing and with no propositional exegesis during the "game." But at the end, Bang!—a convicting exhibition of the Great Commission for all.

Ambiguity vs. Mystery

Addington: It's worth noting that words can often obfuscate when images can reveal. And if it's the ambiguity of the image that we are concerned about, that concern is actually well founded! Ambiguity can be troublesome, especially to those who believe that everything at church should be easy to understand. You think words are unambiguous? Verbal clarity to all was not exactly the ministry mode of Christ when he used parables, which are typically meant to reveal a deeper truth. His artfulness often separated the sheep from the goats. In Matthew 13, when asked why he spoke in parables, Jesus said that "they look but do not see, they listen but do not hear." So, Jesus draws those who will remain in to hear, and ask questions, and discuss, and learn from each other. Ambiguity makes you work harder. You don't know what the *Pieta* is an image of? Keep trying. "Those who have ears to hear, let them hear."

Coppenger: I think it's important to distinguish between the mysterious and the ambiguous.

I speak ambiguously when I say, "I saw a man on a hill with a telescope." (Am I using a telescope to see him? Is he the one with a telescope? Is the hill on which he's standing identifiable as one with a telescope?) On the other hand, I speak mysteriously when I tell my kids that I think Santa would prefer a hamburger patty to a peanut butter and jelly sandwich. They're about to go to bed on Christmas eve, and they want to leave something to boost his energy along the way on a very busy night. The kids are too young to know I'm Santa, and they don't know I'm on the Atkins diet. My wife gets it and smiles. The kids don't have a clue. (They're the goats from which the sheep are separated.)

The parables of Jesus are more like the Santa's-appetite story than the one about the telescope. With the telescope, I failed to speak clearly. With Santa, I spoke very clearly to those grown up enough to know. The parables were not Jesus's fumbling attempts to express himself. Neither were they guessing games. They were sorting devices to see whose spirits could handle the truth.

As for the *Pieta*, I don't think looking harder will pay off if you don't have any antecedent words with which to connect the dots. With no propositional knowledge of Jesus and Mary, you'd be in the same fix I was in when I first saw a photo of *Laocoön*. I just saw a guy and some boys attacked by

a snake. Somebody had to tell me he was a priest who tried to expose the Trojan Horse for the trick it was.

Sit During the Song Service, Stand During the Sermon?

Coppenger: Let me toss another phenomenon into the mix. Awhile back, my wife and I were at a gathering of parents and grandparents of those serving overseas, and the organizer had enlisted a singer and guitar accompanist to "lead us in worship" at the beginning of the program. They were younger than the crowd, and many of the songs they chose were unfamiliar, but we soldiered on as best we could with the lyrics and melodies. This is normal, but what was particularly memorable about that night was the way that they kept us all on our feet throughout their "set." We were up for at least thirty minutes, and it got right uncomfortable. I don't care what the activity might be, whether waiting in line at a restaurant or watching your grandkids play ball, thirty minutes is a long time to stand in one spot, shifting weight from foot to foot as needed.

I got to thinking what made them think that was okay, or even important. Why couldn't they let us sit for a song or two? And the question was not unique to that situation, for I've been stuck in similar binds in church services. If you sit down, it looks like you're grumpy, unspiritual, or decrepit, or all of these.

I've heard it said that the "up and down" of the music service was a sort of holy calisthenics, meant to keep you awake during the sermon. If so, then why weren't we up and down in the music part? It seemed to me that they were saying something like, "Hey, this is worship, and so we stand (and maybe lift our hands) in honor of the one worshipped. Our posture expresses our piety and our upward orientation. When you're done, you can sit down for the lecture."

Well, I think that I worship at least as much during the sermon as during the song service. One Sunday, I heard a pastor preaching on heaven, suggesting that the prophecy of "no more sea" in Revelation 21:1 was a promise that there would no longer be great gulfs dividing people in the "New Earth." That's the "glory to God!" moment I remember in that service, though the music and the rest of the sermon were good. That was the instant when I "attributed worthship to God," my key moment of worship that day.

Which got me to thinking (in light of the thirty-minute-uninterrupted music standups I've experienced in a variety of services), why not mix it up now and then, having the people stand up during the sermon (limiting it to thirty minutes) and then sit to sing? Both are aspects of worship. I think it could help us realize that the movement from singing to preaching is not a movement from the throne of God to the earthly classroom. Both take us to the throne.

Images the Currency

Coppenger: Leonard Sweet has said, "Words used to be the currency upon which ideas were transferred. Now, images are the currency upon which ideas are transferred." That's pretty scary. If someone believes that, then what place is there for the sermon?

Jenkins: I wonder if there is something to be said in this question about different learning styles. My personal learning style is auditory over visual, but that does not mean that I am allowed to teach students simply with words and no visual aids. I understand that in order to be a good professor, I need to communicate in a way that not only resonates with me personally, but also with my students.

In no way am I advocating for a removal of words from a sermon, but could some visual aids be helpful for a great majority of the congregation? Although it may not be central, it must be considered.

Warnock: Where this is a concern, you could major on art forms that are intensely focused upon words, like poetry, rap, calligraphy, or text illumination.

Go Easy on the "Ushering"

Ahrens: I remember Joseph Crider's saying that artistic expressions do not "usher" worshippers "into God's presence." Christ, and Christ alone, is the door through which we enter, and he alone makes this possible. I have lost count of how many times I have heard this expression spoken across pulpits in multiple denominations. Honestly, I wonder if those making such statements even realize what they are saying. Perhaps we say these things because we equate positive "warm and fuzzy" feelings with the presence of

God, and music is good at conjuring such feelings. God is always present when we gather, though we are not always aware. Perhaps a better statement would be, "Let's join our voices and hearts together in song as we enter into God's presence here today." Or something along those lines.

Coppenger: I was oblivious to Joe's and Ann's concern about "ushering." I think you could make an interesting book out of pet-peeve clichés. I have another friend who hates the expression, "the things of God" (as if there were things God didn't care about).

Sermonizing Heavens

Ahrens: As for risking the primacy of the word by giving more and more space to the arts in corporate worship, William Dyrness notes that, given the increasingly visual culture in which we live, perhaps the logocentric nature of the Protestant tradition is in some ways "adapting itself," choosing to "coexist," with the arts apart from being "transformed in any fundamental way." This brings to mind Romans 10:17, which contains the oft-quoted verse, "So faith comes through hearing, and hearing through the word of Christ." Paul continues in verse 18, "But have they not heard? Indeed, they have, for 'Their voice has gone out to all the earth, and their words to the ends of the world.'" Here in verse 18 he quotes from Psalm 19, which tells us that the "heavens declare the glory of God," and specifically in 19:4 that, "their voice goes out through all the earth, and their words to the end of the world." So it would seem that Paul has no problem with the visual coexisting with, or at least supporting the oral sharing of the Word, so long as it is heard and received. Perhaps Paul understood that, in our fallen state, we would need all of our senses in order to even begin to comprehend who God is?

Coppenger: And what about the witness of the "intelligently designed," intricate human body celebrated in Psalm 139, the amazing hawks and peacocks in Job 38, and the seasonal rhythms noted in Ecclesiastes 3? Again and again, God says, "Look!" and not just "Listen!"

Enough with the Lame, Halting, Hesitant, and Unskilled Responses

Raley: I think part of the problem with "word vs. image" is that we can state the primacy of the Word with theological accuracy while ignoring the practical demands of spirituality and worship. For me, it is beyond question that revelation comes through the Word, not through image, and that the presence of God is given by faith in promises, not by means of artistic channeling. But the truth of these statements does nothing to prod people out of complacency or emotional indifference toward God. The presence of God is only granted by Christ in the power of the Spirit through His Word. But we can't assume that people trading words are aware of God's presence, or responsive to it, or expressive of its significance.

In this regard, images, music, and other forms of artistry are primarily responses from God's people to his presence. When those responses are lame, halting, hesitant, or unskilled, something is clearly wrong with worship. Issues like not knowing a song, being worn out by inconsiderate pacing in a service, or not growing in the range of expressions one can make and receive—all become spiritually disabling to a congregation over time. By contrast, when a congregation is growing in the ways that it expresses the glory of God, there is a gathering zeal to meet, to praise God, and to serve.

Which brings me to the second role of artistry beyond words. Just as it empowers responses to God's presence "vertically," it also incites those responses horizontally. Artistry feeds the imagination of God's people to apply his Word.

Inartful Preaching

Coppenger: One angle deserving attention is the artlessness of so much verbal presentation of the Word, preaching that deadens the hearers instead of engaging them. In building a wall to protect the spoken from the visual, many preachers neglect to craft a message (an "artful" one, to use Dan's expression) that does justice not only to the propositional truth of the Bible but also to the psyches of the congregation.

Now, of course, the power is in the gospel, enlivened in the heart of the hearer. If we think we convert people by our eloquence and that God cannot use the clumsy efforts of the ineloquent, we make preaching a PR

exercise and not the opportunity for a divine, transformative encounter. And I'm delighted to hear reports of God's mighty appearing on the occasion of the preaching of the weak. I still remember the Gideon speaker who told of a man in India who picked up a scrap of Scripture from the dust of a street and took it home to pore over it. Through that piece of "trash," he came to know the Lord. I'm reminded of Wesley's report that, after his heart was strangely warmed following the service in a little church on Aldersgate Lane, he couldn't remember what the preacher had said. God had simply used that event to stir his soul. The Lord can and does use anything when his truth is proclaimed, however lame the rhetoric. As they say, "The Lord can use a crooked stick to strike a mighty blow."

But some seem determined, in their effort to push art aside in worship, to push aside artfulness in their preaching. I fear that they're coached and cajoled and clubbed into this position. And a big part of the problem is in their aversion to illustration, despite the fact that Jesus was the exemplar (using parables, metaphors, and similes). Instead, they snicker at the crack that a fascinating preacher "just told stories," not knowing whether that was really the case (in which he should done more justice to the text), or whether he simply brought the text home with vivid historical accounts, analogies, and yes, short stories. Furthermore, Jesus spoke with edgy application: "You've heard this; I tell you that, and it's going to cost you." It was lively, intrusive, and demanding talk. But when you venture in this direction, you may well be reprimanded unjustly for "moralizing" rather than gospel preaching.

Zeal for expository preaching ("unpacking and applying the text") often comes out as exegetical preaching (using a thesaurus to restate the often obvious, with some contextual and summarizing observations thrown in). One has to wonder what happened to the doctrine of the perspicuity of scripture when the preacher spends so much time restating the plain words of the text, as if he's providing the key to some gnostic scripture.

Then there's the matter of time. How often does the preacher cram a 20-minute sermon into 45 minutes, anxious that he match the span exemplified in seminary chapel services when he, in contrast, doesn't have the stuff to fill the span. Afraid that he'll be accused of "preaching sermonettes for majorettes who smoke cigarettes . . ." (or however that went), he drives his people into realms of insensibility, with their fingers twitching for a smart-phone check.

Look, one of the best sermons I ever heard ran an hour and forty-five minutes, and it seemed like thirty. Richard Owen Roberts was speaking at a conference on revival, and we were afraid to say breathe as he brought a piercing word our way. I was reminded of an account I read in seminary, of an enemy of the gospel who come to a Christian service during the Shantung Revival. He came to stir up trouble, but the preaching and Spirit work was so powerful that they found him quivering under a pew at the end of the service. We weren't there yet, but we were looking for some sort of cover. It's not the length that matters; it's the metaphysical and moral drama that holds you.

I once heard of the folly of Middle Eastern Muslims who faced west fearfully and hatefully, geared up for conflict with the "Great Satan" (the U.S.) and the "Little Satan" (Israel). The observer said they might be in for the surprise of their lives, in that God was working powerfully to bring Muslims and others non-believers at their backs to Christ, those from China, Iran, and the "Stans." That may be the real threat to the Sunni and Shia strongholds of Mesopotamia, the Persian Gulf, and North Africa.

Similarly, as preachers steel themselves against the arty types clamoring for attention and involvement, they may be opening the gates to sermon de-emphasizers by their plodding and willfully dull fare. They're starving the imaginations and hearts of their congregants, making them vulnerable to the blandishments of those who would say we need more splash and color and entertainment.

But it doesn't have to be so. Two words: Alistair Begg.

A Healthy Tension vs. Turf Wars

Westerholm: The relationships between music leader and preacher are always contentious. When they work well together, it's glorious. I'm thinking here of the revivalist movements that so many churches see as their pattern for ministry: Ira Sankey and Dwight Moody; Homer Rodeheaver and Billy Sunday; and of course George Beverly Shea and Billy Graham.

But when that relationship breaks down, the worship service can quickly degenerate to turf warfare. Things can quickly get intractable. In terms of the service, the answer is simple: Both people have complementary roles to play in celebrating the gospel with this gathered community. The reality is that often these dynamics are caught up in struggles for power

and authority. I encourage my music minister friends to find a preaching pastor you can enthusiastically support or go somewhere else.

The worst of all, I think we can agree, are the hybrids. As the old joke goes, the only thing worse than "singers who preach" are "preachers who sing."

Coppenger: Touché. (And, of course, just as music ministers should find preaching pastors they can enthusiastically support, preaching pastors should find music ministers whom they can enthusiastically support and who, in turn, can enthusiastically support them.)

"Buddhist" Singing

Coppenger: Let me throw out one more thing. Part of the problem with our music is that we don't use enough words, even when they're good words. Sometimes we sing the same ones over and over again, virtually *ad nauseum*. Not that long ago, I counted over two dozen repetitions of the same phrase, without any breaks. I pretty well got it after the first three or four times, but I realized I was chafing under a notion that has great currency today—that we go deeper in our understanding and conviction each time around. Granted, this seems to work beautifully for some, but I get impatient while they're being transported. Alas, a long string of reiterations reminds me of those Buddhist prayer wheels you see in the Himalayas; every time you spin it, the prayer goes out again.

I'm keener on hymns like *Amazing Grace* and *Be Thou My Vision*, where you use a bunch of words, filling the mind with fresh thoughts throughout. I mean, if the employment of two-dozen contiguous repetitions is so great for insight and sanctification, why don't we ask the preachers to do it too, with our saying "Amen" after each utterance—"Jesus's love is everlasting . . . Jesus's love is everlasting . . . Jesus's love is everlasting . . ." and so on for a couple of minutes.

I'm all for choruses, sung once per stanza. They underscore and develop what's been said in successive verses. But if we camp on a refrain, like "Then sings my soul . . ." in *How Great Thou Art*, and sing it six or seven times at the end, that's weird . . . and numbing.

Now, I have to add that I played the grump on the other side once. Someone at an Alliance for Confessing Evangelicals meeting in Cambridge was rehearsing a complaint similar to mine here, and I thought he was too

sweeping in his dismissal. Turns out, the very Reformed hymnal we were using contained an eleven-fold amen. Now *there's* some serious repetition, and I mentioned it to a reporter who was getting my take on the meeting. Of course, you work through the eleven in less than thirty seconds, usually at the end of the service, with the choir singing it.

Still, the point is that there are so many great words. And hail to the hymn that makes good use of them.

4

What's Next? Incense?

Coppenger: At a reception for Mokota Fujimura at Addington Gallery, where his illustrations for the 400th-anniversary KJV (Crossway) were displayed, the artist handed out small scent sticks prepared by a man who sought to capture the essence of that translation in fragrance. He said that some whiskey aroma was included to honor the "Scotch" heritage of James I.

Don't things get a little crazy when we start "pandering to the senses" by encouraging artists? Auditory and visual arts can be elevating, but do we really want to go down the gustatory, olfactory, and tactual roads in worship? Still, do we want to totally rule them out?

Technicians and Their Smoke Machines

Addington: Well, as they say, one man's crazy is another man's boring. (No one says that, but you know.) But yes, this is a good question. I would suggest that we pander to the senses whenever we simply eat a good meal, and maybe that's why Paul encouraged us to eat first, and not show up at the Lord's Supper all famished. No, let's not pander to *anything* when we worship, least of all the senses . . . *Please* . . .

. . . and *yet*, churches continue to use great lighting, wonderful sound-mixing techniques (using hardware worth thousands and thousands of dollars) and no one is calling it "crazy." On the contrary, most worship conferences aimed at evangelical churches dedicate class after class and

workshops and symposiums to the "tech" of worship—projection and *sound mixing* to pander to our sense of hearing and sight, and they are using such expensive gear to make this all happen. I'm not just talking theater lighting and good amplification; I'm talking big concert wireless sound systems and . . . *smoke machines* . . . and often for churches that see maybe a couple hundred in attendance at best.

"Sensaround" in the Huleh Valley

Coppenger: A couple of years back, a bunch of us went to Israel and Jordan on an SBTS trip, and we had a curious experience in the Huleh Valley, once swamp land up above Galilee. Israeli ingenuity had turned the region from a malarial no-go zone into a combination of farmland and migratory wetlands, a resting place for birds making their way from Europe to Africa and back.

In the national park section, we visited something of a "sensaround" theater where we "flew with birds," our seats reeling this way and that, with a fine mist sprayed in our faces at the flock went through clouds. It was pretty discombobulating, though a fun novelty. I'm not keen on some creative minister rigging a worship center for that sort of thing, with radiant heat from the floor as we consider hell, a spritz of perfume as we envision Ein Gedi, etc. The gospel is essentially verbal and propositional, and we have to be very careful about trying to prop it up—and jazz it up—with tactile, olfactory, and gustatory aids.

Expectations of the Anticipated Majority

Farris: It is well-known that Roman Catholics and Orthodox worship traditions emphasize the use of all the senses within the sanctuary. This is one reason for the thurible censer swinging from a chain in the Mass. And, of course, the Old Testament often mentions the burning of incense. The tradition extends to many of the world's religions and our use or nonuse is cultural. Unfortunately, and this is just me, anytime I smell incense, I am mentally taken not to a cathedral but to a Buddhist pagoda because my initial religious encounters with olfactory augmentation was in this context.

If art is good enough on its own, it shouldn't require aroma therapy or a shot of scotch to invoke appreciation for it. However, to argue against the use of these things would be to argue along the same logical lines against,

say, the use of musical instruments in worship, or against any iconographic element whatever within the church building. Perhaps the primary aspect of the arts and their associated sensory detection among Christians is memetic or semiotic in character: we seek to imitate or symbolize that which is beautiful, joyous, divine, and timeless. Nonetheless, it would seem effective and prudent to stick with the expectations of the anticipated majority in such matters, if there were such a thing among the patrons of the Addington Gallery.

Coppenger: Last year, for an ETS paper, I took a closer look at icons and the churches who give them prominence. Along the way, I coined a curious (ugly?) word, 'karposology.' It drew on the Greek to denote the study of fruit bearing, in this instance in the iconophilic traditions, particularly the Orthodox. I noted their sense of rootedness, encouraged by the ancient images, and how this serves them as they cling like lichens to the forbidding rocks of Middle Eastern culture. But I also noted a sort of primitivism that besets these cultures, even raising the question of why there is no Greek car. Be that as it may, I think there is strong evidence that the rapid, world-upending spread of the gospel in the first century was driven, not by "smells and bells" and icons, but by the preached Word.

Nag Champa, "Stranger Things," and the Sweat Lodge Journey

Williamson: Some sensory triggers have such strong connections with non-Christian practices that it would be unwise to "baptize" them for church use. Of course, most churchgoers would not even consider the use of incense in the service, but I think it's still helpful to look at the reasons why we might object to its use. I realize that you've brought up incense as an absurd example, but it does point to the excesses of "pandering to the senses." When I think of incense, I strongly associate it with mystical attitudes. I think of dream catchers, rune stones, and sweat lodges.

These connections reflect my past experience of briefly venturing into a bohemian lifestyle. During that time, I was around a lot of incense use. Everyone seemed to use a certain kind, which they felt was the genuine incense. (They never really explained what "genuine" or "authentic" incense meant; from that worldview, you either got it or you didn't; no room for reasons.) They all used Nag Champa. It's very potent and easily

recognized, so easily identifiable that I was able to pick it out in a Hindu temple many years later. By that time, I had turned to Christ. I was intrigued that this was the incense of choice; and naturally, it played into the hyper-spiritualized essence of the hippie lifestyle.

This is one area where the church would want to make a strong distinction from the culture. There's nothing intrinsically wrong with fragrances, but some of their uses are too specific. Nag Champa is entrenched in Hindu worship, unlike the generic use of other fragrances such as found in the soap in church bathrooms.

Similarly, music in general is not as evocative as specific genres of music. In a recent church service, I saw a short video with a looping, synthesizer, audio track. I immediately focused on the audio because it mimicked the score for *Stranger Things*. I was further pulled away from the video when I overheard someone behind me whisper, "Stranger Things." Even though this happened a few months ago, I can't tell you the content of the video. There's nothing theologically deviant about eighties electronic music, but it was certainly distracting.

In the same way, I don't find rainbow flags or stickers on many local churches. The churches that do have them are obviously signaling something. On this model, would the use of incense be a type of "mystical signaling," saying, "Yes, we're down with the spiritual scene?" Similarly, imitating *Stranger Things* can say that the visual arts ministry is "relevant."

Another issue: Pandering to the senses can be strongly individualistic. For instance, the purpose of the sweat lodge is to evoke personal visions, and incense assists one in undertaking whatever "journey" he or she may find compelling. It can be highly myopic, concerning only the individual's experiences and feelings. There is no connection with other people. In contrast, the gathering of the church body is about communing with God and fellowship with other people. Sure, there are different body parts, and different experiences that may be subjective, but it shouldn't be so intense that one's sensory experience supplants the recognition of coming together. Instead, church worship aims at a unified experience.

Boundary Pushers Who Try Too Hard

Warnock: It strikes me that the question about incense presumes that artists always want to push the boundaries, to do novel things for novelty's sake, with unclear purpose. To be fair, that presumption is not without

merit. I visited the Hirschhorn Museum on my last trip to Washington, D.C. The galleries contained some really dizzying craftsmanship, but also some pieces that I'd classify as "trying too hard." Much of it was trying to make a political statement, like the terra cotta replica of Osama Bin Laden's compound with houseplants growing in it. The artist stated that he was trying symbolically to replace death with life. Perhaps this is a moral failing on my part, but that kind of pious earnestness earns eye rolls from me. Then there was Yayoi Kusama's giant pumpkin in the sculpture garden, painted with a stark pattern of black and yellow. (A four-foot version of Kusama's pumpkin reportedly sold for $784,485). She's insanely popular. I think I can safely say without fear of contradiction that big painted pumpkins or olfactory explorations of Reformed bibliology, or tactual interpretations of the Song of Solomon are novelties the church does not need.

None of the artists I've worked with in church settings aspire to create new genres of "olfactory worship" or "tactual worship." They are happy to create and innovate with the tools and along the channels that are already widely accepted in worship. The fear of purposeless novelty is unwarranted. If an artist here or there tries something like that in church, they can be redirected to expressions that serve the people and purpose of the church.

A Blessing at Vespers

Stark: I may be the odd man out on this one, but would incense be so bad? I know from our Protestant background, we (rightfully) seek to avoid abuses from the Catholic tradition, but while I would certainly agree with Dr. Coppenger that the gospel is verbal and propositional, I think we must remember that it is also incarnational. Yes, we must not neglect the verbal and propositional—but doing so does not mean we must be iconoclastic. Just because there have been idolatrous abuses of the material aspects of worship, we don't need to avoid the material elements altogether. Incense, for example, was prescribed in the Pentateuch for Israel's worship.

If utilized appropriately, could elements that engage the senses not aid in the understanding and retention of the propositional truth we are communicating? As I have noted elsewhere, our New Testament ordinances are themselves sensory in nature, yet they are richly connected to propositional truth. Moreover, some congregants are not going to be strong auditory learners. Could sensory elements not assist in their grasping and retaining what we are also expressing verbally? The sense of smell, for example,

is often tied to memory. Perhaps a scent-based component to worship would have some benefit after all. Likewise, visual components might help to make abstract concepts more comprehensible for listeners and help the congregation to stay attentive.

I once attended a vespers service with an Orthodox friend. The sanctuary felt other-worldly—filled with incense and icons. Now, obviously, I have theological reservations concerning the use of icons in worship, but nevertheless, I have to admit that if my mind started to wander, the religious imagery and the scents around me quickly returned my focus to the reason I was there—to worship Christ.

I am not suggesting we become more Catholic or Orthodox in our worship practices. By no means! But Protestantism also has a rich sensory tradition. The altarpieces, sculptures, and artwork that adorn the sanctuaries of Wittenberg's Castle Church and St. Mary's Church—two critical churches in the Protestant Reformation—have likewise directed my attention to the propositional truth of the gospel. Neither, I should mention, do I have a particular hankering for incense. But as Dan pointed out, worship services are going to have sensory components even within the more iconoclastic wings of Christianity. If incense is as "crazy" as it gets, is that really causing anyone harm (beyond those who have sensitive noses)?

Undistracting Excellence

Westerholm: For over fifteen years, our church has attempted to pursue what we've called "undistracting excellence." Our official document says,

> We will try to sing and play and pray and preach in such a way that people's attention will not be diverted from the substance by shoddy ministry nor by excessive finesse, elegance, or refinement. Natural, undistracting excellence will let the truth and beauty of God shine through. We will invest in equipment good enough to be undistracting in transmitting heartfelt truth.

The sentiment has garnered wide support and served us well. But, from my perspective as the worship pastor, it also has been weaponized. The term "undistracting" is not as universal as it first appears. Almost any visual alteration to the sanctuary's visual design "distracts" those who prefer what it was formerly. If a musical arrangement reharmonizes a text in a way (minor chords over "long my imprisoned Spirit lay, cast down by sin

and nature's night") and causes people to consider the lyric in a new way, it can be accused of distraction.

My sense is that the next level of thinking we need is to consider (with apologies to Alasdair MacIntyre), "Whose lustrous? Which musicality?" [cf. *Whose Justice? Whose Rationality?*] Leadership in the church needs to consider how decisions are going to affect different consituencies within the church and make good choices. John Calvin (*Institutes* 4.10.30) talks about the need for changes in worship services and says, "I admit that we ought not to charge into innovation rashly, suddenly, for insufficient cause. But love will best judge what may hurt or edify; and if we let love be our guide, all will be safe."

5

Don't They Abuse Language?

Coppenger: While there is a basic concern that the visual, plastic, and musical might crowd out language, there is the opposite problem—that artists can insist on talking at length, obscurely, pretentiously, and unaccountably. One small example: On a recent trip to Spain, I visited the contemporary museum of art in Barcelona, where, in the great entrance hall, one reads

SOME OBJECTS OF DESIRE
+
SOME OBJECTS OF NECESSITY

-

SOME OBJECTS OF NO CONCERN
(divided by)
A FORCE MAJEURE ["irresistible force"]

=

SOME THINGS

And it's repeated below in French and Spanish. This forty-foot-tall word-painting is a work by New York artist, Lawrence Weiner, executed in 2004.

Apparently, this passes as profundity in the Spanish and New York museum world, but if a freshman tried to turn this in as an example of deep thought, the teacher would challenge him to clarify things, and then, if such clarification were possible, suggest some counter-examples, rival accounts of reality, and such.

The problem is, if you press at this point, you're dismissed a slave to logic, literalness, etc., and you're patronized with something along the lines, "It's just supposed to make you think." If, on the other hand, you remark that the words are insightful, you're thanked for resonating with their truth. In other words, it's a total win/win for the obscurantist artist—full credit for praise, total insulation from criticism. This gets tiresome—and is the source of the old protest, taken in its broadest application, "Shut up and sing."

The Baby and the Bath Water

Addington: This is a baby/bathwater situation.

Do we consider much more profane excesses that many random secular musicians have indulged in as reason to not play music in worship?

I would be very interested in what a "text-based-artist" might do in a church exhibition context! How might a Christian artist engage this question about the primacy of the word? I'm curious.

Coppenger: Of course, a lot of artists in the broad sense, are masterful with words. When William Cowper writes *There is a Fountain Filled with Blood*, Isaac Watts writes *When I Survey the Wondrous Cross*, and Stuart Townend writes *In Christ Alone*, the church is in their debt. And I'm fresh from a visit to the stunning Gaudi cathedral in Barcelona (*Sagrada Familia*), whose massive iron doors are covered in biblical text. But a lot of artists are indifferent toward and impatient with theology, and sometimes logic. As a group, they say a lot of sweeping things about man, society, spirituality, metaphysics, etc. I have books full of their manifestos, of their interviews and memoirs. And much of it is both grandeloquent and daft. Yet critiques are not so much rebutted as dismissed as small-minded piffle.

For comparison, artists might consider how they'd feel about a group of theologians opening a gallery of their own art as an enterprise to be taken seriously. The walls are filled with what would normally be taken as refrigerator-door art, the sort of thing a parent might put up there with a magnet. But what if the academic divines became indignant at critics who pointed out their artistic blunders? After all, their brush strokes came from earnest Christian hearts intent on glorifying God. Why be picky?

I'm just suggesting that artists who bring their work and words to the fellowship be open to doctrinal scrutiny, much as staff members who bring their paintings and poems to the fellowship should be open to aesthetic

scrutiny. And even self-effacing: "Now, I'm not a poet (or painter or theologian), and I'll have to defer to Dick and Jane for judgment, but here's what I've come up with."

Something like that.

Two Unfortunate Tendencies

Westerholm: I think that's helpful. Observers or critics of art ought to take an artist seriously and engage their work of art in the terms that the artist has presented it. If an artist has presented a work of art using language, it honors their intent to consider and evaluate the words they have chosen. Sometimes, Christians have overly prized language and assumed that anything without words (like visual design or instrumental music) is meaningless (what Jeremy Begbie calls "hyper-Protestant verbalism" in *Music, Modernity, and God*). But what I hear you talking about is the tendency of some visual artists to treat *language* as dispensable or meaningless. It seems that neither of those tendencies are the way forward.

Coppenger: I posed the original question in the context of concern that propositional truth is taking a beating in the academy and society today. We hear a lot of snarky talk about the "tyranny of linear thinking" foisted on us by "dead, white, European males," and the need to "deconstruct" statements with a "hermeneutic of suspicion," casting everything in terms of power plays instead of efforts to speak with clarity and veracity. In our day, defending consistency and precision in speech is a little like defending the sanctity of heterosexual marriage. The social current runs strongly against it.

Addington: One who would pose the original question above might be a fan of logic and organized thought, so in that case, it might be good to differentiate between the function of art that engages language out in the secular culture, and art that is being utilized in the church to enhance and encourage the act of worship, both of which are used interchangeably in the above series of questions and observations. The statement above starts out talking about the sacred efforts of those within the church, hymnodists, and church architects, but then finishes with a reference to what I assume are secular artists through history, with their daftness and their piffle! These are apples and oranges. The artists that are in the church—true artists that

are true Christians—have not had that much of a voice since the Reformation, and only recently has that started to change. And guess what, most are mindful of this and are grateful and typically humbled when asked to bring their voices and talents to the altar. One will not find any secular sweeping manifestos at that altar, because the Christian's manifesto, artist or not, is God's Word.

But since you brought it up, let's look at art and manifestos in the greater secular culture. These historical documents (which were a ubiquitous phenomenon in nineteenth and twentieth-century art and politics) were part and parcel with "movements," and are often great historical references, signposts that help us to place the artwork of that era into an historical context, to open a window into the mind and motivations of those doing the work. But the manifestos alone are not the work. An artist's manifesto with no artwork is like a list of ingredients on the side of an empty food package: we might try to imagine what all those words we can barely pronounce might add up to when stirred, cooked up, and served beautifully on a plate, but we'll never really get it till we taste it, and then, we will forget the list, because it will not aid in our enjoyment of this sensually thrilling activity one bit. The manifestos aren't the food. They aren't even the recipe. They are merely a dry list of ingredients, really just an effort on the part of artists throughout history to explain the unexplainable, to put a name to the nameless, and maybe also to brace the artist's like-minded comrades and arm them for a war of words in which they soon might find themselves. But in the end, it's the art that matters, and it either works or it doesn't for each person that takes the time to look. (Was that a manifesto about manifestos?)

Coppenger: Indeed, it was. And I think I've been reading different manifestos. While some artist-aestheticians (e.g., Joshua Reynolds) give a list of prescribed ingredients for cooking (balance, texture, etc.), a fair number of them are right contemptuous (as if a food wrapper read, "And we don't use curry, because anyone who uses that is an execrable sod.")

Addington: By the way, when it comes to artist statements, the artist is damned if he does and damned if he doesn't. Manifestoes aren't really in vogue anymore, but laymen still want "explanations" from artists. It's a trap. If the artist tries to explain it, the explanation will rarely do justice to the work, which is not text for a reason. But, if the artist doesn't give an

explanation, he's an elitist. Let the artist make the art, let the critics argue about it, and let the market play with it. In the end, the historians will add it all up long after we are gone.

So, I think the above question is a red herring in *modern* society, where the artist doesn't really want to talk about his work anyway. As a rule, in the post-war art world, artists want to keep quiet about the work and let it stand or fall on its own. It's the art theory and criticism that the art-engaged reader must contend with in our era, not any artist-penned manifesto.

Coppenger: I've heard and read Christian artists who offer more than "God's Word" for their "manifestos" or explanations. Like the rest of us believers who are making arguments for what we do (voting for so and so; joining this or that church; ordering our family life), they more or less make sense in the biblical context, and yes, are open to push back. In that sense, we're *all* damned if we do and damned if we don't.

Addington: As a side note, I love the "take that!" approach in the above suggestion of theologians making art and doing an art show. Yes Lord, let it be! The suggestion above seems to be 1. "How ridiculous a notion" and 2. "If they did it, boy, wouldn't that affront really teach those uppity Christian artists a lesson about engaging theology without proper training!!" But here's the thing: I think many artists would embrace such an act, because it would open up all kinds of dialogue, understanding, and new awareness. As an artist, I *always* want people who are achievers in other disciplines to try their hand at art making. This activity might lead to a deeper understanding of what all goes into making art, and who knows, some theologians might discover some latent talent they never knew they had! Hallelujah!

Coppenger: Uh, oh. I think I just got the "Take that!" laid back on my "uppity" self.

Addington: Here's what really makes that such a great suggestion. Ever since the Reformation, there's been a certain enmity that has existed between the worlds of the theologian and that of the artist. It was mostly residue from the time when the Roman Catholic Church was the leading patron of the arts. When the Reformers washed all signifiers of the Roman Church from their sanctuaries, the art was washed away too. The uneasy relationship has existed ever since. But many in the Reformed tradition have opened their

arms to the idea of a renewed connection between church and culture. The irony of the aforementioned theology/art conflict is the similarity of the places that theologians and artists occupy in our greater culture. They both practice a discipline that requires an act of faith. They both are considered intellectual elitists in Western culture. They both struggle to give shape and voice to the unseen, and to do it with eloquence. So, instead of talking about theologians and artists playing Gotcha! with each other, let us encourage them to meet each other, learn from each other, and add a richness to each other's life and practice. Let's get that symposium started!

Coppenger: A symposium sounds promising. But, first, let's organize that exhibition. Maybe we can start with the paintings of Grudem, Vanhoozer, Packer, and Frame. I'd buy a ticket for that. (Of course, to extend my analogy, we'd have to treat their painting with gravitas rather than as a fun exercise, a lark, to start a conversation.)

Preacher, Shut Up and Preach!

Stark: I would not say this problem is unique to artists in the church. From time to time, I find myself internally screaming at preachers to "shut up and preach." Particularly as a youth pastor, I encountered speakers who were just as "lengthy, obscure, pretentious, and unaccountable" as the artist you described. I remember talking to a group of students one time regarding a speaker's message. These students were deeply moved by the "profundity" of the speaker's words and creative expression, but they were unable to articulate on any level what exactly his message was about—and for good reason! With all those words, random illustrations, and impactful intonations, the speaker had not really said much of anything. But in his own mind, he was really deep.

Artists are not the only ones who misuse and abuse language. Just because some artists are inclined to do so does not mean artists should not have a place in the church—just as the abuse of language by some preachers does not mean we should do away with preaching. We just need higher standards for whom we allow to lead in these areas.

Coppenger: Of course, I didn't raise this to suggest artists should not have a place in the church. Just a word of caution. And you do well to apply it to preachers too.

Doctrinal Soundness

Stark: Doctrinal scrutiny is a must for anyone who is seeking to lead in any capacity in the church. Before I would allow someone to preach or lead worship, I would want to make sure he was sound doctrinally and had a good grasp of the gospel. I would have the same expectation for artists working within the church. Understanding that art and preaching serve different functions (e.g., ambiguity can be a positive in artistic expression while it is mostly counterproductive in preaching), I would nevertheless want to make sure artwork within the church was in line with biblical teaching.

More to the initial question, I would want to know to what end the artworks and/or the artist's words were edifying to congregants. It is one thing to play with self-congratulating "profundity" in the gallery—quite another to play such a game within the church. A key purpose of corporate gatherings is to "equip the saints for the work of ministry, for building up the body of Christ" (Eph 4:12). Indeed, the Apostle Paul argued that this equipping leads to spiritual maturity, which keeps one from being "tossed to and fro by the waves and carried about by every wind of doctrine, by human cunning, by craftiness in deceitful schemes" (Eph 4:14). Thus, little room seems to exist for "lengthy, obscure, pretentious, and unaccountable" talk within the church, for one can hardly see how such talk would work toward the spiritual benefit of a congregation.

Moreover, in 1 Corinthians 14, Paul dealt outrightly with the use and abuse of language within the church. He rebuked the individual who spoke in tongues during the corporate gathering without an interpreter, arguing that such a person "builds up himself" rather than the church (1 Cor 14:4; see also 14:9–12). Paul advocated for the necessity of "revelation or knowledge or prophecy or teaching" for a message to be beneficial to the congregation (Col 14:6). While according to this passage, speaking in tongues may have its place, it is not beneficial in the church *unless* clear, understandable, and doctrinally sound teaching arises from it.

I would make the same case regarding art in the church. While I would not expect or desire for the artwork to be allegorical, overtly pedagogical, or simplistic, I would expect the work to have meaning, and a distinctly Christian one at that. After all, we are a people who believe that images and words have meaning and are consequential, and we are a people who "speak the truth in love" (Eph 4:15); therefore, we expect our ecclesial artists to believe and do the same.

Coppenger: Right. One year, I was the speaker at a church retreat, and I appreciated the professional musician they brought in as my teammate. Things were going well until he took a moment in one of the later sessions to speak a bit on a breakthrough insight he'd had in his Christian walk. He said he'd recently learned to ignore criticism or negativity, and that it had freed him up to do better, more sustained work.

Well, yes and no. If it's only carping, then you mustn't be crippled by it. But some suggestions and even rebukes are fair, and one ignores them at some spiritual (and perhaps even professional) peril. Sure, they can hurt, but that's one way we grow.

But the song service was great.

This isn't to say that I'm always or typically disgruntled at an artist's commentary. The other evening, I heard Jeremy Begbie (whom Matthew just mentioned) speak from behind a piano at a local Episcopal church. Playing chords and passages from a number of pieces, he suggested that music provided a good alternative to visual art in explaining the Trinity. Take a typical abstract portrayal—a triangle, a triquetra (with overlapping arcs), or three intersecting circles—and you have some mutually-exclusive spaces, places where, for instance, Jesus is, and the Holy Spirit is not. Otherwise, the image would simply be a unity without a diversity. But with a three-note chord (e.g., C–G–E), they're all there together in their fullness, with no place excluding the others, and generating overtones. I know it was just an analogy, but so are the three-sided visuals.

So I'm not arguing for an either/or protocol for "arting" and speaking. You can do both in the same presentation.

6

Why Should Artists Have a Seat at the Worship-Leading Table Any More Than Plumbers or Accountants?

Coppenger: My colleague Joe Crider tells of showing one of his classes a promotional video a church produced for its art ministry. In it, a sculptor said that, before this program, he'd been frustrated that there was no place in the church for him to do his thing. Some of Joe's students said that the artist shouldn't complain if his work didn't appear in the context of corporate worship. After all, plumbers and accountants didn't feel the need to bring their skills to bear on what happened during "the eleven o'clock hour" or in the other corporate worship and teaching events.

Apples and Oranges

Brandt: Obviously, God gifts people in different ways. Some gifts are not more "sacred" than others. They are all gifts from God through his Spirit. But I would argue that the purpose of art is more conducive to the worship expereince? The purpose of plumbing is to create, maintain, and fix a building's pipes. The purpose of accounting is to manage financial resources, to track the progress of a company's or person's goods. The purpose of artistry is different. Artists, especially Christian artists, attempt to create something that points to a meaning "behind" itself— to convey a sense of the divine.

Sure, all these occupations are done for the glory of God, but only the artist's work explicitly points to God in worship.

Stark: Exactly. I want our plumbers to make sure our toilets work, our accountants to keep us legal and on budget—and I want our artists doing what they do best, helping us communicate truth in a way that grips the mind and heart. Plumbers and accountants may very well be at the worship-leading table, but it would not be because they are plumbers or accountants. It would be because they have a giftedness in facilitating corporate worship that is Christocentric and grounded in the Word of God. But for that matter, I do not want artists at the worship-leading table simply because they are artists. These artists must be Christ-focused, gospel-oriented, accountable to pastoral leadership, and subject to the Word of God. Nevertheless, we would be foolish not to utilize those who are gifted in communication to help us proclaim the gospel meaningfully, and artists can do just that.

Counsel and Graphics

Coppenger: The question focuses on worship-leading, but let me mention another angle. Dan Addington did, indeed, lead our music (and amazingly so), but he did much more. I remember my skepticism when he urged us to have the ceiling of our meeting space painted black. We were renting a big room in the basement of an office building, a sort of bear cave, safe from the mean Chicago winters. I was afraid it would make it more a dungeon or dive, but we went with it, along with track lighting and a range of colorful images on lighter walls. It was perfect. So, for one thing, Christian artists are great consultants.

Another Addington example comes to mind: When we launched Evanston Baptist Church, I turned to Rick Boyd for a logo. He'd been a great colleague in ministry throughout the years, doing the graphics for *SBC LIFE* and Midwestern Baptist Theological Seminary, including the "prairie fire" logo. Then, when we got permission to put our church logo on the office-building window, the Addingtons executed the layout and positioned it perfectly. (It would have been crooked if I'd done it.) And Steph designed the outreach postcard. It went on and on.

Control Issues

Addington: If artists feel under-utilized when they are equipped to contribute, I would encourage them to search for a place of worship that welcomes the possibility that they seek. If church leaders want to breathe new life into the culture of the church, they might consider opening up possibilities for this kind of contribution. It doesn't have to be at the "worship-leading table." It could take the form of an exhibition that people were free to walk right past if they wanted to. Some people may want to avoid artwork like this because they do not feel interested or equipped to deal with the potentially painful or emotionally affecting content in the work, while others will apply an analytical or interpretive eye, bringing mind and heart to the artwork, and it may become very meaningful to them.

Hmm . . . Is it possible that the inability to *control* the meaning and outcome of a work of art can be threatening to certain churches, church leaders, or denominations? After all, it is almost doctrine in the artmaking world to consider the content of the work not *fully* realized until the viewer or listener has encountered the work and interpreted it based on their own experiences and world view. Many churches and church leaders like to exact a little more control than that.

Coppenger: Well, there is that verse, 1 Corinthians 14:40, that says "all things should be done decently and in order," which was spoken in the context of disruptions from tongues-speaking in the assembly. So interest in "control" is not, in itself, illicit, but certainly, it can be used to squelch good things. I think you have to get down to specifics to sort this out, because we can all think of errors on both sides. And, of course, all parties concerned are interested in control, in people going along with their leadership, or not interfering with their decisions. So, again, it comes down to specifics.

Let me put an example out there. Let's say a painter draws a small cross made of rifles and hangs a child with fatal bullet wounds on it. Off to the side stands Jesus weeping. The artist wants it to hang in the hall down by the Sunday School rooms. Or imagine the organist inserting phrases from *We Are The World* into an offertory based mainly on *Amazing Grace*. Would it be unfortunate for the pastor to say, "Let's not do that. I think it'll stir up more discord or controversy than its worth. I'm all for protecting the school children and for feeding the hungry, but there are cross-currents here we don't need to negotiate right now."

Or take the famous case of the search-for-peace art show at Rob Bell's Mars Hill church in Michigan. It included a painting of Gandhi with one of his quotes. When a visitor to the exhibit placed a note beside the painting, one reading, "Reality check: He's in hell," Bell reacted indignantly. As he reports in his book, *Love Wins*, he thought,

> Really? . . .
> Gandhi's in hell?
> He is?
> We have confirmation of this?
> Somebody knows this?
> Without a doubt?
> And that somebody decided to take on the responsibility of letting the rest of us know?

And, so, Bell gestured toward universalism, making room in his theology for the possibility that all (or at least all nice or admirable people) will be saved, apart from accepting Christ as Savior and Lord. Subsequently, he found his way out of that pastorate, given the furor that developed there.

It's fair to ask whether it was prudent to okay that entry, at least at that time and in that context. Couldn't one argue that, apart from the obvious fact that non-Christians can say great and true things, the decision to give a Hindu a warm and prominent place in an art show meant to advance Christian perspectives on a complex, often intractable, issue was problematic? Isn't it a matter of picking your battles carefully, of exercising a measure of control in this connection? (Or maybe this is simply a case of Bell's picking a battle he'd been meaning to fight for some time, and this was the perfect occasion.)

Lifting Up Plumbers and Accountants

Coppenger: Instead of marginalizing artists in the worship hour, why not go the other way? How might one include plumbers and accountants in it? What about using a plumber in a live sermon illustration, where he caulks a joint? Or use some phraseology in an accountant's audit as a metaphor for the Final Judgment? Or maybe have a day honoring blue-collar workers who come to the service in their work clothes, and tie their presence to a text and hymns on the dignity and indispensability of their labor. Just thinking.

Beautiful Plumbing and Elegant Accounting

Westerholm: Ecclesiology is in play. For example, many churches in the Charismatic or Pentecostal tradition allow great latitude for the person overseeing the service. These worship leaders might, on their own subjective sense, spontaneously decide to linger a while longer on a single song, or they might sing an entirely unplanned song.

Church traditions that use less spontaneity have an opportunity to benefit from the insights of a larger planning team. Thoughtful worship service planning should involve many types of people, including plumbers and accountants. A committee composed of "artistic types" is not sufficiently balanced. But also, plumbers and accountants can be artistic. Plumbers must factor issues of beauty and design into their work, and accountants seek to provide elegance in presenting their information. Again, the arts are not the exclusive domain of the elite.

As a Baptist, I believe the elders and pastors who lead the church should neither *abdicate* their leadership to artistically gifted people, nor *neglect* the artistic gifts in their church. And I'd encourage pastors to appoint artistically minded people to diaconal roles.

Distinct Parts of the Body

Dittman: We do not attribute greater inherent dignity to musical skills than to plumbing skills, and yet in the context of formal Lord's day worship, the former has a duty to lead God's people in joyful noise, while the latter does not.

I write this evening from a dim cafe in La Grange, Illinois, having just returned from a glorious three days on ice-covered, snow-encrusted Island Lake—just forty miles south of the northernmost Wisconsin town of Hurley—and the 294-acre site on which Lyle Dallmann built his family cabin. Constructed from timber logs culled from Island Lake's wooded shores and finished with oak hardwood, field stone chimney, gas-fed wall sconces, wood-burning cook stove, and a long maple dinner table, this fruit of Lyle's stewardship of God's provisions has facilitated a bounty of generous hospitality, faithful camaraderie, familial love, and spiritual rejuvenation. Even so, Lyle is the first to step aside for the wandering musician without accolade when Sunday morning worship lacks a song leader.

Paul compares the principle of member cooperation within the Church body to the principle of biological cooperation within the human body: Each part plays an essential and complementary role in perpetuating life. Thus, on any given Lord's day, when the tribes of God go up to the House of the Lord to worship and sing praises to God, Joseph Dittman, itinerant musician, stands at the head to lead, while Lyle Dallmann, plumber and builder extraordinaire, stands in the body to follow. Regardless, they stand as one in Christ's redeemed body, serving each other in distinct ways on particular days, forever united and equally esteemed in God's perfect economy.

We do not attribute greater inherent dignity to musical skills than to plumbing skills, and yet, in the context of formal Lord's day worship, the former has a duty to lead God's people in joyful noise, while the latter does not.

A Broader Palette

Westerholm: The other thing that strikes me about giving artists a place at the worship table is that they can help invite the whole person to worship. Human beings are rational and moral creatures, so God speaks to us words and commands, which we communicate through Scripture reading and preaching. But we are also aesthetic and emotional creatures; the arts can help appeal to our full humanity and draw out a more fully human response to God. If, say, we limited leadership in worship to reading, praying, and preaching only, it would be analogous to painting with a limited palette, as with only black and brown. The arts help make worship a full-spectrum experience and are suited to evoke wonder and awe in ways that preaching, for example, might not. It's about opening the doors of worship wider, to invite a fuller range of gifts in leading and a fuller range of responses.

"This . . . is . . . my . . . story, this is my song"

Coppenger: I'm reminded of a phenomenon I read about in a book by Michael Medved, *Hollywood Against America*. He was pushing back against a piece of "received wisdom," that Hollywood was money driven and that the producers would turn out whatever the public was willing to patronize. He said that, in fact, they turned out a lot of unprofitable stinkers (such as Martin Scorsese's *The Last Temptation of Christ*) since they were eager to

impress their counterparts in the industry; better to be known as an edgy, sophisticated, creative filmmaker than a "sellout" who pandered to the crowd. They would rather lose a ton of money on *Heaven's Gate* than make a ton of it on *My Big Fat Greek Wedding*.

I think that artists in the church run that risk, wanting to be admired by other professionals, even if it means baffling or boring the people in the pews. So, it might be a good idea to include "philistines" in the worship planning process, just to make sure that the common man gets a hearing, even if he prefers *Victory in Jesus* to *And, Can It Be?*

I know there are other interests in the mix. Certainly, freshness and creativity are great. Artists of every sort are particularly adroit at these virtues. And they may well feel that being good stewards of their gifts means that they must rework melodies, add bridges, alter tempo, and such. But in the end, it's not about the artist. It's about whether those in the pews find their way more readily to God, even if it means singing all three stanzas of *Blessed Assurance* straight from the hymnbook, with a slowed down "This . . . is . . . my . . . story . . ." in the refrain, just like the old folks (and plumbers) like it. There's no professional credit or personalized fulfillment in that, but professional credit and personalized fulfillment are not the point of song leading.

Workplace Worship

DeKuyper: This question depends a lot on what is meant by worship. If it means the time in a Sunday service when we sing songs, then it seems obvious that the musical arts will have a prominent role and the sculptor, plumber, and accountant, not so much. If, on the other hand, worship is meant as those things we do with the purpose of glorifying God, then artists, tradesman, and workers of all sorts have a place at the table. God is glorified by his people fulfilling the work that he has given to them, no matter what that looks like. That does not necessarily mean that his people will get emotional about it, but it sure can be a wonderful witness to those around us.

Christians in the marketplace must ask two questions: "What is the purpose of my life?" and "What is the purpose of my work?" Our purpose in the first is to glorify God, but our purpose in the second lies in the stewardship responsibility God has given us. As God commanded Adam to work and keep the garden he had put under his control, we too are called

to work and keep the resources that God has put under our control, with a view to doing so in a way that will glorify him.

Ahrens: We refer to the music portion of a service as "the worship service," or we invite folks to enter into a "time of worship." Then we proceed to sing! No wonder we don't really understand worship. No wonder we don't have an understanding of worship as a life-orientation. In a sense, we have hijacked the term and used it in a way that limits its meaning.

Coppenger: And, again, to Stephen's point, the way Christians do their work, wherever it may be, is a thing of beauty. I remember standing in a long concession line at halftime of a Bulls-Mavericks game at the United Center. The queues in front of the half-dozen cash registers were so long that people trying to navigate the walkways had to break our lines to get where they were going, so we had plenty of time to watch the vendors at work.

It was madness, with their scurrying back and forth behind the counter, trying to add the right number of jalapeños to the nachos, to maneuver with full drink cups through the squirm of fellow workers, and to get the change right. Most were scowling and abrupt in their efforts, but one lady, the one serving our line, was smiling and even serene as she did her work.

When I got to the counter, and she filled my order, I asked her, "You're a Christian, aren't you?" Her reply: "Sanctified!"

Indeed.

7

Aren't Artists Habitually Cranky, Impatient with and Dismissive of Work that Might Please the Congregation?

Coppenger: Does the church really need people who habitually roll their eyes at the taste of the "philistines" around them? What of artistic types who seem to be looking for reasons to be offended? And what does a church gain if it goes high class but loses its *koinonia*? I think about the fellow who joyfully and sacrificially buys a Kinkade and brings it as a gift to the church. He'll get a cold shoulder from many artists, along with thanks from most in congregation.

Pleasing Sermons

Addington: Hmm . . . We should really be on the same side here: Church leaders *and* Christian artists should *not* be interested in just providing "pleasure." Do preachers worry about their sermons being "pleasing" to their congregation? Would they get cranky if they were asked to be more pleasing? What if that preacher was accused of losing his sense of *koinonia* because he did not want to compromise "truth" at the expense of togetherness.

Coppenger: Yes, we preachers can get cranky if pressed to make sermons more pleasing; and it can be a little disturbing to hear, after a edgy, prophetic message, "I really *enjoyed* your sermon." (Of course, that's just a common way to give you a thumbs-up; they don't necessarily mean that it's anodyne.) But some sermons are meant to gratify, and biblically so, e.g., a word of gospel celebration at the funeral of a saint; the counsel of comfort in the wake of 9/11; a rehearsal of the Beatitudes or the virtues of a Proverbs 31 woman; a scan of the splendor of God's handiwork in the heavens in Psalms 8.

Cognates of 'pleasure' don't have to connote "shallow, hedonistic, and contrived." Otherwise, you'd expect someone to answer, "How dare you, sir!" when you said, "Pleased to meet you." Besides, I've heard people exclaim happily after hearing a take-no-prisoners sermon on sin (their own sins included), "Now *that's* what I call preaching!" They took pleasure in the preacher's getting down to business without regard to whether the people would like him or not. (As I heard one smiling preacher tell another after a particularly pointed message, "I didn't say 'Amen' since you don't yell 'Sic 'em' when a dog has you by the ankle.")

I don't think it's necessarily trangressive when preachers, musicians, or painters do something in anticipation of bringing smiles of pleasure to the faces of the audience. Maybe Monet had a bit of that in mind when he painted the water lilies. He could have chronicled the play of color and light on the surface of a pool of vomit, but he chose something nicer. Millet could have rendered painful tooth extractions in harsh light instead of gleaners in soft light.

Cloying Cheesiness and BOMFOG

Addington: Well, I've read Joseph Crider to fault emotional button pushing in the worship service, and in my opinion, the more sentimental and cloying a work of art or music is, the more you have that cheap emotionalism polluting your worship. Sorry to sound all elitist, but this is the whole point of *excellence* in my opinion. Sacred or secular, a *good* work of art functions on, yes, a higher plane than the cheese we're discussing here. Bach, Handel, Haydn, and Brahms are all functioning on a different level, and so is good contemporary songwriting. The same is true for painting: Rembrandt vs. Kinkade. Discernment and excellence is necessary to avoid the emotional button-pushing of artistic cheese. And discernment and excellence come

from *two* places in my book—education and practice (practice in making *or* in viewing, with various amounts of one or the other). We should hold our artwork up to a higher standard than weekend craft, just like we should hold our teaching and preaching to a higher standard, requiring education and practice. For church leaders to have informed opinions about art that will keep out the cloying cheesiness, they should educate themselves, *or* put some trust in those who have. Like Mark says in a different chapter, use the trained artists as consultants. We have already mastered this in many, well-constructed music ministries, and the visual arts should not be handled much differently. Believe it or not, a lot of churches get this and have designated gallery space in their sanctuaries. Some employ actual curators on the church staff, and I'm not just talking about east coast Episcopal churches. I'm talking about Evangelical, Bible-believing churches in the Midwest, South, East, and West Coast region.

The artists I know who function day to day in the world are keenly aware that familiarity and education is necessary to appreciate all manner of cultural production and communication. I'm not just talking about formal education, but also an education rooted in kindness, accessibility, and a respect for where people are, something that leads to well-rounded familiarity or intellectual curiosity. Many many artists, in and out of the church, love what they do, think it is beneficial to others, want to communicate it, and actually *want* to provide education about what they do in a loving way. Far from the eye-rolling elitists described above, most artists are *very* aware that a comfortable, well-informed viewing public is their bread and butter. How much more so would this be true in the context of the church, where artists are Christians, exhibiting fruit of the Spirit—patience, gentleness, and kindness (and where they have typically had very little art opportunity afforded them). When I've seen these opportunities arise for artists, it has been my experience that they do not roll their eyes. They more typically show extreme thankfulness and humility. Those who *would* roll their eyes are not wasting their time making art for the church, I assure you.

Coppenger: Of course, some words are so negatively loaded that no one could defend things so branded. (For instance, its sounds wrong to *vilify* Hitler, even though he deserved the worst; it's just that 'vilify' implies unfairness.) But the issue is whether something really is "cloying cheese." I can imagine a Bertrand Russell or a Chris Hitchens calling the biblical stories

of the widow's mite, the boy's shared lunch, or the Twenty-third Psalm "cheesy" or too "precious" for serious people.

But let me hasten to say I'm not a fan of Kinkade (nor of rococo painting, for that matter, which I also find too saccharine). And I can think of an analogous form of rhetoric that gets my goat, what's called BOMFOG ("Brotherhood of Man; Fatherhood of God"). During one of Nelson Rockefeller's campaigns, a reporter was tired of his trotting out grand platitudes and turns of phrase to charm the audience without really saying anything, so he coined this acronym. It can make for a nice feeling (though the Bible doesn't say that all men are brothers), but the point is not the conveyance of truth. It's "yada yada." Very annoying.

Why Excuse Arbus?

Coppenger: As Dan knows, I've been known to bring a negative message now and then regarding sin, and I have many times flinched when someone suggested I should be nicer. After all, haven't they read Jeremiah and John the Baptist, not to mention the Jesus of Matthew 25 and the Paul of Romans 1?

But, if I come to think, as some artists do, that there is greater virtue in a grim message than an encouraging one, then I, and they, fall off the horse on the other side.

A good deal has been written about the horrors of *kitsch*, with its "cheap sentimentality," but some aesthetics profs are pushing back a bit, asking, "What exactly is wrong with sentimentality? Are you saying it's unrealistic and superficial, putting a gloss or mask on sad or complex things? Then why don't you criticize someone like the gloomy (and suicidal) photographer Diane Arbus for putting a nihilistic cast on Down Syndrome kids at play in the park? Why is it always better to misrepresent things in a gloomy or contemptuous direction instead of in a cheerful or dreamy manner? Why are sweet dreams less worthy than nightmares?"

Crankiness All Around

Warnock: Artists *can* be habitually cranky. So can the disagreeable old woman who complains we don't sing enough hymns. Cranky people need a character transformation. They need to be discipled into mature godliness. Artists, like us all, need to learn humility and love for others, even

those who might be the "weaker brother" in an artistic sense. I for one have learned to love my brothers and sisters in the church who just *love* Southern Gospel music, even though (1) it's not exactly an aesthetically elevated form, and (2) it's not "my kind" of music. I have had to grow past my artistic crankiness, and I am a better Christian for it. (Besides, Southern Gospel can be quite fun!)

Coppenger: Guilty. One Sunday in Evanston, four of us blessed/afflicted the congregants with a rendition of *Have a Little Talk with Jesus*. It was fun, but we weren't overwhelmed with requests for more.

Shepherding Artists

Warnock: Much of the discussion here is about how to "use" artists and the arts, and about how different they are from "normal" people. This is really a terrible way to think about artists. True, artists often alienate themselves out of social awkwardness or personal pain, but in the church, love should bind us together in unity.

I would argue that what we have in common—the love of God in Christ, our sinfulness, the call to discipleship—are far more important than differences in gift or temperament. Artists need to be loved and shepherded, just like anyone else. If you have the task of leading an artist in your church, I'll grant you that it can be challenging, but it is entirely worth it. Here are some things to try:

- Close your eyes and imagine the artists in your church fully devoted to Christ. What might God do through them?

- Draw them close in relationship to you and to other non-artists. See that they connect in community beyond fellow artists in the church.

- See them as Christians first, artists second. Their identity in Christ is far more important than their identity as painters or singers or designers.

- Encourage them to be transparent about their wounds, and model it yourself. Respond to that transparency with the love they do not expect, not the judgment they fear.

- Give them responsibility.

- When they transgress, do not let them off, but do be gentle.

- Give them some control, and room to experiment.

- Be generous with encouragement, even if their efforts produce mixed results.

- Criticism is very hard for anyone to take. Teach them how to hear it, and model for them how to respond to it.

- Praise is even harder for affection-starved, insecure, arrogant, pride-soaked artists to receive with humility. Teach them how.

- Trust them, and tell them you trust them. They really want to bless the church and not harm it. Give them a shot.

- Encourage them to develop their craft. Sponsor them! Buy a painting or supplies or help pay for a class.

Shepherding artists in this way is messy, but not complicated; all it takes is attentive, fatherly care for their souls. The reward of this effort is seeing fantastically gifted people healed, whole, fully submitted to Christ, giving their lives and love to advancing his kingdom.

Kitsch

Stark: Perhaps Christian artists feel the need to go to the "dark side" because contemporary Christian radio, Kinkade paintings, and movies like *Facing the Giants* so emphasize the need for "an encouraging way to start your day" and for everything to be "safe for the whole family" that we forget the "dark side" of Christianity. For example, we neglect the role of suffering in the life of the believer—that for every David killing a Goliath, we have a Paul locked up in prison or a Job plagued by disease, death, and financial ruin.

Nevertheless, kitsch does seem to be troublesome from a Christian worldview. As Gene Veith has suggested, in dealing with the arts, we must not only be concerned about violating the Second Commandment, but we must also be concerned about violating the Third Commandment—taking the Lord's name in vain (*State of the Arts*). And herein lies the problem with Christian kitsch: It takes the glory of Christ and makes it a cheap commodity. It makes the Alpha and the Omega a mere trinket. When Mel Gibson was interviewed by Diane Sawyer concerning *The Passion of the* Christ, he jokingly described the inevitability of marketing endeavors in relation to his film. He made a quip regarding Burger King and the possibility of a

Last Supper value meal. We laugh at the absurdity of such a thought, but then we walk into a Christian bookstore and see that similar ventures are all around, from "Testa-mints" to Jesus-action figures. Kitsch just seems to cheapen the subject matter, which may be harmless when the subject matter is a common one but might prove offensive when the subject matter is a holy one.

Veith has also argued that kitsch is problematic because it "seeks to gratify its audience's desires but in doing so will offer . . . nothing of real value." Kitsch makes an individual feel good, but its message is incomplete. The problem is not so much that kitsch is a lie; the problem is that it fails to tell the whole truth. It focuses on a sentimental and sanitary version of reality, but it does not help one to grapple with that reality from a Christian worldview. This has ramifications in regard to our theology, and in this way, kitsch may be harmful to the believer. Imagine quoting Romans 8:28 to a woman who has just given birth to a stillborn child, or telling a family not to grieve for the loss of a loved one because "he/she's in a better place now." Such attempts to deal with grief are flat and superficial. Similarly, Christian kitsch of the Pollyanna variety is fake and promotes a counterfeit theology that glosses over real-life problems, sorrows, and sufferings. The woman and family need to know in these moments of intense grief that there is also a place for sorrow in their faith, that Christianity is not just a "happy, happy, joy, joy" religion, that there is "a time to mourn and a time to dance" (Eccl 3:4b), and that often the former must precede the latter. Like the well-meaning but insensitive person in the above examples, kitsch only offers a clichéd, bumper-sticker theology with smiles and "warm fuzzies." But the woman and family need something more substantial—something more than a Precious Moments figurine. They need the Man of Sorrows; they need a Suffering Servant.

In a similar way, some people delight in kitsch of the melodramatic variety, where the focus is so heavily on suffering that little attention is given to the meaning of the suffering. And, so, a person is content to buy a cheap, crucifixion knick-knack because it shows a pitiable Jesus suffering on the cross, but one is not moved so much by the meaning of Christ's suffering as in the "pleasure" of feeling pity itself. It is merely a "one-dimensional" experience (Veith, *State of the Arts*). One feels good for having pitied the man, but one is not prompted to ponder the glory of the Crucifixion, marvel at the mystery of the Incarnation, or reflect on one's own role in putting Christ on the cross.

Of course, I am not suggesting that those who like kitsch are necessarily spiritually immature. I am only suggesting that we may need a deeper aesthetic so that we can have a better artistic framework for exploring our theology. Perhaps this is how a Christian who is an artist can assist in discipleship—by helping to elevate our tastes to the point of maturity so that we can better contemplate items of spiritual value. We are not content to leave our congregations in immaturity in other areas. Why would we allow them to remain immature in discerning what is beautiful?

The occasional cheesy Christian song never hurt anyone. The problem is if the cheesy songs are the only Christian music to which people in our churches have ever been exposed. I want Christians to have something richer. I want them to have a song stuck in their head that makes them ponder the mystery of the gospel and the grandeur of Christ and not just dwell in the mush of being friends forever or buying Christmas shoes. I do not wish to mock anyone for liking kitsch. In fact, I agree with Veith that "a taste for kitsch is a taste for art, a taste which simply needs to be nourished and educated so that it can grow up." In other words, Christian artists and teachers should utilize the kitsch people already love as a "gateway drug" into the world of the beautiful, cultivating aesthetic interest and helping people to develop their palate to appreciate that which is truly beautiful. An artist who has been regenerated by the Holy Spirit could be hugely helpful in sanctifying our aesthetic taste so that we can better communicate and enjoy the splendor of the Christian gospel.

Coppenger: Whew! I'm glad you didn't mock kitsch or its enjoyment. That would have been brutal. (smiley face)

Seriously, thanks for pitching in some Veith. I'm a big fan (the reason I assign the book you cite in my aesthetics classes), but I'm still working on his and other definitions of 'kitsch.' I get the part about its being biblically incomplete, but so are many fine things we sing and see. *All Things Bright and Beautiful* focuses on the comprehensive beauty of Creation but neglects penal substitutionary atonement, the doctrine of election, and eschatology. *In Christ Alone* ignores the prophets' scathing words over mistreatment of the poor. Most hymns leave something, indeed many things, out, but that doesn't make them cheesy.

And I have trouble with excluding feel-good songs, and the expressed pleasure of feeling pleasure, albeit without reference to the crucifixion. Do

we gainsay those Old Testament Jews who sang, with gladness, "I was glad when they said unto me, 'Let us go into the house of the lord'" (Ps 122:1)?

I don't think the main problem is incompleteness or pleasure or artistic simplicity, for we would need to disparage a variety of fine children's songs, e.g., *Deep and Wide*; *Father Abraham*. The problem comes when these works act like a governor on our theological development (as you suggest); when they lead to arrested development; when they play a talismanic role that satisfies us by excluding more and better; when they send us out on a snipe hunt, e.g., the ubiquitous images of Mexico's Our Lady of Guadalupe (who is not the one to help you); Ricky Bobby's insistence on praying to the "tiny baby Jesus" in *Talledega Nights*. When his wife interrupts to say that Jesus grew up, he answers, "Well, look, I like the Christmas Jesus best, and I'm sayin' grace. When you say grace, you can say it to grown up Jesus, or teenage Jesus, or bearded Jesus, or whatever you want."

Nothing wrong with singing *O, Little Town of Bethlehem*, but *Joy to the World* is better. Both point beyond themselves to salvation from sin. *Away in a Manger*, not so much. (And what's this business about "no crying he makes"?) Kind of kitschy.

One more thing: Would "bumper-sticker theology" be okay if it came in Latin, e.g., *Post Tenebras Lux*; *Semper Reformanda*; or *Sola Gratia*? Just asking.

How High are the Stakes?

Coppenger: Why does kitsch need to be perky? Can't dark things convey partial truths?

More than once, I've thought of Sayre's Law when I've heard artists savaging each other, whether fashion judges, architecture critics, or playlist navigators. Wallace Sayre, a prof at Columbia University in the 1970s, put it this way: "Academic politics is the most vicious and bitter form of politics, because the stakes are so low." Anyone who's been involved in committee wranglings over curriculum revision, sabbatical policy, etc., knows what Sayre's talking about. In such settings, one hears that Western Civilization will crumble if we go from a three-quarter to a two-quarter foreign language requirement.

In this same vein, I have to wonder sometimes, "What's a stake if so-and-so enjoys some popularity? What wreckage can he effect, and what

glorious deliverance do you offer, such that souls are rescued and society preserved?"

Handel, Lament, and the Proper Court

Ahrens: This chapter's question rings quite true for me: I am a classical pianist, yet I also participate regularly in the church music program which features primarily Christian worship music, or "CCM." I admit I am not a little offended when people place great value on Chris Tomlin, but, then, when Handel is mentioned, the response is either confusion or humor. I've tried to make peace with that over the years even as I rehearse keyboard parts for *Messiah* with tears streaming down my face in response to the way in which Handel's music portrays the beauty and sorrow inherent in the gospel. In my opinion, there is simply no substitute.

Another example is the story of a friend who was a long-time member of a prestigious symphony chorus, during which time he sang all the greats, from *Carmina Burana* to the *Missa Solemnis*. One Sunday evening he showed up at church still wearing his tuxedo, and I asked if he had come from a performance. The musicians were hammering out a harmonically repetitious CCM song, and my friend and I had to practically shout to hear each other. He sighed and grimaced, and then summed it all up when he stated, "I've just come from singing Bach for two hours." Point made.

So, you can see where I am most comfortable. That all said, though, is it really wrong to find Kinkade beautiful? Perhaps Rockwell (whom I happen to like) connects more to the viewer's context than, say, Rouault? Maybe more refined art asks the viewer to do more work, as Ricky Stark has stated so well, and people are either not equipped or are unwilling to do so? To this point, Don Saliers has written, "Christian public prayer finds praise and thanksgiving far less demanding when lamenting is suppressed." He goes on to state that praise is "easy," whereas looking into the darkness and wrestling with difficult issues takes hard work, work we are often unwilling to do. While folks may very well find Kinkade beautiful, is their rejection of serious or more difficult art actually indicative of a deeper problem? Again, while there is nothing wrong with the enjoyment of Kinkade, one must be careful to not use it to bandage an unattended wound, so to speak.

I've often wondered what would happen if, in a service such as Good Friday, one of the etchings in Rouault's *Miserere* was displayed as the congregation sat in silent contemplation? Would beauty be redefined? Would

the artistically uneducated begin to see the value in art's ability to speak to places in the heart which we usually avoid? I have no definitive answers to those questions as I have never attended a church that valued great art, but still, I wonder.

Lastly, during my many years of teaching undergraduate music at a Christian college, I have adopted a philosophy that I try to teach to my students: As long as the gospel is preached, it does not matter if it is I or a trained monkey who sings the song or plays the instrument. When I meditate on this, I recall Paul's words in 1 Corinthians 4:3: "But with me it is a very small thing that I should be judged by you or by any human court. In fact, I do not even judge myself." The bottom line then is that I, as an artist, should create art—yea, verily I should create "beauty"— that will ultimately reflect who God is, that will reflect his glory. Sometimes this is delightful, sometimes laborious and soul-searching. Removing the desire to be approved by the "human court" could go a long way in resolving the judgmental feuds that result from bruised egos.

The Historical-Encumbrance Dynamic

Warnock: Years ago, my sister stitched and framed a sentimental quote about brothers and gave it to me as a gift. I feel obligated by my relationship to her to display it in my house, even though it doesn't really suit my taste. Is the church in the same boat? When a church member donates a Kinkade to the church, does it *have* to be hung in the foyer? And for how long?

At my own church, the welcome center until recently had a painting of Jesus hung in it that was painted and donated by a church member decades ago. It was a Jesus-holding-a-little-lamb painting, completely out of step with the culture and DNA of our church. (It came down only because we tore out the existing welcome center to expand it.)

Must every artistic contribution remain forever? Older music at least can go out of rotation on Sunday mornings, but visual art seems to remain forever in churches, where no one ever throws anything out. (In every other Sunday school room, you can find a crumbling Bible, missing the binding and the minor prophets, but there it sits because no one has the moxie to pitch it.)

I confess to occasions where I have come across Christian kitsch sitting around the church—a little sculpture of the *Footprints* poem, a paperweight with a ship and a Bible quote, that sort of thing—and hidden them

in a drawer in my office. After two weeks with no complaint, I quietly threw them away.

This historical-encumbrance dynamic keeps churches from moving forward artistically, and frankly, in many other ways, including ministry methodology. A helpful way to frame this dynamic (from *The Three-Box Solution* by Vijay Govindarajan) is to think of three boxes. Box 1 is the "Performance Engine," the main things we do that need to keep going. Box 2 is "Research and Development," where we try new things without being committed to them. And Box 3 is "Selectively Abandoning the Past."

In musical terms, the top thirty to forty songs and hymns in rotation on Sunday mornings go into Box 1. New songs, especially those in styles or genres we're unaccustomed to, go into Box 2. We put aging hymns and songs into Box 3 as we retire them.

Churches should consider designating a person or two with direct and final authority for artistic direction—from the look of printed materials to font choices for lyric projection to paint colors, and, yes, to what art is permitted on the walls. In my church, the worship pastor and communications director share this responsibility, although we allow a fair amount of latitude in adult Sunday school rooms. All the main public areas, visitor spaces, and children's areas, however, reflect our branding guidelines and are kept carefully in line with it. This may be easier to implement in large churches than in small ones.

Parents with iPhones, the Global South, and Living Rooms

Stark: I don't think that the enjoyment of what might be deemed substandard art is a character flaw. In fact, as with children's choirs, there is a time and place within the church for this "substandard art" because some things are more important than aesthetic appeal, such as the spiritual formation of children. Similarly, if a woman who just journeyed through a battle with cancer was giving her testimony and desired to sing the chorus of a song that the Lord used to comfort her in her affliction, I would not in the slightest care how pitchy she was or how sappy was the tune. Artistic excellence is irrelevant in that moment.

Nevertheless, if every week, parents were stampeding over each other and blocking off front rows in order to capture iPhone video of their three-year-old shouting out mispronounced lyrics while picking his nose

and raising his shirt before attempting to walk off stage—well, this is not conducive to corporate worship to say the least. Children's performances are cute (and even beneficial) a couple of times a year; if done well, they even provide an opportunity for the church to build up children to become worship leaders, musicians, and singing congregants one day. But such performances would quickly lose their luster if they were a weekly (or even monthly) occurrence.

Similarly, as moving as the testimony in song may have been in an isolated incident, I think most would agree that our regular worship leaders and repertoire should maintain a certain level of excellence, both aesthetically and theologically.

Aesthetics are by no means the end-all and be-all of the church. Indeed, the most beautiful worship services of which I have ever been a part did not take place in a cathedral but rather in the Global South, in small rooms with crumbling walls and oscillating fans. Here we sang with minimal accompaniment—sometimes with only small percussive instruments—because that was all they had. Yet, even here, there was music and aesthetic expression. There were candles and flowers and wall art. I think there's a universal recognition that a glorious God deserves to be worshiped with the greatest amount of glory His worshipers can muster.

So, is the church going to crumble if our aesthetics are subpar? Of course not. Indeed, some churches have made aesthetic excellence an idol, valuing art and exterior appearances over people. That is a much graver error than poor aesthetic quality. But I do think that what we regard as beautiful reveals what we value and can shed light on what we really believe about Christ, the gospel, and the nature of reality (regardless, to your point, of whether we value the sappy and sentimental or the melancholy and nihilistic). And I do think that to whatever extent possible, the artistry in worship should reflect to participants the glory and majesty of their God. To that end, leadership has a responsibility to safeguard what artistic expressions we promote in the church. Kinkade may be fine for your living room wall, but with all due respect, I think we could find something more suitable for an altarpiece—or even for the vestibule.

Buried Treasure

Blackaby: We should be wary any time a population (especially one as diverse and quirky as artists!) is spoken of in sweeping generalizations.

Nevertheless, as with most stereotypes, the description above contains truth. Some artists are guilty of every charge above and more (speaking as one married to an artist)! Some artists wrongly blend the arena of corporate worship with their own personal desire for cathartic expression and soul-searching. Clearly, the artist who turns a blind eye to the needs of congregation has strayed away from what it means to belong to the body of Christ. However, I believe a case can also be made that the reverse is equally true.

To illustrate, let me briefly share a recent encounter that, while not related to art, demonstrates the same, larger dilemma. Not long ago, a pastor shared his frustration that the businessmen in his church were halfhearted and resistant to join the activity of the church. When pressed, the pastor explained that some had been asked to serve on the bi-weekly rotation as ushers and a few others were enlisted by the finance committee (naturally). What eventually became clear to this pastor was that, while the mentioned tasks were important for the church, they were far from challenging or stimulating for the businessmen. Successful businessmen (in one case, a high executive in a Fortune 500 company) are naturally skilled in money management; yet, it was their driving passion, forward-thinking mind, savvy problem-solving skills, etc. that resulted in their wealth and position in the first place. What they found in church lacked the challenge, excitement, and risk that they experienced Monday through Friday. The church was squandering some of the sharpest minds in America on tasks other members could easily fill.

My point is simple: Too often the jobs given to artists in the church are far from challenging. Incredibly skilled artists are called upon only when an updated Noah's Ark mural is needed in the new nursery room. As the church, we often focus on the need for the artists to be proper stewards of their skill but forget that the church is also called to be a good steward of our artists (or any uniquely-gifted people God brings into our congregation for that matter). In fact, in some cases, the church may be hindering the artists from presenting a full offering of their talents back to God by restricting their offering to mundane, thoughtless activity. Like the parable of the talents, we are content to simply bury for safe keeping what we've been given. The church has lost focus if they look only to deploy their artists in "pleasing the congregation." Artists should strive to please God, not man; and we shouldn't expect the Great Creator to be satisfied with anything less than the best the artist has to offer. How tragic when the secular world makes better use of God-given talents than the Church!

Ahrens: I like your analogy of the "buried treasure." I agree that it seems we relegate artists to the Sunday school or some other department that is not a place in which the whole church will engage. This is not to say that the Sunday school doesn't deserve the best artistry, etc. (As an aside, it makes me wonder how much we value Sunday school when we use it as a place to plug in artists or others we don't quite know what to do with!) I wonder if the reason we don't use artists more prolifically in the church is because we do perceive them as different and, thus, we don't know how to engage them? Going back to the Sunday school reference, I think it might do us good to "be as little children," as Jesus commanded. For it is often in the Sunday school that artists are accepted and even delighted in for their artistic offerings.

Red, White, and Blue Roots

Walker: I write this having just concluded my twenty-ninth Fourth of July. It's the one holiday that brings together all the grandiosity and flare of what it means to be American. One memory, from July 4, 2001, strikes me in particular. Our church had rented our town's big pavilion, and all day there were activities centered on the church's appreciation for Americana. It was wonderful. There were hot dogs, beanbag tossings, races and competitions of all sorts, and sparklers.

Later that evening, surrounded by red, white, and blue decorations, our church hosted a "God and Country Service." We celebrated both the church's and the community's veterans. We sang *Onward Christian Soldiers* and *The Old Rugged Cross*, along with the *Armed Forces Medley*, where the veterans stood in turn as their service songs were played. It was a fun evening, one imbued with a sense that being both American and Christian was a privilege.

Now, at this point, I could pick up the criticism popular amongst evangelicals my age that Christians have too closely woven their narrative and identity with that of the American military-industrial complex. Because, we're more sophisticated (at least we like to foolishly convince ourselves so), we're sufficiently enlightened to approach patriotism with a sense of condescension.

I won't do that. Yes, as a political and theological conservative, I can fully attest to the fact that I've seen some weird stuff that made me uncomfortable both as a Christian and as an American. But that's not my focus.

Beneath what some may consider the "kitschiness" of such events the culturati consider unreflective nationalism, there's something right about what's going on.

The aesthetic of holidays like the Fourth of July communicates something that Evangelicals my age are pining after and totally whiffing at—a sense of rootedness. My generation longs for "community" and "authenticity." We often forget that prior generations had it. (We just mistakenly think they weren't as cool, or suave, or nuanced as us.)

That aesthetic—the patriotic music, the brashness and grandiosity of it all—engrave or embed memories richly with symbolism. On this model, 'red, white, and blue' are code words for love of neighbor, an appreciation for citizenship, and a desire to see our nation flourish in a manifold manner. And no, the average conservative Christian I know isn't animated by grand illusions of a takeover.

On issues like abortion and gay marriage, we mourn the loss of a common culture that celebrates what the Bible celebrates—life and the covenantal union of a man and woman. It's about being in tune with how God created all people and all nations to function, about seeing our ideal of "rootedness" strengthened, not stupefied.

When I hear media elites slam the Religious Right for its looming theocracy—with the hysteria that events like a God and Country service would surely generate—I just laugh. If the aims of Andy Griffith and of communities like Mayberry are the accomplishments of yesterday's theocracy, there's nothing to fear.

Coppenger: I think of two related, awkward moments in my own experience, each corresponding to a different take on the issue. The first came when I was a philosophy graduate student who played in a church orchestra. The music minister had scheduled a patriotic musical presentation for an evening service, and I said I wouldn't be involved. It seemed out of place. Don't get me wrong. I was an infantry officer in a round-out battalion of the Second Armored Division and was on call to go into harm's way for my country. But, again, the celebration of our country seemed an odd fit here.

I've shifted in my thinking though the years, closer to Andrew's position, and recently, I had a contrasting uncomfortable moment when I admitted as much during a panel discussion at a Christian university. The conversation had come around to the matter of displaying an American flag in the church auditorium. One of the profs was confidently dismissive

of that practice, and I didn't see anyone eager to disagree publically. So, I said it didn't bother me. Ah, "But how would you like it if you were an international student visiting that church? Wouldn't you feel marginalized or stigmatized, depending upon your home country's relations with the US?"

I put myself in their place and observed that I wouldn't be offended if I were in a foreign country, even an oppressive one, and I saw their national flag as part of the décor in their auditorium. I would give them a Romans 13 "Amen," following Paul, who said we should respect the state, even with a thug like Nero on the throne.

How much more I could welcome the flag if the nation had a First Amendment, if it had spent hundreds of thousands of lives to free its slaves, if it had served as the "arsenal for democracy" during two world wars, etc. You're not worshipping the flag when you display it or worshipping the nation when you sing *God, Bless America*. You're thanking God for the nation state—this one in particular—rehearsing his providential handiwork in its composition and protection, and resolving to preserve/renew its best for the best. If that "kitschy," so be it.

8

Aren't Artists Prone to be Prima Donnas?

Coppenger: The expression 'prima donna' comes from the arts, and it's understandable. While singers, painters, and such may have good reason for careful attention to their voices, the humidity in the room, etc., their attention to detail can strike the fellow parishioner as finicky and spoiled. For instance, if a well-meaning Sunday school class wants to hang some paintings in their room for a few weeks, they may well be rebuffed by the artist unsatisfied with the light or the lowliness of the setting. If the paintings are hung, then the artist may have a meltdown over the church secretary's attempt to feature them in the church paper in low-resolution. It doesn't take much of this for the church to say, "Never mind."

Addington: I'd say never mind, too, if the artist is being a jerk. Again, we need just look at other disciplines, and see what respect is afforded them. If this is across the board at that church (bad attention to printing quality, a lack of sensitivity to appropriate placement, lighting, etc.), then it's the church staff with the respect problem, not the artist.

Cabal: Let me note that it's not just an adult issue. I remember in particular having the children's worship minister (who oversaw the worship for hundreds of children) bemoan the "diva" problems she was having with some praise singer girls in the fifth grade.

Not Just Artists

Westerholm: It is worth noting that, while artists do struggle with pride, pride is not exclusively the struggle of artistic people. It is also an issue for those who feel themselves better than artists and who view financially successful work as better than artistic labors. It is an issue for anyone who views their own preferences and conventions as superior to others—artistic or not.

Stark: I have witnessed similar dynamics at other institutions where the emphasis on production and branding standards greatly overshadowed—and, at times, hindered—the accomplishment of ministry objectives. Nevertheless, I don't think the prima donna mentality is unique to the artist demographic. There are people in other areas of the church who are quite, shall we say, particular and demanding. There are even people on staff at churches who lack the basic ministerial qualifications outlined in Scripture and who are infamous for stirring up trouble if they don't get their way; nevertheless, their temperament and behavior are tolerated because they (like an artist) are esteemed for their "talent" and "creativity." Never mind the toxic environment that surrounds them; their "giftedness"—or at least "flashiness"—is valued over character and substance.

Meanwhile, many of the Christian artists I know defy the prima donna stereotype, exuding instead a spirit of humility and a desire to collaborate rather than dictate. So, before we pick on the artists for being divas and fixate on the speck in their eye, perhaps we should start taking a hard look at *all* areas of unhealthiness in our congregations and clear out the logs that have piled up over the years. After all, unrepentant prima donnas have no place in any church leadership—artistic or otherwise—and we must cultivate an attitude of servanthood among all those who will stand beneath the bright glow of the proverbial spotlight, whether on a stage, in a Sunday School classroom, or on a church committee.

An Occupational Hazard?

Dittman: I agree, but let me focus on a besetting issue for artists—individualism—a serious threat to church cohesion and unified worship. It preoccupies the artist, and understandably so, for great art is defined largely by its individuality, and the artist who does not aspire to greatness is no artist at

all. Thus, the artist nurtures, cultivates, and coddles any singular aspect of his expressive power which can distinguish him from the huddled masses, any unique trait which lifts his voice above the murmuring drone of mediocrity. Unfortunately, this drive, if left unchecked, becomes the enemy of any who would be a leader in Christ's church, of any who would be exalted through servanthood, through service to those very same nameless, indistinguishable citizens who are the foils for the aspiring artist.

> For though I am free from all men, I have made myself a slave to all, that I might win the more . . . I have become all things to all men, that I may by all means save some. And I do all things for the sake of the gospel, that I may become a fellow-partaker of it. (1 Cor 9:19, 23–24)

In his letter to the Corinthians, Paul establishes a model of service in stark opposition to the artist's individualism. For, instead of amplifying character traits to distinguish himself from the crowd, he adopts character traits to identify himself with the crowd. While individualism regards the self as first, servanthood regards the self as last. How can we effectively minister if we do not empathize? Does not the author of Hebrews commend Jesus as the only fitting arbiter between God and man because he can empathize with fallen man? Because, being fully God, he also lived a fully human life? Did not the Pharisees despise Jesus because he ate and drank with sinners? Did not Jesus identify with the lowly creatures he intended to save?

> For we do not have a High Priest who cannot sympathize with our weaknesses, but one who has been tempted in all things as we are, yet without sin (Heb 4:15).

And are we not also called to be a priesthood of believers, bearing with one another in love? Therefore, we must cap the font of individualism and cease to fawn over our own unique gifting; instead, accepting obscurity for the sake of true religious practice, for the sake of the orphans and widows among us, the believing artist must divorce himself from individualist inclinations. The artist cannot enter the doors of the church and effectively minster to the bride of Christ unless he first abandons the identity of Artist and embraces the identity of Servant—abandoning individualism and embracing the community of the local church.

My Way is Yahweh

Coppenger: It's always interesting to see what paradigm church leadership has chosen. Some see their Sunday morning gatherings as troop musters in military assembly areas, where ammunition is resupplied, attack plans are reviewed, and equipment is double-checked. The congregants are then expected to storm out of the building to fight the good fight for another week.

Other pastors see the church as a hospital, a place where the wounded-by-the-world-the-flesh-and-the-devil can check in for medication, palliation, consolation, and rehabilitation. The last thing you want to do is to scorch them with fresh guilt or distress them with dangerous missions.

Indeed, each Christian institution has its own ethos, its own style, and artists can feed off those styles in hubristic ways if they're not careful. If, for instance, the work of the staff is the point—as in a think tank, where you can name the heavy hitters, even when you forget the top man—the stars can get an inflated view of themselves and ride their prerogatives into the ground. If, on the other hand, the top-down, corporate mentality rules, the one who controls the branding images can become insufferable.

Let me toss in an experience I once had with a graphics man for a Christian institution I served. We were trying to get together some time-sensitive promotional material, and we were told that the PR shop couldn't get to it for a month. Previously, we'd been told that going outside was *verboten*, given the need for corporate identity, brand stewardship, quality control, etc. So, we were stuck.

In desperation, we decided it would be easier to get permission than forgiveness, so we turned to an outside free-lancer who had done a lot of distinguished work for other Christian agencies. We told him we'd like him to make it kosher, so he worked hard at matching the font of an earlier piece they did in house. The product was first rate.

About a year later, we found ourselves in another crunch, where we needed something impossible for the home shop to supply in a timely fashion. And we'd found that working with them was no picnic when they did have time. We were never consulted on design, and when we ventured something as trivial as a suggested paper size, we were ignored gratuitously. So, we contracted another outside job in emergency circumstances, and the work went well . . . until, that is, a piece of it got back to the graphics man.

To make a long story short, we were called on the carpet, where we met with another round of consternation, not so much from the office director as from the artiste, who was indignant that this new piece did not

fit his design template. The point wasn't that it was shabby work, that it undermined the cause, that the Kingdom was affronted, etc. Rather, it was that his artistic vision has been ignored.

He explained that he couldn't go home at night knowing that he had settled for anything less than excellence. That meant excellence in his terms. But it really meant control on his terms. In the midst of the conversation, I suggested that we all had beloved projects, conceived from top to bottom, whether curricular, organizational, familial, missional, logistical, or operational. And we were forced to "eat a toad" again and again, adapting to rulings, opinions, circumstances and such. And I suggested that artists were not the exception.

He came off as if he were saying that artists were special because they had an overarching vision which must not be sullied or hurried by the sweaty interventions of philistines. It was as though we were trying to graft Waldo into *The Last Supper*. But, truth of the matter is, the rest of us are continually pressed to add Waldo or delete Thaddeus in our precious work . . . and life goes on.

I appreciate artistic integrity as a good thing, but a lesser good, subservient to Kingdom needs. And I would ask the artist to realize how much "artistic integrity" the non-artists all around them are called upon to sacrifice for the group good, whether in planning a mission trip, preparing a syllabus, or filling out a calendar.

A Screening Process

Warnock: In ten years as worship pastor near St. Louis, I had lots of musical talent, but very few prima donnas. I credit part of that success to my screening process. I always interviewed anyone who wanted to be part of the worship team. I asked about three things, in the following order. First, Conversion/Character: Were they saved and growing in Christ? I didn't expect full maturity at all (we had teenagers on the team most of the time), but anyone not evidently saved and growing was given a pass. Second, Community: Were they relationally engaged as part of our church? I once had a talented player from a nearby college town who wanted to drive in and play on Sundays. I refused. Anyone leading us has to be in community with us. Third, Competence: Could they play or sing? Again, I didn't expect virtuosity, but they needed to be able to master the music for a given week

in about an hour's worth of rehearsal time and not have major technical challenges.

When I had problems, as occasionally I would, I pulled people out of rotation. I wasn't about to put people with toxic attitudes in front of the church. I'd rather have a less talented player whose character I had confidence in than a guy with an amazing gift, who was a ticking time bomb. The screening process helped avoid this most of the time.

With minor adjustments, I think this pattern could work for churches of all sizes, and could apply to arts besides music.

Consider the Children

Addington: I'll bet a Christian singer-songwriter with a guitar would love nothing more than to sit down with a class of kids and sing with them with no concern for the acoustics of the room, and they would be welcomed! So why does the visual artist get the short shrift in this question? Why do we assume that his/her reaction would be any different? I think a Christian artist would be *overjoyed* to talk to children about their artwork, and hear their candid, unguarded responses to it. In fact, I dare say that most artists *much more* enjoy children, with their unbridled honesty, their surprising and vital creativity, than the typical adult audience that has long since sacrificed those attributes. Artists typically live out Christ's ideal about looking to children as examples, and inviting them to come. Let's put artists in these situations, watch how they engage children, and then *learn* from them how to actually communicate with kids. It could be very instructive to people laboring in "children's ministry." Win, win.

9

Aren't Artists a Risky Lot, a Bit Too "Bohemian"?

Coppenger: Through the years, I've been collecting biographies of artists, and the image is often not pretty (nor is it for philosophers, for that matter). For every more or less conventional Edward Hopper, there seem to be scores of troubled souls represented in our museums—Picasso; Van Gogh; Rousseau; Larry Rivers; Andy Warhol, etc.— many with mistresses. A fair number have been suicides. Is there something toxic about the artistic environment, something which encourages loose or spiritually troubled living?

We speak of "theater people" in not so affirming ways, and such books as *Mozart in the Jungle* show that even "fine art" is riddled with morally diffuse people.

In church, where holiness is valued, should we be comfortable with swinging wide the door to artists? Even a Thomas Kinkade, whose personal life was messy?

A Bogus Stereotype?

Addington: I assume we're talking about moral messyness here . . . moral failings that artists and bohemians are prone toward. I know a lot of artists. How could I not? I've run in the professional circles for twenty years, and too many years in academia before that. The artists I knew and know were 90% family men and women, dedicated husbands and wives (I'm talking unbelievers here), and I've never seen harder workers than these people

83

who work day jobs so that they can go home and make art—basically working three jobs . . . day job, artist, promoter/business man—all the while raising families, and doing civic duty to boot. No, that image of the bohemian is a stereotype born of eighteenth and nineteenth-century stories, and a few post-war art star biographies. It has nothing to do with modern day professional artists.

Actually, it might be a losing proposition to say that *any* segment of society exhibits more moral failing than any other. In my personal life, I have heard more second-hand scandalous stories from associates in the church about associates in the church than I ever have from artist friends, both Christian and non-Christian.

Bolt: Is the question *really* based upon a false stereotype? After all, Dr. Coppenger did provide well-known examples of spiritual and moral failings on the part of famous artists. Of course, we may be engaged in a little armchair sociology here. Fortunately, we may be able sidestep the statistics and still answer the most pressing aspects of this question.

First, there does not appear to be anything inherently toxic to the artistic environment. What about nudity? It exists in the medical world. What about frequent use of the intellect? It exists in the business world. Why should the artistic environment be considered any more toxic than medicine or business?

Second, examples of morally bankrupt people from an artistic environment do not establish the toxicity of the environment. The *people* are toxic. They would have been toxic to greater or lesser extent in virtually any other profession.

Third, every social group tends to have its examples of immoral people. Consider the sad reality of fallen ministers. The media loves to harp on such stories.

Fourth, the people we see in the history of art are *famous* people. They are under the limelight. Just as we see every bump, bruise, and blemish on our political heroes (or enemies), so also we see many of the moral failings of famous artists.

We should feel comfortable swinging the door open to artists. But that does not mean we must swing the door open to *all* artists, or morally suspect characters from any social group (depending on what we mean by swinging open the door).

Coppenger: I'm sympathetic with much of what's been said in these responses. For one thing, I've been privileged to meet a number of the artists who've had shows at Dan's gallery, and they're admirable people. And yes, you take people case by case. But the question is one of generalities which raise concerns (which we're addressing here).

If it helps, let me suggest the kinship of my own profession with that of artists, at least in the eyes of the church. Before I went to seminary, I did my undergraduate and graduate work in philosophy, which can raise its own suspicions in the church. I'll never forget the ROTC annual inspection when the visiting general told me, upon hearing of my focus, "Son, philosophy majors don't make good officers." (I spent 28 years in the infantry trying to prove he was wrong.)

We're often reminded of the two explicit mentions of philosophy in the Bible: Colossians 2:8—"See to it that no one takes you captive by philosophy and empty deceit, according to human tradition, according to the elemental spirits of the world, and not according to Christ"; and then there's Paul's wrangling, with very limited success, with Epicureans and Stoics on Mars Hill in Acts 17—with his subsequent resolution in 1 Corinthians 2:2 "to know nothing among you except Jesus Christ and him crucified" (or, as the critics interpret it, "I'm done with trying to reason with those philosophical fools"). So, in this sense, we philosophers are among the "bohemians." (And who doesn't know a child of the Sunday School who came back home as damaged goods after a college encounter with philosophy?)

But here's difference I see. Christian philosophers are more likely to agree with the critics of their profession, admitting that there is a lot that is anti-Christian and sub-Christian there, and then leading the charge against the decadence they find there, whether against Peter Singer's radical utilitarianism or Sartre's atheistical existentialism.

We're likely to become apologists for godly perspectives and critics of those who would demean faith and virtue. And, yes, it costs us professionally.

I may be way off on this, but I think that Christian artists are more likely to circle the wagons professionally and less likely than Christian philosophers to say, "You don't know the half of it."

I'd like to believe that disproportionate waywardness in the artistic community is a thing of the past, but when I read books like *Mozart in the Jungle* and track the AIDS obituaries, I have to think there is more sexual looseness in Chelsea than in Seminary Village. And while skads of artists

are not involved in hooking up, smoking dope, and such, it's not clear that you can advance far in the profession without being fairly laid back about such behavior.

When I edited *SBC LIFE*, I did an interview with a half-dozen Christians at work in the entertainment industry in Hollywood and Burbank. One spoke of being like a "servant in Caesar's palace," another of the heat she caught for displaying a small Christian calendar in her cubicle, and yet another of finding an entry-level job as a bartender in a soap opera, a job he'd never take in real life. It's not an evangelical-friendly environment.

In contrast, I've done a fair amount of military service, including five months in the Pentagon. It's a very evangelical-friendly environment, with no need at all to wonder if your enthusiasm for a noon Bible study might damage your career.

In this sense, I would say that biblically conservative Christians in the arts are often heroic.

Cardinal Law, Harvey Weinstein, et al.

Westerholm: It has been interesting to watch Hollywood in the last twelve months. In 2015, Hollywood's darling (Academy Award for Best Picture) was *Spotlight*—the film depiction of the widespread sexual abuse in the Boston Roman Catholic church [on Cardinal Bernard Law's watch]. Less than two years later, the sexual abuse scandal filling the news was not in the religious section of Boston, but in the progressive section of Hollywood. Miramax's Harvey Weistein and Philip Berk (former president of the Hollywood Foreign Press Association); television's Charlie Rose and Matt Lauer; the New York Ballet's choreographer, Peter Martin; congressional representatives and federal court judges—all forced to resign over accusations of sexual misconduct. The narrative of lax morality within the arts has recently taken a new turn. In a new way, those *within* the community seem to be willing to say that there is a problem.

Coppenger: I'm glad you brought up both these cases. These patterns of abuse have been astonishing and horrendous, with billions of dollars in reparations being awarded to a long list of victims. And, of course, this sort wickedness is not limited to the Catholic Church and the media. Michigan State University had to pony up half a billion dollars to cover the torment

that the gymnasts' doctor, Larry Nassar, visited upon the girls in his care. Terrible stuff.

But I want to say a word about the incidence of *consensual* decadence and put in a word of defense for the clergy, especially the evangelicals, those of our tribe. Yes, of course, preachers fall, but when they do, and it becomes public, their ministry is over, suspended, or diminished typically. Not so much the painter, the musician, the sculptor, the poet. Of course, he or she may face personal turmoil and grief from sexual sin or legal and physical troubles from drug use, but careers are not wrecked by the revelations alone. Musicians and actors can come on talk shows and regale the audience with humorous stories of life with their partners (with whom they cohabit without benefit of marriage), their forays into drunkenness, etc., and then they can get back to work without loss of income. But a Billy Graham or a Mike Huckabee couldn't get away with that. (Indeed, it wouldn't be easy for a senator, a CEO, or a general to joke about such things on national TV.) The moral expectations are different.

Wounded People

Warnock: Often people create art of out of personal pain. The kind of sensitivity that makes people good artists can come (not always) from brokenness, alienation, inadequacy, or even abuse. Artists tend to be wounded people, and as such, will share in the kind of pathologies that wounded people are prone to, including unhealthy habits and relationships. Artists of course are not that different from non-artists, except that their art gives them a platform that can magnify their influence in the church. The solution, I think, is simply careful pastoring, attentive care to the souls of artists.

The recipe for harm comes when artists hide their wounds behind their art rather than finding healing in Christ and the Christian community. There is a tendency for artists to wall themselves off in their art and to insulate themselves from challenge and accountability that really open loving relationships would bring. Often this insulation is birthed out of fear. Sadly, non-artists in the church often accept that barrier, and leave the artists alone, preferring not to get involved in the mess of that artistic soul, and accepting the "she's an artist" rationale for relational distance.

The gospel calls us to a kind of relating to one another where there is no Greek or Jew, no artist or non-artist, but where we are one in Christ Jesus, where we love one another as Christ has loved us, and where we

confess our sins to one another so that we may be healed. The personal pain of artists can make that kind of relating messy, but that's what love does.

Coppenger: I just watched the Biography Channel's story of Jacob Cohen, aka Jack Roy, aka Rodney Dangerfield, and what a poster child he is for your point. As a comedian, he trades on the fact that his life has been difficult, full of affronts, missteps, and disappointments. Those who know him say he's not just joking when he says he has the sense that he "gets no respect." Whether, in his routine, he's saying that he was so ugly that the doctor slapped his mother when he was born; that Jehovah's Witnesses say, "We're not interested," when he opens the door to them; that the dog stands at the door and barks when he wants Rodney to go out, etc., he works out of genuine pain and a battle with depression. But he spins his sadness into commercial gold.

The System of Acclaim

Coppenger: I remember reading a happy take on the 2013 Tony Awards, calling it "a celebration of independent spirits. In the tough-fought Best Musical race, a show about a shoe factory saved by transvestites edged out a tale extolling a nonconformist bookworm." Quoting Charles McNulty of the *Los Angeles Times*, a piece in *The Week* read, "This wasn't a banner year for musicals by any stretch," but when the two main contenders for Best Leading Actor in a Musical "came down to two men in dresses"— *Kinky Boots'* Billy Porter and *Matilda's* Bertie Carvel— "you know the year can't be that bad."

I'm just saying that it's takes a grounded Christian to stay true to the Bible in a general culture that devalues Scripture at every hand.

Special Psyches, Not Tailored to Stability, Predictability, and Security

Dittman: Though I would like to agree with Dan and believe artists are no more susceptible to "moral messyness" than the rest of society, on the contrary, because an artist must explore the depth, width, height and breadth of human emotion and must continually practice the communication of such emotion—who will deny the heart of human emotion frequently wallows in "messyness"—an artist cannot avoid the higher risk of moral taint

and decay. Can anyone stand up right now and argue the profession of law enforcement carries no greater risk of violent death than the profession of accountant? Each vocational pursuit carries with it its own inherent risks. If it be pursued with proper dedication and attention, the pursuit of art necessitates higher moral risk, and since the human will proves frequently weak and ineffectual in resisting the world, the flesh, and the devil, those who fly closer to the flame will undoubtedly suffer the singe.

Much has already been written on the subject of the "artist" without properly defining the term. In my contributions, I use the term 'artist' to describe any individual striving to communicate any particular emotional truth through any chosen physical medium, which I have confined to three broad categories of expression—musical art, visual art, and movement art. For further clarification, I refer to Francis Schaeffer's *The God Who Is There*: "Communication means that an idea which I have in my mind passes through my lips (or fingers, in most art forms) and reaches the other person's mind. Adequate communication means that when it reaches the recipient's mind, it is substantially the same as when it left mine."

Certainly, there are many professional painters, sculptors, illustrators, photographers, musicians, singers, composers, dancers, and choreographers all struggling to earn a living and succeeding in maintaining decent marriages, stable incomes, and respectable lifestyles by cultivating acceptable and well-wrought aesthetic modes for their time and place. I do not deny these can be called artists. But I speak more of the "artist" in an ideal form, as one who molds cultures through the execution of powerful communication, and when we refer to the working professionals, we speak of those who have assimilated the culture in an exchange for acceptance, in most cases ceasing to mold the culture. Many are those who have traded the pursuit of art for the pursuit of stability, predictability, and security. Unfortunately, stability, predictability, and security have little to do with art (though an artist may enjoy all three in varying degrees throughout the seasons of his pursuit), for artistic communication involves both artist and audience, a congregation of minds, bodies, and spirits. Whenever two or more are gathered in art's name, stability, predictability, and security can never be guaranteed also.

It cannot be denied that God has gifted certain individuals with powerful artistic skills: magnified sensitivity to emotions and uncanny deftness in communicating emotional truth. But the intensity of the gift compels these same individuals to seek out equally intense experiences in a quest

to expand the emotional vocabulary by which they communicate. Like moths drawn to a towering spiral of flame, many will disintegrate with a tiny crackle and a single wisp of smoke, a drop of fuel in the fire, falling into licentious and profligate living.

Quite contrary to the stereotype of emotionally damaged individuals, artists walk through life with a heightened sensitivity of emotional existence, many having cultivated detachment from and mastery over potentially debilitating emotional awareness through a persevering dedication to craft. An artist must understand the fine adjustments in his chosen medium—adjustments in pitch, timber, tone, light, color, contrast, articulation, posture—and execute these nuanced adjustments to communicate effectively the subtlety of emotional experiential truth, to push the buttons that evoke the emotional experience in his listeners. Far short of being damaged emotionally, artists pass through crowds as princes among paupers, broadcasting priceless seeds into the soil of anonymous streets, the impoverished in rags sifting through dust to gather even a mite of emotional wealth.

Yes, artists are risky. But as the called-out of God, we are charged to be fishers of men, and fishing for such complex creations will always be risky. Yet God has not given us a spirit of timidity, and thus we must strive to understand the risks particular to a pursuit of art and engage the artists in our midst, not as eccentrics prone to profligacy, but as unique creatures of God's hand, crafted in His image, and highly capable of creative brilliance. Artists can quicken the imagination of the next generation of Christ-followers, equipping us with the sense of wonder necessary to tell the magnificent story of God's saving work from infinity past to life everlasting. Yes, artists are risky. But we need artists in our churches now more than ever, to awaken our slumbering consciences, to demonstrate the glory of God's creative being, to strike our flinty, routinized worship, and inflame a zeal for spirit and truth.

What About Rappers?

Williamson: There seems to be a growing acceptance of rap music within the Christian fold. Associations that once gripped rap are loosening. And these were not pretty associations. Similar to the antiestablishment thought connected to bohemianism, rap music was once considered to be chocked full of violence and profanity. It seemed like the only form of rap was "gangsta" rap. Not too long ago, it would've been fair to say that rappers were also

a rough bunch because of the association with the most well-known rap artists at the time. Even the current persona of rappers could be easily considered vulgar, crude, and offensive. Yet, there is a growing acceptance of this art form. And this trend falls under Gene Edward Veith's pronouncement that art needs to be redeemed from its corruption. Christian rappers are attempting to save the form by replacing the content. The redeemed can rap; the genre doesn't require the focus on materialism and sex that's been so prominent in that community. And just as rap can be redeemed and distanced from secular associations, those on the visual art scene aren't required to buy into the avant-garde persona of loose morality. And the eccentricities of artists do not qualify them to be card-carrying members of the bohemian party.

Edwards: I agree that individuals tend to be grouped into stereotypes and generalizations. But just like some may be squeamish about artists because they bear the stereotype "bohemian" (or something else), I think our culture is increasingly squeamish about labeling anything out of fear of wrongly generalizing (i.e., we dismiss all stereotypes). But don't stereotypes usually arise from elements of truth?

I think we would admit that there have been artists who were clearly immoral. Is it worth asking the question: Is there something in the field of art that draws people to a particular immoral lifestyle? To continue the example of rap that Eric used: If we are to "redeem" rap, don't we need to wrestle with whether or not there are any essential elements to the form that lend themselves to the misogyny, violence, materialism, etc. associated with rap? If there isn't a fundamental change in something, in what sense can we call it "redeemed"?

Ahrens: Benjamin, you bring up some good points here. I think it's true that stereotypes arise out of some element of truth, as you say. The example of rap music is a good one, and one that I have struggled with. For example, when I'm at a stoplight and I hear it coming from someone's car next to me, I immediately conclude that the message is negative, etc. A close Christian friend of mine has taken rap and turned it into a ministry as he travels around speaking and rapping mostly for teenagers and twenty-somethings. His message is biblically grounded and clearly shares the message of the gospel. I'll admit, it's not my favorite music, but I have stood back and seen the reaction as many in the audience have given their lives to God as a

response to his message through rap. His audiences respond positively, but he has received a great deal of criticism from people who say there's no way he can being doing a work for God through this obviously corrupt form of music. How does one respond to that? Richie (my rapping friend) has continued to expand his ministry even in the face of these criticisms.

In your last sentence, you ask "If there isn't a fundamental change in something, in what sense can we call it "redeemed?" I think it is an important question we all have to ask, whether we like rap as a style or not. Is music really neutral—in and of itself not corrupt? Do the lyrics really make the difference?

Coppenger: Of course, at Southern, we were all familiar with our seriously-Anglo and scarcely-bohemian, Owen Strachan. He's a Bowdoin college grad, with an M.Div. from Southern and a Ph.D. from Trinity. He's now a theology prof at Midwestern and expert in Jonathan Edwards, but first taught at Southern Seminary's Boyce College, where he did a call-and-response rap called *Boyce Anthem* with students at a basketball game (viewable on YouTube). You can judge whether he's redeemed the genre, but at least he seems to be an upright citizen of the seminary community.

The Duck-Billed Platypus

Ahrens: I think one's notion of 'bohemian' lies at the heart of the matter. It seems that what is considered "normal" or "conservative" within Christian circles is, itself, a preconceived idea that we think is a "heaven or hell" issue, when really it is just one of cultural and personal preference. The correct gauge, then, is to be found in the issues of morality and of valuing people. Additionally, the question to ask is whether one's talent is being used to the glory of God and edification of the Body of Christ. This may sound like I'm trying to be humorous, but when this bohemian question comes up, I often think of the many humorous animals in God's creation—for example the duck-billed platypus—many of which are far from the norm. It seems that perhaps God values the bohemian, too.

Responsive Bohemianism

Williamson: It has been said that the culture of the audience affects the culture of the artists. Clement Greenberg, a notable art critic of the

mid-twentieth century, claimed that the development of the avant-garde culture could only thrive because the elite class supported it. The artistic lifestyle only occurred because wealthy spectators bankrolled these radical artists. He said that the avant-garde grew out of the support from the "rich and cultivated." (Likewise, Greenberg noted that kitsch existed mainly because people wanted art that didn't require effort.) Artists could only produce such content and live such lifestyles because their benefactors tolerated and, more so, encouraged it. He stated, "For one man to spend time and energy creating or listening to poetry meant that another man had to produce enough to keep himself alive and the former in comfort." The comfortable have both stability and the means to support the arts. In other words, the audience has an influential role in the content. Peggy Guggenheim, a patroness of modern art, illustrated this influence when she joked about the number of abortions she'd endured.

As Tom Wolfe put it, the artists had left the *salons* but hadn't left the world of the upper class. In Wolfe's words, artists have to keep one eye on their fellow creatives as well as on the "culturati": "Success was *real* only when it was success in *le monde*." Bohemia's rejection of upper class society was only superficial; artists couldn't exist without their patronage and had to appease their audience. I take this to mean that the Christian audience would promote different content in addition to a different culture of the arts. The market influences the art as well as the artists. Aesthetic expression isn't intrinsically the result of artistic angst or a shattered soul. The audience dictates the content as well as the acceptability of the personality. Where the church commissions art, it will also vet the artist. In promoting the arts, the church can also promote the culture of the artist.

10

Aren't Artists a Different Language Group, Speaking a Tongue Most Don't Understand?

Coppenger: Let's face it, relatively few Christians are into the jargon of the arts, and it can be downright uncomfortable trying to keep up with their conversation. Indeed, it can be embarrassing, with the hearer wanting to interrupt for clarification time and again, but afraid to look like a rube: "Excuse me. What's an opus?"; "What do you mean, 'wash'? Was the paper dirty?"; "Are you saying that 'Swing Low, Sweet Chariot' is not a hymn?"; "Is Stoppard at the Guthrie something like Kobe at the Forum?"; and, "Oh, yeah, I enjoy chiraschuro too, especially when they bring around the hump of the brahma."

When those artists and their followers get together, you have a different language group. You might as well give them their special space and time to do church, just as you do the Koreans and Haitians. It's nice to have joint services now and then, but its hard to have church potlucks with folks who insist on kimchee—and real fellowship with people who keep talking about the distinction between J. S. and C. P. E. Bach, when all you know is Bach, and that barely. God love 'em, but don't ask me to care when they're going on and on about the "fabulous padehdoo" (or something) they saw some dancers perform up in the capital last weekend.

Dork Forest

Warnock: Artists are far from the sole offenders here. Lots of groups have insider language. Think of it in the sports you don't follow (NASCAR? lacrosse? curling?). Ever overheard conversation among engineers, investment advisors, attorneys, computer geeks, Trekkies, or gamers? And let's not forget theologians, for crying out loud. They can be downright incomprehensible.

A friend of mine taught me the term for this. When you're in a group of people, and two or three of them start using insider language in front of others, he calls it entering the "dork forest." Don't get lost in there.

The solution is, on one hand, to be patient with artists when they disappear into the "dork forest," and, on the other hand, to encourage them to love their brethren by not alienating them with foreign language.

Coppenger: Indeed, let's not forget the theologians and other biblical scholars. The other evening, I went to a showing of a wonderful defense of the authenticity of the biblical text, a great pushback against Bart Ehrman and company, against those who argue that the accounts have been corrupted through the centuries. The production values were very high, with beautiful walks through world-class campuses and libraries and interviews with top-flight scholars, a number of them with predictably-impressive British accents. Here were papyri, there codices; here uncials, there minuscules. And I have to give them credit for explaining what most of these technical terms meant. Rightfully so, for the film was pitched to laymen as well as professionals. But, sure enough, they slipped in some words, unconsciously, that "everybody knows," but not really, e.g., 'exegesis.' We just can't help ourselves. But we don't have to apologize for using them since they denote and connote important things that we'd also like to explain to newbies. The same goes for the language of artists.

Brazil or France?

Coppenger: Let me bring up a distinction I've found in my travels. When I go overseas, I notice that some cultures are delighted when you try some phrases in their language. The Brazilians are a case in point. On my four mission trips there, I've picked up a hundred or so words in Portuguese, many of them Latinate cognates of terms we use, such as redenção

("redemption") and oração ("prayer"). I've found nice parallels in sister languages, as, for instance, their word for church, *igreja*, tracks with église in French and *iglesia* in Spanish; and *obrigado* mirrors 'obliged.' And some I've just had to learn cold—tambén ("also") and *muito* ("very").

My efforts at speaking Portuguese (and even spelling 'Portuguese,' what with that second 'u') have been a pretty sad affair, but I find the Brazilians unfailing encouraging as I've tried. Not so the French, who usually seem impatient, even indignant, at my forays into conversation, whether asking directions on the street or ordering something at a restaurant. When I try, "*Donnez moi deux billets, s'il-vous* plaît" ("Give me two tickets, please") as I hand over cash at the station, the clerk is likely to translate it into English with a sour, exasperated look. The implication is something like, "Sir, you are soiling my language with your pathetic pronunciation, and your presumption in appropriating a tongue so far above yours in sophistication is scarcely worth acknowledging."

In my experience, artists in our churches are more like Brazilians than Frenchmen. You can ask the dumbest questions ("I've got an extra $20. Could I get a nice painting for my wall at one of those downtown galleries?")—and some not-so-dumb questions ("How come they call a flute a woodwind when it made all of metal?")—and they'll work with you. Mispronounce 'Wagner' ("wagner" instead of "vahgner") or call a trumpet a bugle, and they'll probably ignore the "fox paw," or smile and offer a kind correction.

Ask them about their work—"How in the world do you do that and not get paint on your clothes?" or "Does it hurt when you hit high notes?"—and they'll give you an interesting explanation, maybe even more than you want.

Of course, you can get their dander up a bit if you hack on something or somebody they respect—"That Picasso stuff is garbage"—and they might return an uncomfortable silence for what they take to be misdirected enthusiasm—"Now Stephen Seagal, that's what I call a real actor!" But more often than not, I've seen them pick up graciously with something like, "I hear what you're saying, but take a look at this," or "Yeah, but when it comes to action heroes, I'm more a fan of Daniel Craig."

Of course, you can get your fingers burned, but this can happen in any discourse. Tell a Bears fan that Ditka wasn't so hot or a Democrat that ObamaCare is a disaster, and you may have a tussle on your hands.

Addington: Well, you answered your own question beautifully. In my experience, once the spotlight is on them, artists spend most of their social time and stage time as educators, generously and gently opening the doors for other people to step into a place of appreciation, as opposed to the "Dork Forest." And why not? It benefits them, in the long run, to patiently teach others about how to appreciate their product. To paraphrase what you said above, Artists *do* speak another language, but that language isn't "art-speak." That language is art itself, and like the student of any new language, learning it will always be valuable to the student.

A side note of irony: That uncanny first paragraph which pretends to decry the second language of artists could *only* have been written by a student of the arts!

Immersion Learning and the Plunge

Dittman: It would be better to approach an artist's specialized language not as a nuisance, but as an opportunity, not as an annoyance, but as a rite of initiation. There hardly exists a culture or subculture that allows full participation without at least a familiarity with its language. Because culture by definition requires sharing—shared beliefs, shared attitudes, shared behaviors—and sharing requires multiple persons, and multiple persons need some method of communication, and communication requires some form of language, and language requires specificity in order to function effectively, it's no surprise artists use a specialized language. Thankfully, if indeed the artists in our churches have a more Brazilian than French attitude towards outsiders, what a brilliant opportunity to access this specialized language and perhaps to take some new understanding into our divinely-appointed conversations with the artists we brush elbows with on our daily commutes.

In the same way that a person might travel across oceans to immerse himself or herself in an unknown city with an unknown language, expecting, by this method, to more effectively acquire the language, we can consider the company of Christian artists as immersion experiences and thereby benefit from the passion they exude when talking about specific areas of artistic interest. Who better to equip us to engage the arts and the artists of our fallen world than the redeemed artists in our midst?

Coppenger: When I taught at Wheaton, the sociology or anthropology folks were offering a "plunge" experience for their students. In the dead of winter, they'd drop them off without money for a few days on the streets of downtown Chicago, leaving them to fend for themselves. On campus, they'd read about the "homeless" experience, but their insight deepened dramatically as they wandered vulnerable in the "concrete jungle."

I forget the details, but their sojourn included things like lining up for a meal at Pacific Garden Mission; looking for cardboard to shield themselves from the wind and a grate venting steam to catch some warmth; dozing "with one eye open," alert to those who might mess with them; checking out alley dumpsters for just-expired and still-packaged Twinkies or melon balls; panhandling for enough coinage to get a cup of coffee at White Hen Pantry. Some pretty intense education.

I'm not saying that artists are a pitiful lot and that empathy is what they need most. Rather, I'm talking about the great gains that can come from casting yourself into a radically unfamiliar culture. Maybe some parishioners could enlist their artists and musicians for a course in the terms, techniques, challenges, and delights of their respective disciplines. Panhandling for artistic knowledge can be a humbling experience, but it's good for the mind and soul.

Bedside Manner and a Helpful Mechanic

Stark: I believe this takes us back to the pride issue we have raised several times in our discussions. Christian artists should not assault congregants with their high-brow jargon. Instead, in humility, they should speak in common terms—not because congregants are dumb but rather because they function in a different field. When the jargon is unnecessary, it should be avoided. I would equate this with a doctor who has good bedside manner. She could just come in and explain your pending surgery with complicated medical terminology that only she and her peers understood—or she could take the time to explain your procedure in language and concepts with which you were already familiar. Most people would probably prefer she do the latter. In the same way, a good artist should be able to connect to another human being with a common language rather than trying to speak above everyone's head.

That said, non-artist congregants should be patient when artists use unfamiliar terms. As Mark Warnock pointed out, every field has a

specialized jargon. For instance, I have no skills when it comes to auto maintenance. Therefore, when my mechanic tells me what is wrong with my vehicle, he might as well be speaking another language. I just tell him to fix the car. Nevertheless, even though I don't speak his language, I can still appreciate the beauty of a well-running engine, and I can still give thanks for his ability to make my car function again. In the same way, you don't need to be an expert on the artist's lingo or to even completely "get" every aspect of an artist's work in order to appreciate and enjoy good art. Let the artist use his specialized vocabulary; you just relax and enjoy the music (or painting or poem or film).

Sherpas

Westerholm: Isn't this part of the role of the art critic? To serve as a Sherpa for people trying to climb "Art Mountain" (or, to combine Mark Warnock's analogy with some Tolkein, to serve as the *Ent Onodrim* of the "Dork Forest!"). My point is that much modern art has become so abstract that art critics are needed to explain the art to the public.

Coppenger: See! There you go, you jargonmeister: *Ent Onodrim*. What in the world is that? You're talking (I think) about those righteously-indignant, giant, fearsome trees in *Lord of the Rings*. I had to look it up . . . and, yes, I'm glad I did. Instead of running away from the confusion, I addressed it, and I think it's fair for us to urge our congregants to do the same.

Sometimes I include vocabulary words in the daily readings quizzes I give my classes. As I work through the assignment myself, I circle a word they might not know and then scribble 'V' (for "vocabulary") in the margin and circle it. (Of course, some of them are new to me, too.) I figure it's fair to toss a few of them into the multiple-choice test, and I have perverse fun in making up the bogus options to the right answer.

I'm amazed at how often they'll say something like, "I've seen that word before, but I never quite knew what it meant." They've passed over it for years without so much as a pause (even when dictionaries were right at hand), never bothering to get clear on 'ubiquitous,' 'extant,' or 'obsequious,' or to explore the roots of 'hierarchy,' 'Mediterranean,' or 'admiral.' It makes me echo that ESPN meme, "C'mon, Man!"

(And did you like the way I used 'roots,' avoiding 'etymology'? Probably should have done that with 'meister' and 'meme' too.)

11

In Our Eagerness to Deliver Fine Presentations, Don't We Risk Enlisting the Unregenerate in Leading Worship?

Coppenger: We're all familiar with attempts to enlist lost people to sing in the choir (as we recruit them to play on church-league softball teams). We hope to up the quality of our performance and build bridges for evangelism. But then we have non-believers as, in a sense, "worship leaders" in our churches. Could Apostles Paul and Peter have countenanced such a thing as this?

Content, the Issue

Addington: Well, we've had this conversation about a specific guy, and it turns out, while I didn't know his heart, I did see his actions, and he, three years later, was still there and was, *by far*, the most dedicated instrumentalist we have ever had—dedicated to the church, and dedicated to me as worship leader, treating the activity with respect, keeping me informed of when he would be present or gone, committed to rehearsing when it was time, and taking that activity seriously. Not to name names, but apart from the two worship leaders in the band, he was the one who stuck with it and treated the task with honor. That's anecdotal, yet it's real.

Now, I *don't* call that worship leading, and I don't call hanging work in the lobby worship leading either. But worship leading and hanging artwork has to do with *content* decisions, just like deciding what we will study in Bible Study next. And I would be very sure, as a church leader, that those put in a place of authority to make *content* decisions were trained, vetted, and dedicated believers who had the love and concern of the congregation and the act of honoring God as their paramount motivations.

Coppenger: He was, indeed, an amiable, skillful participant. And there wasn't a question of content, he being a drummer. (Though, maybe an ill-placed, editorial rim shot during announcements or the sermon could have stirred up confusion, but that didn't happen.) And we were a small op-eration, a young church-plant outside the Bible Belt. Sometimes seminary students ask me how we crafted our music program, and I say half-jokingly that we built it around whoever, graciously, showed up.

An Evangelistic Success Story

Warnock: When I first came to my church in Chicago, people made a point of telling me that one of the men singing in the choir was an atheist. He was a liberal guy, a social worker, who saw some strictly functional human value to the practice of religion, even though he didn't believe any religious truth claims. He was married to a woman in our church whose faith was strong; he attended church to support her faith. Curiously, she didn't sing in the choir, but since he really liked music, he did. The burning question was whether I would let him stay?

I contemplated it. I figured I could either be "principled" and ask him to leave, or I could enjoy the irony of an unbeliever singing God's praises week after week. Ultimately, since he was not visible as an individual leader, but part of a large ensemble, I decided to let him stay. I'm glad I did. Four years later, he was sitting in the choir loft listening to the sermon when God finally broke him, and he prayed and invited Christ into his life. As it turns out, it was music that made the difference. He had been listening intently to a Chris Rice song whose lyrics suggested that he was meant to be filled with more than just questions. Once he began to doubt his doubts, faith arose, and he was born again.

People without Christ come to faith more readily in community. In-viting artists into community as artists can have evangelistic advantages.

Having said that, my practice has been to insist that all our visible leaders, both singers and instrumentalists, are Christians. Non-Christians may sing in the choir or play in the wind orchestra, but not in the worship band.

Coppenger: This is a gratifying account. I do wonder where the "visible" line is drawn, given that most choirs are seated in full view of the congregation.

Warnock: You make a fair point, and I honestly don't know if I would make the same decision today. I made an exception for my atheist choir member, but what if there had been three of them, or five? It sounds like a joke: "Two atheists and an agnostic join a Baptist choir . . ." Would I countenance a choir full of atheists just because they could sing well? Definitely not.

But some churches do! I was talking to my uncle recently, who is an executive pastor at a big church in North Georgia. Apparently, there is a sizeable horde of unsaved professional musicians playing in churches around metro Atlanta. They circulate from church to church, picking up checks from congregations who just *have* to have top-tier bands, despite the fact that they don't believe in God, and that some of them live conspicuously unchristian lifestyles. Churches pay them and deliberately look the other way if asked when the drummer got saved or why the bass player is cohabiting with his girlfriend. Though the short-term effect is high impact worship music driven by a tight house band, I think it's a pastoral and ecclesiological disaster. Can you imagine a worshipper of Molech playing for shekels in the Jerusalem temple because he's good on the shofar?

The other dynamic at play lies in how the cultural position of Christianity has shifted. My atheist choir member attended a Midwestern church in the mid 1990s. Back then, there was still a sizable "mushy middle" that would shrug at an atheist who decided to sing in the church choir every week. Those days are gone. Though evangelical Christianity once occupied a large space at the center of American culture, it has been slipping toward the margins ever since. The church's influence has declined, and the cultural divide between believers and unbelievers has grown much sharper. Christians are more serious, and so are atheists. I can't imagine that either a church or an atheist could make such an accommodation as easily. One of my undergrad students at the Christian college where I teach told me that on campus today, you're either an all-in Christian or you completely reject the faith. There appears to be less and less middle ground.

Not Softball; Not Construction; More than Content

Scott: It seems to me that there are number of issues involved here that need a little more clarification. First, recruiting people to play in a soft-ball league is not the same thing as leading worship. While it is certainly true that Christians should do everything to the glory of God (including softball), players assembled out on the softball field are not the same as the church assembled for worship. The main goal in reaching out to unbelievers to participate in a softball league should be to establish evangelistic relationships.

Second, it is important to remember that the church building, and all it entails, is not the church itself. A New Testament church consists of regenerated people. In fact, the church does not even need a building, or pianos, or song books, or pictures, or trained musicians to be a church or to conduct worship. Those things might be helpful or beneficial to the church in some way, but they are not essential or necessary. Therefore, it is one thing to employ an unbeliever to construct a church building or paint a picture for the lobby and another to employ someone to participate in or lead the worship service itself. Church worship is done by church people.

Third, there could be a problem with the definition of a "worship leader" here. It seems that reducing worship leading to making content decisions is problematic, especially when it is said that this is "just like deciding what we will study in Bible study next week." If we follow that logic, it seems plausible that we could have an unbeliever lead a Bible study or even preach the Word so long as a believer has reviewed the content of the message. This practice, however, would violate biblical principles like those taught in 2 Timothy 2:1–2, where Paul instructs Timothy to deliver the Christian message to "faithful men who will be able to teach others also." The phrase "faithful men" can only refer to believers in this context.

The connection this text has to the music service cannot be ignored. Paul's exhortations to the churches at Colossae and Ephesus describe the singing of songs in worship as being equivalent to "teaching and admonishing one another" (Col 3:16). Corporate worship has a teaching element to it in which believers mutually encourage one another in the faith. It is hard to see how an unbeliever could rightly participate in this exchange, particularly in a prominent place in the service.

Finally, the New Testament presents unbelievers as outsiders who come and observe what is going on in the church (1 Cor 5:12, 14:23; Col 4:5; 1 Thes 4:12; 1 Tm 3:7). The early church made a clear distinction between

who was in the church and who was outside. Involving someone who is unsaved directly in the worship of the church seems to blur this distinction.

Cabal: Right. Picking up your second point: If the question were re-worded to substitute 'building-making' or 'film production' for 'leading worship,' most Christians would not have a problem with enlisting non-Christians. In fact, specifically with building production, Solomon harnessed non-believers in building the Temple.

Real Worship; the Actual Worship Leader

Bolt: Of course, if the Bible is true, there are tares among the wheat, and we have unregenerate people worshipping with us and even leading worship when we meet. But the question regards people we *know* to be unregenerate. Setting that qualification aside, there are two other difficulties with the question. Both problems may be found in the phrase "leading worship."

First, the actual worship leader is not the individual artist strumming the guitar or painting the canvas or whatever else. The worship leader in a corporate worship gathering is the pastor or pastors who shepherd that church. This does not mean that the pastor has to sing, but rather the pastor is the authority in terms of spiritual leadership and worship in this scenario.

Second, the unbeliever is not actually worshipping God. True worship requires coming to the Father through the Lord Jesus Christ in the power of the Holy Spirit. And that is something the unregenerate person simply cannot do. The unbeliever here is facilitating worship through his or her God-given abilities, but he or she is neither worshipping nor leading worship?

The Showboating Mormon

Coppenger: I know that sounds outlandish, but let me recount an incident. When I was a pastor in south Arkansas, I went by the home of a member, only to discover Mormon missionaries there, talking with her in her living room. She invited me to stay, and so we discussed some theology in front of her.

The next Sunday, at the invitation following the sermon, one of the missionaries came forward in front of everyone, took my hand, affirmed that he was a Christian, and then returned to his seat. He was showboating,

trying to meet head-on the evangelical claim that LDS folks were not true believers.

I wouldn't put it past a fellow like that to ask if he could join the choir to further confuse impressionable folks in the congregation.

I know that's an extreme case, but if the logic of inclusion is that there should be no barriers if the person doesn't twist or muddy content and if he's talented and faithful, then what's the problem?

Aesthetic Goals or Doxology?

Westerholm: By enlisting non-believers, we reduce artists to means for achieving aesthetic goals rather than as human beings. We lower the task of gathered corporate worship to celebration of art rather than doxology. Perhaps most troubling, if including unregenerate people in worship ministry is seen as a means of evangelism, then it represents a misunderstanding of the worship event and of unregenerate people. It will confuse non-believing artists as to the essential nature of the gospel. Put simply, non-believers rely on their own merits to be acceptable to God, and their inclusion in public church ministry reinforces that faulty reliance more than any words we could express to the contrary.

Coppenger: I agree there can be a problem with the lost getting a sense of "works salvation." By being in the choir week after week, they may come to think that they're covered somehow when it comes to the Final Judgment.

Special Events?

Coppenger: Let me bring up something else, an item my wife Sharon recalled to my attention. "Week after week" is one thing, but what about special events? She mentioned an interesting business meeting discussion in a church we attended near Indianapolis. The topic was whether to pay an outside musician for a special Christmas event. She remembers the meeting (which I had to miss) not only for the lively discussion, but also for the amiability of the parties to the dispute after the matter was settled. They'd all taken their time to "walk around on the table and throw some sand in the air," but then they showed they were friends when all was said and done.

The issue that evening was not so much whether non-believers could sing a recitative or play the harpsicord for us, but whether we should use

church funds to pay them. (I witnessed such a team at work one Sunday at a big, old, mainline church in Detroit.) So there are two issues –remuneration and one-off performances.

Having just heard Vanderbilt musicians perform Bach's *St. Matthew Passion* at one of Nashville's Episcopal churches, I have to say I was pleased they did this, even though I was confident that at least some of the singers and instrumentalist were not Christians. That notwithstanding, I was moved by their rendition of *O Sacred Head, Now Wounded*. Unfortunately, some faculty member took it upon himself/herself to include politically-freighted slides with scenes of refugee camps, trying to equate Christ's atonement with Syrian suffering. (Which reminds me that some people could mess up an anvil with a rubber hammer.) I wish there had been a "worship leader" to ride herd on content, but this was more an artistic event for them than a worship affair. Still, it was very gratifying (if you closed your eyes at the right time). The same goes for my experience of the Nashville Symphony's *Messiah*, for which they "import" paid soloists of uncertain spiritual provenance. When the "Hallelujah Chorus" comes around, I'm gladly on my feet, hoping that whoever's singing up there can sense, along with us saints, the glory of it all.

Bottom line, in this context and in light of what's been said above, I'm more comfortable with special events with honoraria (particulary in outside venues) than with standing arrangements, compensated or not. It's sort of like the difference between giving thanks for the Christianly-gratifying performance of a gay actor (e.g., Ian Charleson as Eric Liddell in *Chariots of Fire* and Ian McKellen as Gandalf in *Lord of the Rings*) and using them in church dramas, should you have such.

12

What About the Weaker Brother?

Coppenger: Artists are a hardy lot, not given to swooning in the face of blasphemy, obscenity, and such, but can they be insensitive to the plight of the weaker brother who is susceptible to seduction or confusion? Could elements of the service or the room cause an impressionable convert spiritual distress while the artist doesn't notice?

I'm reminded of a time at Wheaton when I was asked to emcee a discussion on Christian rock music. The room had pretty well decided it was okay, but then a genuinely sweet fellow came to the mic and said that he wasn't judging his neighbors, but that since rock had been the soundtrack to his pre-conversion decadence, he couldn't make it to the concert that night (featureing Larry Norman, Randy Stonehill, and the Daniel Amos Band) since the associations were too bitter and the chance of relapse into old patterns of thought and feeling were too strong. The same sort of thing might surface if the church featured a series of paintings of Mary, which could bring back conflicted memories of a past in the sacerdotal tradition, and maybe even sow confusion over whether one might pray to her for better access to Jesus.

The Range of Weaker Brothers

Addington: When Paul starts talking about not being a stumbling block to weaker brethren, and about all things being lawful for him, but not all

things being useful (all things permitted, but not all things are edifying), I think he may have actually been opening the door for a kind of diversity in worship. If anything, he was more concerned that Jewish converts *break* with the old requirements of the law and with making sure new Gentiles Christians were not led astray into believing they had to start observing Jewish law, e.g., regarding circumcision and diet.

Coppenger: Of course, Paul was concerned with entanglements with the ceremonial law. He made this clear in Galatians. But in the weaker brother passage, he also shows concern that the mature ones not run roughshod over the sensitivities of the "slower" brothers who had no "Old Testament" past, those who'd offered meat to idols in their pagan days and were now seeing Christians blithely consuming such food. So there were concerns on both sides.

Let me give an modern example: I'm something of a film buff and have written a bit on this in Christian publications. Early on, in Evanston, among university students at Sunday lunch, I might pose a "trivial pursuit" question like, "Can you name ten Robert Duvall movies?" And off we'd go—*To Kill a Mockingbird, The Natural, The Great Santini, The Apostle, The Godfather*, etc. On one of these occasions, I remember a homeschooled, Moody Bible Institute student in the mix, and he had little grasp of Duvall's filmography. He'd been raised and educated in a setting antithetical to most movies, and it was no accident that he wasn't up to speed.

It struck me that there were two ways to go wrong here—first, to apologize, embarrassedly for our moral negligence in seeing an R-rated movie such as the *Godfather* and to henceforth join him in abstention from all such films; second, to badger him for his "backwardness" and "cultural illiteracy," and press on with our film game, next naming ten films with Gene Hackman, Gene Wilder, Steve Buscemi, or Meryl Streep. Wouldn't it be better for us to frame our next question on something along the lines of cool minor league baseball teams (e.g., the Lansing Lugnuts; the Toledo Mud Hens) or college mascots (e.g., the Akron Zips; the University of Arkansas-Monticello Boll Weevils)?

I'll grant you that the "weaker brother" or his advocate can sometimes be a sort of "sensitivity thug," bullying you into excessive separation from the world. But we can't deny the other problem, that of the liberated brother who looks down on those who choose a more cautious approach and

rushes these unworldlies into something that will wound their consciences or confuse their souls.

When Self-Worship Intrudes on Real Worship

Addington: When I speak, for instance, of cultivating diversity of worship, I mean that perhaps not all congregations should look alike; some will be austere, and some will be lush, and the character of the assembly is a reflection of where those people are in a maturity sense, and in a plurality sense. (I hope we can see beyond the "liberal buzzwords" that I used there and accept the meanings at face value.) I know that sounds like I'm saying that art-permissive congregations are more spiritually mature, and I'm not, but I *might* be saying that those that prohibit art because of OT law are *less* mature, and I feel that Paul would make this call as well.

Idolatry is the result of a heart that does not seek God first. Our idols are really ourselves. If I get so proud of my worship leading, or my work of art in the baptistery, or my well-crafted sermon, or my modern dance performance, I have already committed idolatry during the worship service.

Coppenger: Of course, the culture pushes us hard toward this sort of self-idolatry, and, as the old saying goes, "The world gets into the church more than the church into world." I think of the Broadway song Sammy Davis Jr. made famous, *I Gotta Be Me*. We more naturally think of this as anthem for "progressives," but it can just as well serve "regressives." The same could be said for Frank Sinatra's *I Did It My Way*. What's missing in all this is the biblical ideal of dying to self, seeking to glorify God and edify the saints.

A Mutual, Navigational Challenge

Ahrens: You've written that "careless imposition of this or that work or genre on the fellowship can stir up old associations and confusions." The words "careless imposition" stood out to me here, and I think this just might be the crux of the matter. If every genre and work of art that caused "stumbling" in a brother or sister were removed, I would venture to guess that there might not be much left. This principle even applies to music currently practiced in the church. I remember the story of one sister who said she could not abide the singing of hymns by the likes of Watts, Wesley, and others of their era, because it conjured up memories of spiritual abuse in a

congregation she had attended as a youth. Is the solution to throw out these foundational means of congregational worship, or should the real attention go towards walking beside this sister and intentionally aiding her in a journey for healing that has obviously been neglected? Granted some visual works of art are more explicitly controversial in their nature (portrayals of nudity, etc.), but I think the same principle would apply. It seems here that the onus would be on both the mature and immature believer to navigate a mutually acceptable path.

To tell the weaker brother that they should just stay home and not attend a gathering where Christian rock was being played, or that they simply could not attend art showings because of controversial visual works of art, would be to prefer one against the other, and not to value or understand where the immature believer was in their journey. On the other hand, to tell the mature believer that the use of the arts has to be limited to a select few pieces might have detrimental effects as well. That said, though, there may be times when we simply *have to choose*: Is the type of art being presented something I can live with? If not, then I, as an intentional Christian believer, must choose what is best for *me*. This is the kind of diligence every believer must practice in *many* areas of life. Then, even as we provide these unique opportunities for each, we can also work to provide experiences that are mutually acceptable, whether musical or visual. That sounds like a lot of work, but I do not think the nature of the issue allows it to be any other way. It seems this is the only way to avoid "careless imposition" either towards the mature or immature.

St. Peter's Foot and Johnny Cash's *One Piece at a Time*

Coppenger: Let me pitch in two illustrations, one from Rome, the other from Nashville. First, when we last visited the Vatican, I took special notice of a centuries-old statue of Peter, seated in the basilica that bore his name. Through the ages, pilgrims have touched his right foot and worn the toes down smooth to an unarticulated piece of metal. It shows our weakness for superstition, and churches need to be very careful about displaying physical objects that could prompt tactual devotion in pursuit of special blessing. (It seems to be a universal weakness, which I've seen reflected in settings as varied as the display of reliquaries at The Cloisters in New York and the lattice work around the Mahdi's tomb in Omdurman, Sudan.)

As for Nashville, I mention a Johnny Cash song I referenced in a sermon. I asked them to imagine that we're having some "good ole" Nashville music playing in the background at a church fellowship function, including the classic, *One Piece at a Time*. (It tells the story of an automobile factory worker who stole parts year by year, finally getting enough of them to build himself a ludicrously hybrid car, which he drove around town, "driving everybody wild.") But what if there were a just-released prison convert in your midst, one who'd served time for running a "chop shop?" The song might not be so funny in that situation, but, instead, pointlessly awkward, drawing attention to his sins and making him wonder if these people had any idea of how their laughter could discomfit him. And it wouldn't help to switch to *Folsom Prison Blues*, if you're doing a penitentiary-ministry meet-and-greet with man who, indeed, "shot a man in Reno, just to watch him die." If you're turning to Cash in these settings, better to go with *Man in Black* or one of his classic covers like *Why Me Lord?*

To paraphrase Paul on the weaker brother, "Don't be knuckleheads."

Meat Dishes at the Church Potluck and Song of Solomon

Stark: I'm certainly sympathetic toward someone who might be "triggered" by the contents of an artwork, particularly when he/she may be enticed toward an old pattern of thinking (regardless of the artist's intent) or be re-traumatized with the reminder of something painful in his/her past. Just as it would be inhospitable for someone to serve alcohol in the company of a recovering alcoholic, so too would it be insensitive to force someone to take in an artwork that he/she may not be emotionally or spiritually prepared to encounter.

Nevertheless, I do wonder how far we can take this concession within congregational life. Just because someone might hypothetically be offended or tempted, does that mean we should not utilize the arts within the church? Would we apply this line of thinking to other areas of the church? I had a friend in seminary who was a vegetarian; she opposed what she perceived to be the inhumane treatment of animals in food production, and so she abstained from eating meat for conscientious reasons. Would this mean that her church, out of deference to her, should not allow any meat at the next potluck? Or does Romans 14 (regarding what one eats or doesn't eat) simply mean that we should be patient with one another on issues that are not of primary theological or practical importance?

I am sure most of us would agree with C. S. Lewis that "the salvation of a single soul is more important than the production or preservation of all the epics and tragedies in the world" (see "Christianity and Literature," in *Christian Reflections*), but does this mean we should avoid creating and displaying artwork simply because someone *might* be turned off from the gospel, be led astray, or be reminded of past sins from which they had been saved? If that's the case, then out of consideration for the "weaker brother," the church's censorship would have to extend beyond artwork to the very Word of God. For instance, should the recovering porn addict read Genesis 2, or will the mere thought of a naked man and woman be too much for his imagination? Should we avoid the postdiluvian account of Noah out of fear someone might have the impulse to get drunk and expose himself? Will the redeemed adulteress be able to hear the story of David and Bathsheba without the inclination to fantasize about a former lover? Can the conscience of a repentant abortionist withstand passages on the pagan god Molech and the Canaanite practice of child sacrifice? And what if the middle school boys with their raging hormones discover the talk of breasts in the Song of Solomon?

Surely, this is not what Paul had in mind when he told believers to avoid causing their brothers to stumble. Instead, his point seems to be that while we may have differences of opinion on certain peripheral matters of extra-biblical morality, we respect each other's consciences and seek to "pursue what makes for peace and for mutual upbuilding" (Rom 14:19), being willing to place restrictions on our own freedom to help our brothers and sisters along in their journey toward mature discipleship. This certainly has implications for what art is displayed in the church, but it is not reason to ban artwork from the building altogether.

Sermon Illustrations

Coppenger: Let me shift gears. What about sermon illustrations? What if you referenced a movie, which is 99% unobjectionable, but its 1% (for nudity, language, violence, etc.) could earn it an R (e.g., *Schindler's List*)? And what if your citation encouraged some to attend the movie, thinking your mention of it was some sort of seal of approval. After all, the pastor attended it. Might the tender Christian feel ambushed and resentful for your implicit commendation, and stronger brothers wish you hadn't set the new believer up for a jolt?

I remember a discussion we had at a *Kairos Journal* editorial session, one that concerned reference to a Harry Potter novel. A lot of Christians have enjoyed those books and movies, counting them good fantasy literature, engaging for kids. But a team member would have none of that, for Potter dealt amiably with the occult. This brother drew a firm line against playing off of any Potter character or event in his preaching. So, we cut that reference and essentially resolved to eschew film references.

Of course, that can be right difficult, given the way movie culture has permeated our vocabulary. I remember hearing a preacher on the radio criticizing a young West Coast pastor for his habitual, "cool" use of film references. But about a month later, I heard the same older pastor say that, since he had spent so much time on a particular text, he'd have to go at "warp speed" to finish the series on time. Uh, oh, a *Star Wars* reference. Doesn't that series speak of "The Force" that governs everything, without reference to Yahweh? Might a viewing encourage one to dabble in pantheism or Gaia thought? You can't be too careful.

Well, actually, you *can* be too careful. And it's not just with the movies. What if a pastor refused to use the great D-Day/already/not yet/victory illustration by Oscar Cullmann for fear that impressionable listeners might get into Cullmann and come to share his enthusiasm for the parlous World Council of Churches; or avoided the Karl Barth story on the profundity of "Jesus loves me, this is know . . ." lest the teenagers become neo-orthodox Barthians, unwilling to say that the Bible *is* the Word of God.

Christian School Scruples

Farris: When I was a teacher at a large Christian High school, we had a major issue over whether to use Edgar Allen Poe's works in English. Salinger was definitely out, but the list of questionable works was long. Of course, just getting kids to read at all was considered by some to be a victory, and to make a book off limits was a sure guarantee to get it read. When I was in high school a classic example of contraband was *The Summer of 42*. I think I read every word. Still, there is no excuse to include utter trash like *The Perks of Being a Wallflower* in any school curriculum. And if someone is offended by *The Tell-Tale Heart*, I am happy to go with another choice.

Coppenger: You bring up a huge topic—what we should use/permit in Christian schools. I've dealt with this on several fronts. For one thing, I

think we evangelicals get a bad rap for being censorious in order to protect our little snowflakes and for being "indoctrinational" to brainwash our wards. But having taught in both a secular university and a couple of Chicago-area public schools, I can testify that the predominating secular ethos is both censorious and indoctrinational. In the latter setting, you can expect the "liberating," I-feel-your-teenage-pain assignment of *Catcher in the Rye* and *The Scarlet Letter*, but you'll look in vain for *Screwtape Letters* and *Pilgrim's Progress*. Disparagement of the church and its values is lovely; esteem for godliness is repellant.

Of course, in stark contrast, I was frustrated to learn in the mid-seventies that I'd have to foreswear attendance at movies and Broadway productions if I were to teach at a Christian college in the Northeast. I was a freshly-minted Ph.D., seeking employment in this sort of school, and the initial phone conversation was going nicely until I learned that, as a faculty member, I wouldn't be free to attend Broadway productions like *Sound of Music* and *My Fair Lady*, or even *The Ten Commandments* at the local movie theater.

No thank you. I perfectly understood that there was a lot of toxicity on stage and screen, but "teetotalism" in this regard seemed extreme.

13

By Patronizing the Arts, Aren't We Introducing a "Gateway Drug" to the Culture's Godless Realm of the Arts?

Coppenger: It's one thing to safeguard the goings on in the local church, but what shall we say to Christians as they encounter the outside culture? Artists have worked around the edges of propriety for centuries. When Christendom ruled the day, they could still introduce titillation by laboring in noble contexts such as the Bible (e.g., Adam and Eve; David and Bathsheba), mythology (Leda and the Swan), or historical lore (Rape of the Sabine Women). Now, of course, all restraints have been removed. And once the believer is introduced to the "Artworld" (a term popularlized by aesthetician Arthur Danto), they may soon find themselves going father and deeper than they should.

Teaching an aesthetics course at Midwestern Baptist Theological Seminary, I took my class over to the Nelson-Atkins for a walk through the galleries. I asked them to imagine that they could pick one painting for display in their home for a year and then had them explain why they made this choice or another. Things were going well until we turned a corner and found ourselves at the foot of a large vertical painting by Thomas Hart Benton, *Susannah and the Elders*. We were all a bit embarrassed, and none of us lingered at the painting, but some might have been fascinated by the prospect of finding other racy offerings in museums and galleries.

And though the artists might be able to keep things "strictly clinical," these students might not have this capacity.

Addington: I would venture that actual pornography is much more accessible in today's digital culture than actual art is. If you want titillation, you don't have to make a trip to the Moulin Rouge today. I promise you, no one is going to a Thomas Hart Benton show for cheap thrills. The gateway drug is not art. The gateway drug is our electronic media. It's the pipeline that gleefully distributes their latest wardrobe malfunction. And everything worse is just a click away.

Many, if not most, of the artists I've encountered in a twenty-year career in the business see their calling in part as an *antidote* to the glut of profane images that crowd our screens and our consciousness. We are flooded by photography, video, and sloganeering that appeals to our basest nature with the sole purpose of getting us to buy stuff we don't usually need. We're exposed to this cheap, horrible beauty so much that we don't even notice it. This is all imagery meant to encourage idolatry. Artists work against this, and they use many strategies to do it. They might encourage the viewer to look away from the constant spectacle in order to contemplate the humble still life; they might subvert the crassness of commercial imagery and sloganeering by appropriating it and revealing its methods while calling its values into question; they might present a narrative that transports you to another place or time through either illustrative imagery or through abstract means, sparking your imagination, involving your heart, and offering an often challenging alternative to a future that needs you to consume with as little questioning as possible. No, I would suggest, that at a deeper level, below the skin, the majority of artists working are trying to provide an alternative to the cheesy, spiritually-dead, mass culture that we navigate every day.

If we tallied how much time we spend in museums and art galleries per month, and held that up against how much time we spend per month on-line on all our devices for pure pleasure and entertainment, we would throw this question into very sharp, even convicting relief. If we are seriously looking at fine art as the threat, we are fatally misguided. As a church, let's bark up the right tree on this one.

Venturing Out from the Ghetto

Stark: Christians are the light of the world (Matt 5:14–16). As such, our calling requires engagement with the darkness. Certainly, we must not practice evil, and we are told to flee from sins such as sexual immorality, idolatry, and youthful passions (1 Cor 6:18, 10:14; 2 Tm 2:22); moreover, we are told to pursue righteousness and to "set [our] minds on things that are above, not on things that are on earth" (1 Tm 6:11; 2 Tm 2:22; Col 3:2). Therefore, certain safeguards must be put in place before the believer can engage the arts. Nevertheless, we are also admonished to "walk in wisdom toward outsiders, making the best use of the time" and to "let [our] speech always be gracious, seasoned with salt so that [we] may know how [we] ought to answer each person" (Col 4:5–6). Jesus himself in His High Priestly Prayer specifically states, "I do not ask that you take them out of the world, but that you keep them from the evil one"; instead of asking God to isolate his people, he asks that God "sanctify them in the truth" (Jn 17:15, 17). He even states that their mission will parallel his own: "As you sent me into the world, so I have sent them into the world" (Jn 17:18). Hence, we are not called to ghettoize ourselves; rather, we are called to be agents of influence in the world around us.

Coppenger: At Wheaton, new faculty took a seminar in the integration of faith and learning, led by our philosophy chairman, Arthur Holmes. One of the key books we read was H. Richard Niebuhr's *Christ and Culture*, a book I still use in my classes forty years later. In it, Niebuhr lays out five ways that Christians throughout history have dealt with the rest of the world. He calls them "motifs," and they're not meant to be mutually exclusive. God's people may be called to major on one or the other, but different believers and groups can complement each other through their varying emphases. Indeed, all of these approaches can be in play within a single Christian. For instance, I take a "Christ Against Culture" approach regarding alcohol. I'm a teetotaler. It scares me, I resent its record of ruination in the world, I love the alternatives, and I don't think I personally have any business touching the stuff or modeling its use for people it could hurt. But some great Christian folks don't share my fears and scruples.

Next, in the "Christ and Culture in Paradox" vein (associated with Luther), I often cast my political vote for the "lesser of two evils," because they're really all you have in a lot of situations. The world is messy, and you do the best you can with what you have.

The "Christ Above Culture" approach resonates with my appreciation for the National Prayer Breakfast, featuring Christian speakers such as Mother Teresa and Eric Metaxas rather than the Dalai Lama or Muslim Congressman Keith Ellison. You don't get an America out of Buddhism or Islam, though of course, non-believers are welcome in this nation, which is heavily indebted to the Judeo-Christian tradition.

As for "Christ of Culture," I think it's good for the Chicago Transit Authority to put a Bible-quoting placard on the El trains during poetry month, a card bearing passages from Song of Solomon right alongside the verse of Robert Frost, Carl Sandburg, and Lawrence Ferlinghetti. Our guys can stand with their guys in the artistic canon.

And though I'm not a post-millennialist, I think our preaching, teaching, and activism can give testimony to "Christ the Transformer of Culture." For one thing, the pro-life movement has decreased the incidence of abortion in America. We can make a difference, at least in the short run, before Jesus returns.

On this broad model, there's room both for hopeful culture warriors and enclave devotees (recently celebrated by Rod Dreher in his book, *The Benedict Option*). I'm glad for the prayers of monks on Mount Athos and for the litigation of Beckett Fund attorneys. I'm blessed by no-trick-or-treat purists and the Halloween-candy-foragers, both from my church. I think we keep each other honest.

Watching TV with Jesus

Stark: Yes, we live in a fallen world. Yes, there is much immorality. But this immorality is not limited to the art world. It is all-pervasive. Much licentiousness exists, for example, in the sports world and in the political world. And how many of us have worked jobs where foul language and pin-up calendars were par for the course? But no one tells Johnny he should give up football or abandon his dream of becoming President of the United States, and no one forbids the construction worker to show up on the job the next day. We need Christians in all these realms, connecting people with the gospel in all they do—being salt and light in their spheres of influence.

If this is our Father's world, then no topic is off-limits for us. Rather, in the name of Jesus, we are called to redeem all things. Instead of teaching congregants to hide from an evil world, we as the church must do a better job at training our people to engage culture—whether through the

arts, politics, sports, or science—with the power of the gospel. We have a responsibility to help Christians think through these issues and be "wise as serpents and innocent as doves" (Mt 10:16).

I have a good pastor friend who seeks to avoid isolating himself from culture; yet, he also does not want to follow mindlessly the whims of the culture. He calls his approach to engaging culture "watching TV with Jesus." Basically, his approach entails thinking critically about the television show or movie or book with which he is engaging, and he analyzes it from a biblical worldview. In other words, he is not just passively absorbing the message of a sitcom, film, or novel; rather, he is seeking to "test every spirit" as an audience member.

Now, obviously, this approach has its limitations. One could not opt to watch a porn movie and excuse his behavior, saying he is just trying to analyze the movie from a Christian worldview. There are just some things that Jesus would not watch, shows that would have him changing the channel or just turning off the TV. The Christian must be ready to do the same. But the arts also provide plenty of opportunities to interact with other worldviews and to offer a Christian response, and believers should make the most of these opportunities.

Are there dangers in engaging the art world? Sure, just as there are dangers in engaging anything else in this fallen world. I know of philosophy students who have abandoned the faith, and I know of a "Christian" missionary who abandoned his family for a Muslim woman. Likewise, those ministering to drug addicts and rescuing prostitutes expose themselves to much immorality. But these cases and these risks are not cause for retreat. They are a call to "be watchful, stand firm in the faith, act like men, [and] be strong" (1 Cor 16:13). There will be much within the art world in which we cannot participate, for to do so would dishonor Christ and would involve our conforming to the pattern of this world. But where we can engage— where we can be salt and light—we must go, we must participate, we must become a part of the conversation, and we must speak truth.

Westerholm: And let me add that, while there certainly are many pagan aspects to the art world, to consider them completely "godless" denies God's common grace. Furthermore, no single section of our sociey possesses exclusive claims to pagan influence. Even areas of life with overtly religious themes can be driven by pagan priorities.

And Yes, There Will Be Casualties, as in Any War

Blackaby: Should not the idea of a "godless realm" imply the need *for* greater Christian awareness and involvement? Where should Christian's be "salt and light" if not in a "godless realm"? Is the question much different from a pastor's asking, "By taking members of the church to the shady parts of town to deliver food and water to the homeless, aren't we introducing them to a world full of sexual promiscuity, drug use, and an array of other heinous sins?" A Christian who never follows God into the dark and taste-less places is probably not following at all. Perhaps a more troubling issue is the congregation's lack of awareness in the first place.

Now, obviously, the problem is not nearly as simple as I've implied. The formidable danger posed by the world's perversion of the arts should not be casually dismissed. The staggering statistics of Christians addicted to pornography is a case in point. To rally the troops for a head-on charge without recognizing the risk of casualties is beyond foolish. That being said, the danger posed should compel Christians to be educated and aware rather than blind or groundlessly hopeful that the godless arts culture simply goes away. Christians should obviously act with great wisdom and much prayer, but this is no different from how we should act in any other arena of cul-ture (work, school, McDonalds, the post-office, etc.). In every evangelistic encounter, there is the possibility that the Christian will be introduced to dangerous ideologies and troubling questions that may act as a gateway to other such material and raise doubts about their faith. The danger is real and should not be ignored, but, obviously, the solution is not to abandon the practice of evangelism. Furthermore, in today's world of media bom-bardment, the idea that any person can remain oblivious to the realm of the arts seems impossible. Is it not better for the church to act as a careful guide and give an example contrary to our godless culture rather then to stand back and let our people stumble through the jungle alone?

The Christian Motorcyle Association

Reichert: You're spot on that Christians should deliberately seek out the godless realms and shine the light of Christ. There are always concerns that entering such realms may transform the messenger more than the mes-sage transforms the godless. As evangelicals, we certainly choose Niebuhr's

Christ-transforming-culture paradigm. But I would add that not every Christian is equipped as an ambassador of Christ to these foreign realms.

For example, I'm a member of the Christian Motorcycle Association. To become a member, you not only must be born-again but you must complete a basic educational module on evangelism. In the module, they explain that some Christians are simply not equipped to enter hard-core cycle events and remain on mission. For example, one member won a case of beer as a door prize. He was wearing his CMA colors, so everyone suddenly felt awkward. But he just casually turned to some Hells-Angels-type who had won a calendar and offered to trade. Classy. But if he had turned white, mumbled something like "That's the devil's brew" and chucked the case in the trash, no hearts were going to be won for Christ at that event.

In the same way, if one is a Christian with some aesthetic talent and a demeanor that fits well within the artistic "godless realm," then one is equipped for the artistic mission. And no, not everyone who has a heart for Christ ought to stroll into some New York modern art exhibit and offer comment.

14

Aren't Field Trips Awkward?

Coppenger: Aren't "field trips" awkward? When an arts-sensitive church decides to take a fellowship field trip to a museum, gallery, film festival, college dance recital, or theater production, it may well run into something embarrassing or appalling, whether in terms of scatology, nudity, blasphemy, or other forms of tawdriness and madness. How does a group of believers, especially in mixed company and with "baby Christians," negotiate conversationally what can be a jungle of offense?

Dan Addington, who led music at our Evanston church, sold art in Chicago, and we would publicize the "gallery walks," which included his place along with about twenty others, in Chicago's River North neighborhood. This went pretty well as long the exhibits featured landscapes, abstract works and such. But one night we came upon nudes by a photo-realist in the show, and as a pastor, I was in a bit of a bind, having promoted a church trip to see the show.

The same sort of thing arose in connection the dance department's spring recital at Northwestern University. It featured twenty short performances (some with our attendees), several of which, I think, would have been illegal a hundred years earlier. So, again, you have to be very careful about taking your people to something artistic, because you can get backlash for endorsing something offensive, though the artists may be oblivious to the problem.

Addington: Yeah, that's part of the messiness of living. It can be awkward, and I wouldn't fault a church leader for scouting ahead if they felt that they would be perceived as going soft on nudity by taking a field trip to a museum or gallery. Are those trips officially sanctioned by the church, or is it a matter of a voluntary group of adults going out to an event together? If a sanctioned church activity, it really doesn't happen that much. Church leaders usually take people to theological lectures or Christian concerts, where the danger is more "Will they be exposed to a doctrine the speaker believes in but my church doesn't?" So, do we decide that those people can handle that exposure, or do we decide to not risk it, because those ideas might pollute us? There comes a time when we face the question of whether to shelter others or to let them assume personal responsibility.

You take a bunch of folks to the Art Institute, and they might see a nude. So what do we do then? Well, there's no firm answer. Some will go to the museum, some won't. Some will inform their people (as if they don't already know!) what they might see, letting them opt-out if desired. Maybe this is part of the Pauline stumbling block conversation.

Preparing Your People for What They'll See and Hear

Raley: The awkwardness is real, but we pastors are charged with discipling people in the midst of their awkwardness. The benefits of field trips far outweigh the relational costs. In the past, we've canceled Sunday evening service to attend a Bach concert *en masse*. The previous week, I presented some material on *Jesu Meine Freude*, the motet being performed, raising the spiritual and theological issues in the work. I also got a bunch of comp tickets, and we let people know that if they couldn't afford to go, they should come anyway. The music director of the chamber group was more than happy to build an audience that way. And the gratitude many people felt at receiving the gift was quite moving. Instead of raising a status or income barrier (awkward), the field trip deepened connections.

And here's another example: Last spring, I announced during a Wednesday night Bible study that I was playing violin in a show by Uncle Dad's Art Collective at a local hangout called The Naked Lounge. I just wanted to see what would happen. A number of sins are implied in that one sentence. I had to specify that no one would be naked at the lounge. The lounge was a coffee shop, not the Tiki Lounge that had the neon martini glass on its sign. Also, the "show" consisted of new songs written and

performed by locals—nothing worse. Further, "Uncle Dad" was not a real person. And finally, the fact that the group was a "collective" did not mean that they were communists.

It's just hipsters, people.

After the study, to my surprise, several of the church folk decided to see the show. Two or three older guys came, along with one of our young men (five years clean from meth) and my wife. They entered to find the audience at the Naked Lounge fully clothed in vintage thrift attire. There may or may not have been some cross-dressing. It's sometimes hard to tell. There were massive, frenetic murals on the walls—and for that matter on some of the people, along with piercings and vibrant hair color.

I was playing in two jazz numbers arranged by an amazing arts entrepreneur and pianist named Josh Hegg. Other songs were more experimental, sometimes mixing live instruments with recorded sounds and sometimes featuring lyrics that were challenging to track. As a classical violinist, never having played straight-ahead jazz before, I was definitely out of my element.

But, in another way, these were my people. Classical musicians are more versatile, and weirder, than they get credit for. Some of them make the Grateful Dead look square. So, this was an awkward moment when my friends from various camps all met each other. And absolutely nothing cringe-worthy happened. The church folk were not offended, just curious. They weren't even offended when the door opened and the unmistakable odor of weed drifted in from outside. They all knew it was California. Church people, in my experience, are not usually fragile and uptight themselves. They are uptight about the other Christians. The young man is still clean, not compromised or "destroyed by another's liberty."

I do not mean to suggest that there are no spiritual problems with exposing people to the cultures that live alongside us. But guided engagement is better than isolation.

Not Edifying, But Eye Opening

Jenkins: My first such experience was an art walk in L.A. I attended with a group of undergraduates from California Baptist University. The amount of nudity and the number of downright offensive things was extensive, and I remember feeling incredibly uncomfortable at sculptures of erotic women

being crucified. Going through the gallery, I wanted to shield everyone's eyes including my own.

Later, among grad students in intercultural studies (in a class called Aesthetic and Intellectual Expressions of Culture), I toured the De Young and Legion of Honor museums in San Francisco. This experience caused me to understand the interaction that art had with culture throughout the centuries and within the city of San Francisco, where I was living.

The point of these two stories is that the art displayed in both of these venues was representative of their cultural setting. A walk through them helped me take the pulse of the community and gain an understanding of how they represented themselves. Though I might not say that these experiences were edifying, they were eye opening. They gave exposure to a way of life that I do not see present in churches and gave me access to a crowd that would not be present in churches.

Coppenger: I suppose we're often faced with the challenge believers would have faced in Pompei. Must they always avert their eyes, or was there a time to take a reading on the range of art there?

The Wizard of Oz

Farris: My oldest son is a marketing producer for NBC Universal in Burbank. He just finished *The Darkest Hour*, and has, for example, done trailer editing for the latest Batman iteration and other, recent, well-known feature films. Part of me exudes pride that he has been so successful at such a young age, and part of me winces that he is part of one of the most godless industries around. But he assures me there are Christians everywhere and that he strives to be salt and light wherever possible. I would rather see him being a successful witness through hard work than be like a nephew musician of mine who has a record of shunning responsible work and a normal life for occasional night gigs and time to write music, along with ten thousand of his closest friends doing the same thing here in Nashville.

My biggest gripe in these commercial art forms today is the lack of quality. I have not seen very many movies or heard very many songs in recent years that can distantly compare to the era in which I grew up. They are too formulaic, blue-screen heavy, and filled with homogeneous acting (or non-acting). Where is the next John Wayne, Leonard Nimoy, or Johnny Cash? Whatever sells to the largest common denominator is the MO these

days. Of course, my son accuses me of showing my age and demographic, but a quick look at the stats reveals similar sentiments. Movie attendance is down, but some attribute that to technology. At any rate, yesterday's movies have a lot more artistic value and cultural depth (of both the good and bad kinds) than the stuff of today's vintage.

Coppenger: I think you sound an important note here. When insulated, we can have the sense that there is this awesome godless culture out there, whose allure is virtually irresistible and whose charms and excellences are stunning. I've found that what the world has to offer is often lame and tawdry, incomparable to the best the Christian tradition presents.

I think of a happy shock I got when traveling to my annual army training at Fort Irwin in California's high desert. I'd been flying into Ontario down in San Bernardino Country and taking a rental car up the Cajon Pass, on past Victorville to Barstow. But I did the math and figured I could fly into McCarran at Las Vegas and make the trip just as well, this time from the east. I'd never seen Vegas, so I thought I'd give it a look, albeit, with fear and trembling. I'd seen it portrayed as a sort of magical kingdom of earthly delights, an unspeakably-beguiling Babylon, which shaped our national consciousness. Like Ulysses, I would have preferred to be lashed to the mast, but there wasn't boat available on the main drag.

What I discovered was impressively sad. Yes, the lights were bright, but there was so much moral and physical shabbiness in the side streets, in the patrons of the sports gambling parlors open to the sidewalk, in the discarded flyers blowing around, etc. It gave me new appreciation for the splendor of God's people and their work.

This was a "field trip" that took me behind the curtain in Oz, and I discovered that the "wizard" was just a weak old guy with a PA system.

15

Don't the Arts Smack of Elitism, Making the Church Haughty? After All, the Arts Have Great Cultural Caché in Society, and a Church Embracing the Arts Can Begin to Strut.

Coppenger: When the congregation does get on board with more lofty and widespread use of the arts, it seems to become more prideful, as if her sister churches were somehow second-rate.

Cabal: When I was directing one of the television programs at an extremely large Baptist church, I did sense pride and condescension from certain artists, from "patrons" at the church, and even from congregants towards other churches who did not have as many arts programs as they did.

Branding and the Letter 'M'

Coppenger: I got scorched once by an organist who thought I was damaging the church's aesthetic brand. He'd been in place for years when I arrived, and he was pretty grumpy with the (biblically conservative) changes I'd brought. But his first written complaint came at the point of my request that we sing *I'll Fly Away* after my sermon on heaven. He said it wasn't biblical, though it was (cf. Ps 90:10). But his big gripe was that we had descended into the fever swamp of Stamps-Baxter music, having left the heights of

refinement. He recalled the glory days when the church would regale the region with exalted concerts, with folks even driving in from northern Louisiana to hear First Baptists perform Bach. And now, what would they think of us! Well, of course, I loved Bach, but I didn't think we would damage God's work with a rousing round of Albert E. Brumley.

I suppose that if we're to think of New Testament "branding," we have to turn to 1 Corinthians 1:26, where Paul says, "Not many of you were wise by human standards; not many were influential; not many were of noble birth." We're a pretty low-rent lot, to the greater glory of God, who stoops to save the likes of us. (Of course, "starving artists and musicians" can easily fill the bill, along with us other nobodies.)

I love the testimony of the Countess of Huntington, whose patronage was a great help to the eighteenth-century Wesley/Whitefield revivals in England. Late in life, she said that she gave thanks for the letter 'M,' for without it, the verse would read, ". . . not *any* were influential; not *any* were of noble birth."

Of course, we don't need to go out of our way to be "down home," but neither should we sweat being "uptown."

Anti-Artistic Strutting

Warnock: Another way to strut is to be anti-artistic and proud, like fundamentalist churches, who just preach the Bible and don't go in for all that frilly, artsy nonsense. Or think of mission-driven churches who focus on evangelism and discipleship and crow that they don't allow "distractions" like paintings or cantatas to cloud their vision. Pride is a danger on both sides.

Addington: Again, I would suggest that the churches I've seen that embrace the arts are *not* the strutting churches; they are the welcoming, inclusive churches, and they institute these programs out of a spirit of evangelism and worship, not out of a need to impress. I'm not saying that that hasn't ever happened in a church, but that has not been the case in evangelical churches I've seen, heard, and read about. I have, on the other hand, encountered churches that strut because they would never give the time of day to those involved in such elite (read "left leaning") activities, and they are very proud of that contrary position! I am also under the impression that this is a fading position, and that there is much more openness than

even ten years ago when I was having these conversations with other artists and church people. I'm also not sure I would agree that the arts have great cultural caché these days anywhere. Artists have to deal with the distance caused by perceived or assumed elitism all the time, and all we can do is continue to do outreach and demonstrate that the arts offer all of society a lot, from the little, economically-challenged school kid, to the city that invests in art to add beauty, attract business, and create tourism.

Coppenger: For what it's worth, I don't mean "left leaning" by "elite." Some of the biggest patrons of the arts have been conservative, e.g., David Koch, who gave $100 million to Lincoln Center, and a variety of others with Republican connections, such as Donald Rumsfeld, the Frist Family, and Nelson Rockefeller.

Strutting Otherwise

Ahrens: While the arts may be an easier target due to their visual nature, and the fact that most folks categorize them as expensive "accessories" rather than "necessities," I think it is important to remember that the arts aren't the only thing that can make a church strut. What about the celebrity preacher with the tailored suit or trendy clothes, and perfectly (or not-so-perfectly-on-purpose) coifed hair? How many times have we heard someone say that they attend a particular church because of a certain preacher or teacher, or even because of a certain musician? Isn't it just as easy to look down on a congregation because their pastor/teacher/musician is not as accomplished or well-known as someone who has reached a kind of "celebrity" status in another church?

Do not misunderstand: I think every workman is worthy of his hire (1 Tm 5:18), and a pastor/teacher/musician who has put in the time to educate and equip himself or herself is due respect. But just as for the arts-embracing church, those with great pastors and leaders must "have this mind among yourselves, which is yours in Christ Jesus," a mind and heart imbued with humility.

Neither Ostracizing Nor Adoring

Westerholm: Of course, churches must battle pride in all its manifestations. In the battle against pride in the arts, it is helpful to view the arts as

functional instruments of action (as Nicholas Wolterstorff explains in *Art in Action*) that can serve the church. If the arts are to become great in our church, they must be the servant of all (Mk 9:35).

To be fair, the church should recognize its own temptations toward fear or fascination with artists. That leads to ostracizing or adoring artists. The church must endeavor to view its artists as members of the body, not as means to a cool atmosphere, nor as malcontents to the faith.

Ahrens: I agree wholeheartedly with Matthew, who, using Wolterstorff's model, highlighted the need to "view the arts as functional instruments that can serve the church." Indeed, anything we do as part of the gathered church, or even as individual Christians, can fall into some pre-labeled cultural category of elitism. Because of this, I believe the church must carefully, prayerfully, and humbly model the reflection of all beauty back to its source, which is God himself. This could go a long way in redeeming the arts (visual arts and oratory, included) to the glory of God.

Georges Rouault or Fanny Crosby?

Coppenger: Back to caché. When I visit the opera or theater in Chicago, I find a host of benefactors, including the major corporate concerns in Chicago—Boeing, United Airlines, Allstate. And when I read the *New York Times* or *Wall Street Journal*, I find artistic arcana receiving lavish attention, while only the most cursory, and often mean, treatment of spiritual matters can be found. You could see a hundred people saved at a revival in your church (yes, I do take red-neck pleasure in saying people *get saved* at a *revival*), and it will get little or no notice in a major paper. But let some adept do an installation of Jolly Ranchers at the local museum, and he'll enjoy twenty column inches of adoration for his imaginative take on the AIDS epidemic. It's very cool to be arty, no matter how vacuous the art.

I remember a scene in Woody Allen's film, *Manhattan*, where he mocks someone putting on airs in their pronunciation of 'Van Gogh.' But putting on airs in the arts is *de rigeur,* if I may put on airs to use a bit of French. Actually, pronunciation is a big part of class, one of the reasons we go to college. There's nothing more embarrassing than reading 'Freud' as "Frood" instead of "Froyd" and 'Rouault' as "Rooalt" instead of "Roo-oh." And the church whose members can rattle off references to Gabriel Fauré, George Herbert, and William Blake is more sophisticated than one where

they speak more readily of Billy Graham, Warner Sallman, and Fanny Crosby. And they know it.

I just read through the most amazing issue of *New York* magazine, itself a paradigm of worldly posturing. Surprisingly, they ran a respectful cover story on Yankee reliever Mariano Rivera, who is explicit about his Christian faith. Typically, they marinate the reader in morally-decadent perspectives, events, and personalities. But here, for a moment, the light broke through, but only because Rivera had the Hall of Fame creds. Nevertheless, they hastened to tip their hat to the swells at the 2013 CFDA Fashion Awards at the Kennedy Center (with a photo of an embracing gay couple, Robert Tagliapietra and Jeffrey Costello) and somebody named Delfina Blaquier, who used scatological language to express her frustration over some photograph of her husband at the Sixth Annual Veuve Clicquot Polo Classic. That's where the status can be found. That's where Armani and Chanel buy their ads.

It can be a scary crowd, and the church has to always be wary about caring what these cultural mavens think of them; and wary about not caring what those oblivious to the CFDA might think and value.

Big Box, St. Paul's, and a Bamboo Hut

Farris: In my greater neighborhood, where there is enormous growth in all directions including many new churches, there is a noticeable lack of churches with any visible artistic adumbrations. It appears that the favored aesthetic is function-over-form. In other words, new churches around here, including my own, occupy a great big box, suited as much for aircraft maintenance as worship. In contrast, the last time I attended worship in St. Paul's in London, I was completely blown away by the Gregorian chant and the total sense of worship brought on by use of all the senses.

My childhood mega-church has a large ballet troupe, an organ built by the Casavant Frères Company (opus 3644), a full orchestra, and a stained-glass rose window. It is also a signer of the Manhattan Declaration [on the sanctity of heterosexual marriage] and spends millions on missions every year. Indeed, one can worship diligently in a box in shorts and sandals, or in a dark suit, or anywhere in-between. It takes all kinds to comprise God's kingdom.

I for one am glad there were no shopping strips in the Middle Ages. Otherwise, there might not be any form of Chartres, Cologne, or

Westminster to be had; only ecclesiastical Levittowns. Christianity deserves more than that. But a bamboo hut in an isolated jungle where God is proclaimed is just as precious to the Father.

Coppenger: Right. I'm glad that the Holy Spirit doesn't do a critical assessment of architectural splendor before consenting to work in a particular building. And, come to think of it, my most stirring spiritual moments have come in a wide variety of venues—including an open-sided, tin-roofed "tabernacle" at church camp; a traditional auditorium, with stained glass and padded pews; in a church fellowship hall filled with folding chairs; in the weekday silence of a European cathedral. God works his mighty way in both humble and exalted settings, so we can be *grateful* that this or that building encouraged worship, but not *proud* that we were associated with it in some way.

16

Shouldn't the Church Have Other Priorities?

Coppenger: Most conservatives say the emphasis should be on evangelism; most liberals want the spotlight on "social justice." Sure, the arts are nice, but they'll always be on the back burner when there are souls to save and hungry to feed. If they can make out their case that their art wins people to the Lord or motivates people to give toward the clothes closet or food pantry, let them do it. But what business does the church have on sidetracks when a lost, broken world is crying out for the basics.

The Rich Young Megachurch?

Addington: It does come back to this if those are the *only* two things that a church does. I would urge *all* megachurch wannabes to sell their multimil-liondollar sound equipment and give the money to the poor (or to missions, to make this equitable), just as Christ asked of the rich man, and see if they do it, or if they walk away like the rich man did. So, let's either follow this line of reasoning honestly in *all* ways in our churches, or acknowledge that we do a *lot* of things that are not spelled out in Scripture, and most of our outreach programs, church events, concerts, etc., are all a part of that.

Coppenger: Good question. Of course, the answers could go in different directions. One church might say, "Ouch! We're convicted. We're going to sell off a lot of stuff, cut back programs, and go high-speed-low-drag for the

humble essentials." Another might say, "Okay, that's a good reduction to absurdity. This sort of divestiture is nonsense, so let's get off the high horse about these two priorities and let a thousand flowers bloom." (At which point, the literary artist objects to mixed metphors.)

Many Means

Wilkinson: The New Testament teaches Christian liberty, which can be tangentially applied to this issue. All individuals are called to evangelize and worship, but other than utilizing the Word explicitly, the means of evangelism seems open. Paul employed philosophy; some have used tracts; others, social justice; and some, all of the above and more. I can readily imagine the case of an individual who is called to evangelize through art, the "Jesus painter" or the "Jesus sculptor," if you will. Based on God's creativity and beauty in creation, there seems to be a place for all of it, so long as it drives the unregenerate to the convicting Word.

Ars Gratia Artis . . . Not

Cabal: I don't see using the arts for the sake of art as being a legitimate purpose for the church, as nowhere in Scripture does it recommend anything of the sort. Instead, we see the people of the church attempting to honor Christ in everything they do together, be it eating, singing, distributing food to widows, etc. Likewise, art (and I don't just mean painting, because, if you're using music, you're already using art) can serve the church.

Why should a megachurch not have multimillion dollar sound equipment, incidentally? In order to project enough sound for tens of thousands of people to hear at once, a bullhorn is simply not going to cut it. Getting out the sound of the pastor and the music produced by the worshipping musicians simply does not come cheap.

Coppenger: While we talk elsewhere in this book about how a lot of good art can be affordable, there is no denying that quality can be expensive, and I'm not just talking about gratuitous ornamentation. It's been decades now, but I still recall the shock I had when learning how much an individual letter cost for a church exterior—something like $200 in those days' dollars. The whole thing would run into the thousands, and these were just letters, not masterpieces of religious art. Sure, we could have thrown up some oil

cloth and replaced it every few years, but it seemed good to signal and enjoy stability with letters that didn't rust or fade . . . and, yes, to let people know this wasn't just a warehouse. You have to make some investments to get the work done well.

Enobling

Warnock: The church *better* have other priorities! Like the gospel, the Great Commandment and the Great Commission. But all things in proportion. A church can see to the main things and still nurture artistic excellence. There are lots of churches that are doing so effectively.

If the church is reaching artists for Christ and discipling them to maturity, we should expect that artists will find a way to influence and ennoble the corporate life of the church as they exercise their God-given gifts.

Coppenger: In my college years, you could still find "home economics" majors in the land, but explicit training in homemaking has fallen on hard times. You still find cognate courses under "domestic technology," "consumer science," and such, but hints at appreciation for the "old days" are likely to prompt reference to *The Stepford Wives*. Still, there is some concern that we've thrown the baby out with the bath (pun intended), and appreciation for the curriculum is enjoying something of a comeback.

I bring this up to suggest that church home-ec is pretty important. Consider the classic topics: food (its taste, appearance, and nutritional value); clothing (its functionality and appearance); the purchase and coordination of furnishings; money management; family relations; child development; landscaping; and so on. All of these are in play in the church, with aesthetic values much at issue.

I think of my apartment in Camden, Arkansas, the summer I served First Baptist as a youth director. It was a dump, with unwashed dishes in the sink, dirty clothes on the floor, and spill stains on the kitchen table. Enough to make a home-ec major gag. Almost made *me* gag. So, in this connection, it's important that churches not come off as dumps.

By the way, the expression, 'home economics,' is a bit redundant, in that the word 'economics' is made from the Greek words for "house" (*oikos*) and "law" (*nomos*), a composite once referring to the steward (often a slave) who kept the house in order. And by extension, the steward of the "church

house" should attend to all that "makes a house a home" for those who seek to glorify God.

When Mark speaks of those things which "enoble the corporate life," I imagine he's thinking more of a song service with *In Christ Alone* rather than *Ain't No Flies on Jesus*. But I think it's fair to speak of the range of details that help make the place uplifting rather than downdragging.

Inevitable

Stark: I guess my question would be this: Isn't art inevitable? As human beings made in the image of a God who creates and sustains beautiful things, will we not naturally do the same?

From the opening chapters of the Bible to its conclusion, we see the presence of poetry and song among humankind. More than that, we recognize that when God revealed himself to us through Scripture, he chose to speak not only in paragraphs but also in stanzas. Furthermore, when he prescribed how the Israelites were to worship him, he provided detailed accounts for the construction and decoration of the tabernacle and temple. Even in the New Testament, as Steven R. Guthrie has pointed out in his book, *Creator Spirit: The Holy Spirit and the Art of Becoming Human*, we find that being filled with the Holy Spirit often entails singing and music-making (cf. Eph 5:18–21 and Col 3:12–17). Therefore, by design and divine sanction, we sing, we make music, we rhyme, we sculpt, and we paint. The question is whether we will do it well. Art will inevitably be in the church. But will it be good art, and will it be consistent with our mission?

Now, we can all think of excesses here. Maybe a Vegas-style fountain synched to music in front of your sanctuary isn't the best use of church funds; arguably, such a venture would fail on both aesthetic and missiological grounds. Moreover, being good stewards of the church's resources would certainly require us to prioritize the fulfillment of the Great Commission over a piece of art. But can we so easily divorce artistry from our divine calling? Is the kingdom we're advancing not a beautiful one? Granted, its primary beauty is spiritual, but we see in Revelation 21 that it will also be glorious materially. Will this advancing kingdom not have cultural implications, including artistic expression? Is not our "chief end," to quote the Westminster Shorter Catechism, to "glorify God, and to enjoy him forever"? If so, then would the arts not be an expression of this? Indeed, the

arts for a believer seem both to arise from and result in the enjoyment of God. Would they not therefore be a worthy investment?

Moreover, to what are we evangelizing people? Are we not calling them to know, love, and enjoy their Creator? Then, can the arts not serve as a pointer to the glory of God and as a picture of the beauty of the gospel and the new creation? If so, then would the cultivation of the arts within the church not be a noble calling?

Yes, we must be fiscally responsible in regard to the production of art within our local congregations, just as we must utilize financial discretion as individuals and within our own homes. But I don't think we can simply view the arts as dispensable or dismiss them as a waste of resources. Indeed, in their proper place, they can facilitate our mission to glorify God and make disciples. As with anything, abuses and excesses exist in regard to art in the church, but when done rightly, art can be a valuable means for expressing and enjoying the glory of God.

Church for the Economy? for Technology?

Edwards: Part of the problem is that we too easily confuse God's purposes for churches with his purposes for Christians, and vice versa. Christians think that if they, as individuals, have a responsibility to do something (or an opportunity to do something), then the church has the same responsibility, and churches tend to think that Christians must live their entire lives bound up in the mission of the church. Though there is overlap between the two, there are also differences. As Baptists, we believe in a separation of church and state, which means churches should not be political bodies or governments ecclesiological bodies. That does not mean that Christians should not be involved in politics, but the Christian's responsibility to be a good citizen is not then put back onto the church so that now the church has a responsibility to be a political body. We have to learn to keep priorities for the church and priorities for the Christian distinct.

If we are talking about the church *qua* church, then the Great Commission provides the priorities. I don't think the church has any role in cultivating and promoting the arts. A church may get involved in the arts in some capacity if it can indicate how that involvement will help it fulfill its mission. For example, if a church has gifted artists and resides in a community that's focused on the arts, it might use artistic endeavors to meet

people, build relationships with them, and hope to open up opportunities for the gospel.

Though art as art is not a priority for the church as church, the church and the Christian can still contribute in specific ways to the arts. The church is called to disciple its members to submit to the lordship of Christ in every area of life, so while the church may not hold clinics or classes to provide skills in the arts, they should help artists to understand how their pursuit of art can be used for the glory of God. And individual Christians should be encouraged to pursue professions in the arts to utilize their ability for the glory of God. To say that the church's priorities do not include promotion of the arts does not mean that a Christian should not have that priority. But the fact that a Christian can have that priority does not mean now the church should cultivate the arts, any more than the church should be involved in stimulating the economy, advancing technology, or any number of vocations that individual Christians may pursue.

Shaping the Cultural Context for Evangelism

Blackaby: You make some great points. I've seen some Christians get all bent out of shape and angry when the church didn't drop everything and immediately and go all-in to join them in their new vision or calling. One thing the church is rarely short on is drama!

What I wonder though is whether the church sometimes thinks too small in the way we define our calling to the Great Commission. I think of William Craig in his book *Reasonable Faith*, where he argues for Christians to think of shaping culture as opposed to only pursuing personal evangelistic encounters. I wonder if there is a similar mindset regarding the arts. The church tends to regard the arts as valuable only if they evoke or assist in a one-on-one witness relationships, but we often neglect the way the arts are, for better or worse, shaping the culture in which those witness relationships take place.

So, I agree that churches obviously shouldn't cancel prayer meeting and replace it with poetry classes. But at the same time, I think the church should not necessarily view the arts and spreading the gospel as an either/or scenario.

Coppenger: This brings to mind a thought I had on a trip to Japan, when visiting the National Museum of Western Art, just down the way from the

Tokyo Metropolitan Art Museum. I was struck by how many of the paintings were based on Bible stories, typical of Medieval and Renaissance art. It occurred to me what a pleasure it could be to serve as a docent in these halls, simply acquainting visitors with the stories behind the portrayals—the Annunciation, Jesus's baptism by John, the Crucifixion, etc. (A year or so later, I had a confirming experience while standing before an altar piece, *The Conversion of St. Paul,* in the Dallas Museum of Art. The couple beside me was baffled by the subject, and they were fascinated when I briefly told them the story, including the stoning of Stephen, the Damascus Road encounter, the missionary journeys, and the epistles. They hadn't had a clue, even there in the Bible Belt.) So, by flooding the culture with excellent pointers to the creative splendor, the reign, and the mercies of God in Christ, we set the stage for explanatory witness.

Apostolic Artists

Ahrens: This question recalls to mind the word 'apostolic,' which, of course, implies deference to the teachings of the Apostles (as in "apostolic faith"), but the Greek root speaks more generally to being sent, in this instance, by God to the lost world. Recently a young lady from my church won a full scholarship to study clarinet performance at Indiana University—no small feat. She had already played with some prestigious orchestras and studied with a renowned teacher, all in preparation for an orchestra career. She is a dedicated Christian who has consistently made it her goal to glorify God through her music. Just before heading off to IU, she shared with me that an evangelist friend had approached her and told her she needed, instead, to attend a Christian college or Bible college where she could use her music to "do a work" for God. In response, I would say that she is being apostolic by pursuing this call to study her instrument. I can think of more than one orchestra who needs a dedicated Christian artist who can share the love of Christ and be "salt and light" in what can be a very dark place, a place to which many other Christian ministers would not be able to go.

It is in this way that I believe we should think of the arts in the church. This recalls to mind Romans 10, where Paul asks the often-quoted question, "How can they hear without a preacher?" He goes on to immediately state they have already heard, and that the voice of all creation (Psalm 19) has declared the word of God. This "artistry" of God has "preached," just as my young friend's musical abilities and Christian spirit will "preach" in

her future career. Can the arts help to share the love of God with those who might not otherwise be receptive? If so, then we should let them "minister" and take the gospel where it might not otherwise be able to go through the exclusive use of words or music alone.

Williamson: It's interesting that the musician was cajoled by a friend to enroll in a Christian college because that would ensure her work to be for God. It is intriguing that this friend made this sort of dichotomy. It's complicated as to where we draw the line. Would it be under the same characterization if a Christian were to study painting at a secular institution? Could a Christian fashion designer still do a "work for God" at a secular school of design? Wouldn't we want our youth to attend Juilliard? I believe that the church should encourage the tendency to venture out. And, as you so eloquently put it, the church should not fear that the "artistry" of preaching is multidimensional.

Coppenger: I agree that the fellow who constructed a dichotomy to discourage her enrollment at IU got it wrong. But I want to mention another angle. When I taught at Wheaton, Christian confession and evidence of Christian conversion was a prerequisite for admission. Some said the school would be strengthened by non-believers in the classroom. They'd keep us on our toes; the diversity would enrich our discussions; their exposure to our "integration of faith and learning" could lead them to salvation, or at least to greater respect for Christian thinking in the various disciplines. Others argued that Christians should get out of their cocoons attend other local schools like Northwestern and the University of Chicago. There they could be salt-and-light missionaries and better positioned, with prestigious credentials, to advance in an often-hostile secular culture.

It all sounded reasonable, but a colleague offered a qualifying word: When you're in the presence of non-believers (whether or not the college is predominantly Christian), you spend time on apologetics. You have to frame your discussions so as to acknowledge the dissenters in your midst, and it can be hard to get into the finer points of discussion on the particularities of the Christian walk in this or that vocation—the sort of dialogue we're featuring in this book. In an unapologetically Christian setting, you're able to go farther and deeper in considering the biblical angles on whatever the subject may be, whether philosophy, sociology, or biology. And public performances (whether recitals, concerts, or the remarks of visiting

lecturers) are more likely to probe and celebrate the richness of Christian doctrine, church history, and worship.

I served on the long-range planning committee with Harold Best, dean of Wheaton's conservatory, and I'll never forget something he said at our first meeting. We were talking about goals, and one of the profs suggested that we should become (or continue to be) the best Christian college. Harold suggested, rather, that we should aim at being the best of all colleges because we were profoundly Christian. In other words, leave out Christ, and you're second rate from the get-go. You miss out on the main thing that should inform all that you do.

That being said, some are called to venture out into the secular academy, others to nurture themselves in a Christian institution. Thank God for both opportunities.

Feeding Souls

Ahrens: Artist Makoto Fujimura, in his book *On Becoming Generative: An Introduction to Culture Care*, recounts a time early in his marriage during which he and his wife, Judy, had to ration their food in order to make it last through the week. In the book, Fujimura recalls an evening he sat alone waiting for his wife to come home from work. As he sat worrying about their shortage of money for food, rent, bills, and other necessities, Judy finally arrived home, carrying a bouquet of flowers. Fujimura admits the irony of the fact that he, the artist in the family, became upset and asked his wife how she could think of buying flowers when their refrigerator was literally empty. Her response, Fujimura states, has been etched into his heart for over thirty years now: "We need to feed our souls, too."

Since the day I first read Fujimura's book in 2013, Judy's words have been lodged in my heart, too. They have caused me to ask questions such as, why did God create a red rose? Or the exotic birds we see on all the nature channels and in *National Geographic*? What is the point of the landscapes in our national parks that elicit a gasp when we view them? What is the point of color anyway? Why do we not live in a black and white world? I have to conclude that art and beauty have some purpose and are integrally connected to our existence as human beings. And this conclusion leads me to believe that God delights in beauty, too. Otherwise, there would be no delight in it for us as image bearers.

Thus, to answer the question of whether the church should have other priorities, one has to consider the *function* of beauty in the life of every human. *Of course,* we need to provide Bibles and fresh water and mosquito nets. But people go to symphonic halls and art museums for a reason, and I believe it is in search of food for the soul, whether they realize that is why they are going or not. Providing art to the best of a congregation's ability shows that we not only value art, but that we understand our Creator made it a part of the world we live in for a reason.

Perhaps if a church cannot afford to outright purchase art, they could make space for artists to display their work inside the church building. The church would enjoy the beauty, and the artist's work would have greater exposure. As for music, one might be surprised at how little it costs to perfect a cantata compared to the depth of truth its performance could bring. There are many groups and individuals who would gladly lend their gifts and callings in the arts to the church at a low cost if only we would take the time to seek them out.

Testimony to God's Extravagance in Grace

Westerholm: Priorities are another way of talking about expenses. I've been reading Calvin's *Institutes* where he talks about why God makes promises to his people (2.8.4). Calvin argues that God "is not content with having obtained reverence for his righteousness," but longs "to imbue our hearts with love of righteousness and with hatred of wickedness."

While believers have the Holy Spirit, the world doesn't. What the world knows about God, they discover from the church. Do our ministries testify that God is lavish and extravagant, not in worldly categories of conspicuous consumption, but in generosity of grace? When our priorities reflect a bare pragmatism, we lose a chance to witness to the abundance and overflow of our supernatural God.

17

Aren't the Arts Expensive, When Funds Are Short?

Coppenger: When I was executive director of the State Convention of Baptists in Indiana (SBC), we were involved in planting a dozen or more churches each year, and many of the two hundred churches we already had were quite small. We did what we could to support the young pastors with funds from the Home Mission Board (now the North American Mission Board), and the churches often had to turn to the Baptist Sunday School Board (now LifeWay) for "off the rack" architectural drawings. As I recall, blue prints could be had for as little at $35.

Pastors' wives had to work outside jobs so that they could get insurance, and many of the young pastors were themselves bi-vocational. An extra $100 could make all the difference in covering rent, and the continued performance of their cars was always iffy.

How then might you tell a church like this that they needed to invest in art, whether a painting (framed or mural), a commissioned piece of music, or an upgrade to landscaping?

A Desideratum, Not an Imperative

Addington: I wouldn't. I don't actually think expensive arts are mandatory in any situation. I think that creativity is something that thrives in hard soil. I think that, in fact, creativity and problem solving go hand in hand, and

143

if a church is in need of problem solving, they could do worse than having some real creative thinkers in their midst to keep that church going and healthy.

There is no way churches at this level are going to be collecting art any time soon, or being patrons of the arts, and that shouldn't really be a goal anyway. That's not what churches are for. But churches do need to serve their congregations, and if they have the means, economically, physically, creatively, manpower-wise, etc. to sponsor exhibitions or concerts or programs which help people connect with truth and consider Christ, then godspeed!

Coppenger: Your "hard soil" point is well taken (and your creative service in our frugal church plant much appreciated). Reminds me of "Necessity is the mother of invention."

Pro Bono

Warnock: Most of the artists in my church—painters, photographers, and graphic designers—are more than happy to fund their own projects or work pro bono, if only we will allow them to lend their voice and touch to our mission. You don't need a big budget; just start with who you have.

Coppenger: And a lot of pro bono goes on in the church, at many levels. Accountants pitch in with the books; teenaged baby sitters do nursery duty; nurses supply shots to mission volunteers; and realtors help as commissionless property scouts. So, it's reasonable to expect artists to contribute some things without charge. But, of course, there is a something of a difference with a lot of artists: While the accountants, realtors, and nurses likely have reliable, often salaried, income, painters, songwriters, and such may well live by the skin of their teeth, working odd jobs on the side to keep their artistry afloat. Their volunteer contributions can be more sacrificial than, say, that of the plumber who fixes a leaky faucet in the church kitchen.

That being said, for our little church plant in Evanston, the Addingtons, Dan and Steph, did all sorts of pro bono work for us, including painting a big, Celtic-cross-in-a-pasture-with-lambs drop for the space behind the pulpit. Godsends.

Where There's a Will . . .

Wilkerson: Lots of varying-priced art exists, and many people within congregations, even small ones, are very talented individuals. A possible solution could be to get cheap art that nevertheless moves the congregation to worship and/or to operate on a barter system. Perhaps someone would be willing to *create* for the church in trade for free auto service, free plumbing, or free food instead of cash.

I can imagine the Israelites' not being overjoyed at giving up their gold and silver for the sake of the tabernacle. At some point, we need to trust God if we are convicted to "get art." We have to be honest about that conviction, but to begin with a defeatist attitude might limit what God would have done.

Coppenger: Barter! Now there's an idea. Reminds me of a refrigerator magnet I bought recently at the Newseum in DC: "Will Write for Food."

Seed Money

Raley: I think the issue is less that of acquiring pieces than nurturing talent and building connections with artists. If a church were to approve a budget that acquired a $10,000 painting, that might suggest skewed priorities. Might. Depending on the reasons, setting, etc. But what if a church were to invest $10,000 in developing a range of talents—to pay a student arranger to reimagine some hymns; to buy materials for a painter to create a mural; or to provide wood for a furniture designer to make a communion table? Our church is doing all three of these things, and they won't cost anywhere close to $10,000. The impact on our worship is already terrific.

Coppenger: It's said that the difference between the chicken and pig regarding ham and eggs is that the former's involved, the latter's committed. On that scale, the church may be more comfortable with donating eggs than ham to artists, but it still costs and counts. And what an encouragement it can be to the saints involved, both creators and "consumers."

I know it's different, but I'm reminded of appeals I get from a variety of institutions raising funds. It helps me to hear that whatever I might give will be matched by a patron; the multiplier effect is gratifying. Similarly, it can

bless the church to know that the modest amount they invest will trigger a lot of "matching" work for the sake of the Kingdom.

Aesthetic vs. Ascetic

Stark: Matthew, I love that your church is equipping members to participate in the cultivation of the arts in your local body. Obviously, I am in large agreement with much that has been said in this discussion already—from utilizing wise stewardship to encouraging members to use their gifts for the building up of the church. Nevertheless, I think the struggle for many Christians is in resolving the tension between the aesthetic and the ascetic. In other words, how do we justify spending $10,000 of our church budgets on art when that money could be used to translate Scripture into the language of an unreached people group or feed starving children or help pay the salary of a missionary? Shouldn't we be willing to do without beautiful things so that we can get busy with the work of missions and evangelism? To quote C. S. Lewis, "The Christian knows from the outset that the salvation of a single soul is more important than the production or preservation of all the epics and tragedies in the world" (from "Christianity and Literature" in *Christian Reflections*). To put it bluntly, where do we get off commissioning a piece of art for thousands of dollars (or millions if we include architecture) when so many people are dying each day and going to hell without having heard the gospel of Jesus Christ? Of course, I think all of us in this discussion would be avid proponents of the arts *and* missions/evangelism and would view the aesthetic vs. ascetic tension as a false dichotomy. But how do we resolve this tension in the minds of many believers?

Coppenger: I remember how this excellent question rattled around Wheaton when Robert Schuller was building the Crystal Cathedral in the late 1970s. Those were the days when Tony Campolo would come to chapel with convicting stories of Third World need and First World affluence. What could possibly justify that stunning outlay for church architecture in Garden Grove, Orange County, California?

Well, yes. But one has to push the logic a bit. If direct hunger relief, tract printing and distribution, etc. always trumped aesthetic projects, then we would *never* get around to buying a church piano or to painting the interior walls. As long as lives and souls were in the balance, such that

the investment of a dollar or an hour for less-than-direct efforts to save them would be a seeming indulgence, then you would always be obliged to forego arts spending. The result— bare plywood and concrete-block decor; lighting limited to only as many 60-watt bulbs as you needed for reading; and musical accompaniment on a comb kazoo. Of course, this is catnip to ascetics, but I think it falls short of the biblical ideal, which honors the tabernacle-adorning work of Bezalel in Exodus and the instrumentation of Psalm 150.

More Affordable Than You Think

Coppenger: I could offer a happy testimony about buying some art. You can get some great pieces for not much, comparatively speaking. And the pleasure is so durable. Sharon and I bought an encaustic work Dan did, and then we commissioned his wife, Steph, to do a water-color collage of the folks involved in the music ministry of Evanston Baptist Church in its early years as a church plant. Both hang in our den. And then, when I was preaching through Revelation, I commissioned a drawing/painting a week from Dan to go with the text. We have ten of those framed on our dining room wall. The total for these twelve works is under $3,000. I know we got incredible deals for them since they were kind friends and colleagues, but there are comparable blessings to be had from other Christian artists. And when I think of the relative lameness of some other $3,000-batches of purchases in my life (just stuff of various sorts), I kick myself for not investing in more art through the years.

Patronage

Farris: Churches through the ages have always been conservatories for arts, in architecture, painting, sculpture, and music, among other forms. Not every local church can be a Chartres Cathedral, of course, but most churches could host art workshops that bring in talent and activity. It is important to allow opportunity for those so inclined to pursue arts within the context of Christian community without necessarily pulling from any general budget. Usually art patrons exist who will earmark funds for specialized purposes, but otherwise, I don't think it would be prudent to spend money at all on art work that was not fully agreed upon by the donors. And again, the investment value for long term use is a sliding scale, and should not be

the primary driver for purchase decisions for a church body. It is perhaps difficult to argue for an original when a print might suffice.

Coppenger: I get a little skittish when we talk of patrons earmarking funds for art in the church, for these special designations are always more enticing than the budget for light bulbs and cleaning cloths. But, fact is, some funds just won't come the church's way unless a special cause presents itself.

And patrons often give more than funds. They give actual works of art. Indeed, a number of the great museums of the world display the paintings bequeathed by wealthy collectors, and that might suggest a channel for aesthetic advance in the church. Of course, the widow might want to pass along one of the dogs-playing-poker classics or an "art piece" that works better over the bar in an old Western saloon, but that's a bridge one can cross down the way. (If decent, it might help in a youth-mission-trip fund raiser.)

Sharon and I were the beneficiaries of a large framed photograph from one of our parishioners in Arkansas, Thase Daniel, an internationally celebrated nature and wildlife photographer, whose work appeared in *Field and Stream* and *Reader's Digest*. This particular photograph, from her book, *Wings on the Southwind*, hangs prominently in our home almost four decades later. Churches might enjoy such treasures as well if they brought up the subject.

A False Dichotomy

Raley: Ricky raises a crucial point about how we lead people to view the expense of the arts. My $10,000 figure muddies a point I need to emphasize more, namely, that for most churches, the vast majority of the time, art should cost zero. This is especially true in the People's Republic of California, where the cost of doing business for churches escalates every year. Over several years of cultivating painters, script writers, etc., our church has not spent more than a couple hundred dollars.

But, again, how do we move people past the false dichotomy of arts vs. evangelism? Today, evangelism is more than arguing that Christ died for our sins. We have to help people reimagine their lives. What does it feel like to be free of sin? How does peace with God change your home or your work? Testimonies or sermon illustrations help with these issues, but ultimately spurring someone to reimagine life is artistic territory.

Also, evangelism flourishes because of evangelists. Believers need to go out into the world joyful, healed, and motivated by a worshipping heart and mind. The arts can play a role in forming evangelists. I would go further. They do play a role in forming evangelists right now, for well or ill. If a church is a place where the redeemed imagination flourishes, people are going to be won to the Lord.

Neither of these observations justifies spending *any* amount of money on the arts. But they do underline how the arts relate to evangelism.

Coppenger: Ricky brought up the need for a both-and approach to art and missions, and here you suggest ways that the former serves the latter. Off the top of my head, I think of Pulitzer-prize winning photos which have mobilized people, whether for good or ill. Think of Joe Rosenthal's shot of the Marines raising the flag on Iwo Jima's Mount Surabachi or Kevin Carter's image of the starving Sudanese child with a vulture standing in the background. Though many photos are misleading and tendentious, the point is that an image can be quite powerful . . . and can be harnessed for the sake of evangelism.

And to Matthew's point, the abundant life Christ offers is alert to the beauty of God's creation and his handiwork through his people. I think of Dwight Moody's conversion testimony, of how the birds on Boston Common never sounded so sweet as when he first came to the Lord.

18

Won't we Find Ourselves in the Offending Role of "Talent Show" Judge if We Open the Gates to the Arts in the Church?

Coppenger: Sure, we may have some great art and music surface if we show ourselves more friendly to this community, but once we open the door to member-contributions, how on earth will we step up to adjudicate them without creating a lot of hurt feelings and division. "Pastor, you put up Cindy's paintings! Why not mine?"

Before long, we'll have *The Gong Show* in church, with Bob wanting to play *Precious Memories* on the saw, and Linda wanting to put her black velvet paintings of Abishag in the fellowship hall. Why even open this can of worms?

Necessary Gatekeepers

Addington: Before long??? Oh Mark, it's already there! I guess that's why music directors and curators are hired—to make those offending decisions, 'cause if they don't, it falls on the pastor, and that will always be the case as long as there is music in the church.

Westerholm: And the distastefulness of evaluation should fade when the other options are considered. Indeed, church leadership serves as a

gatekeeper to worship service participation; it's is not a matter of *if* this happens, but rather, as it *does* happen, what sort of criteria are used to determine what elements and which people are involved.

Warnock: This is true. Worship pastors have a *spiritual* responsibility with respect to what is put in front of their congregations. Every church has that man or woman who thinks the Lord gave them a song, though he apparently forgot to give them a voice to go with it. We can allow our congregations to be tortured once or twice by a less competent musician to make a point, but poor artistry is a cruel distraction in worship. I'm sure we've all sat painfully listening to a hopelessly out of tune soloist. If they're seven, it's cute; if they're forty, it's pathetic. Making the same point from the other side, both Aquinas and Jerome said that singers should avoid theatricality in singing because it distracts from devotion. The overriding principle is that artistry in a worship setting should be transparent. Attention should be given to what is being presented, not in the manner in which it is being presented, whether overly showy or just bad.

The main point, however, is that worship pastors or arts directors must be the gatekeepers. We dare not open the doors to just anyone.

Stark: It does come with the territory, though not just when it comes to music and the arts. How many people are nominated each year to be a deacon simply because they have a likeable personality? It's hard telling someone that he/she is not quite ready to sing on Sunday morning or read a poem on Wednesday night; it's even harder telling individuals they can't serve on the diaconate because they don't meet the biblical requirements, or be an elder because they lack the ability to teach or be a youth Sunday School teacher because their theology is a train wreck. This is part of our calling as pastors and church leaders—to safeguard the congregation, including when it comes to what artistic media we allow into our churches.

Coppenger: Ministry can be hard, unless you style yourself as the amiable recreation director on a cruise ship, wanting everyone to have a good time, regardless of skill. ("Okay, you did hold the shuffleboard stick by the wrong end, but who cares? You had laughs, and the sea breeze was delightful.") To put it another way, you have to put on your big boy pants if you're to be effectual in church settings.

Auditions, Alternative Venues, Ditch Digging, and Style Codes

Warnock: For music in worship services, the best way to protect the church is to have clear musical standards that everyone must meet, and a clearly defined audition process that everyone must go through before they go on the platform. Smaller churches may have looser standards, and larger churches may be more demanding, but in no case should exceptions be made. Even the pastor's niece must audition. It is far easier to make and communicate a hard decision on the front end than to do so after months of grimacing through something that never should have been permitted in the first place.

Certainly, churches should encourage the development of new or young musicians, like a family would, but that, I think, is a separate issue from putting the burden of worship leadership on people who are simply musically unqualified. We should give emerging musicians opportunities to gain experience leading and playing in the right setting. Churches need platforms for developing talent. In smaller contexts, that may well be the Sunday morning platform; in larger churches, it may be alternate venues like kids' worship or prayer breakfasts.

Watters: One way to avoid flooding is to dig ditches. In the same way, one way to avoid those awkward offers of poetry readings for the potluck or solo music performances for the main service is to set aside time for artists to share their art in territory designed for those poetry readers brave enough to share their art.

The way my church does this is through the Valentine's Day Extravaganza. Every year, on either the Friday just before or the one soon after Valentine's Day, church members will let their hair down and perform their secret talents. The theology professor from the local seminary will get out his trumpet and play some Michael Bublé after the elder who works at UPS leads a choir ensemble, just before a cast of members from all walks of life performs a skit. Nobody expects perfection (although an elder's wife screens the acts ahead of time), but the setting is perfect for artists to express themselves without the awkward situation of choosing winners and losers—who's in and who's out. At least, until the Not-So-Newlywed Game begins.

Extravaganzas give artists the chance to introduce themselves to each other and to those they never would have met otherwise, who can give

them opportunities to use their talents in other settings. It also gives worship leaders, for example, the chance to evaluate a person's skill without having to test and vet them personally. One way, then, to avoid talent show judging is to go ahead and have the talent show, but let the audience decide for itself, organically, with low expectations.

Raley: If ministry leaders set the context for how work is used, then a lot more people can be included. We have several painters, and I've spent years talking with them about their work and encouraging them to develop. One woman produces very high quality and often abstract paintings. Another woman takes the approach of an illustrator, often making a biblical scene come alive from an unusual angle. The worst thing we could do is try to establish some kind of style code to burnish our artistic credentials, turning up our noses at "mere illustrations." We can be big enough to shape the right context for someone's work. But it's a two-way street. Artists and musicians have to be collaborators if they're going to work in our church.

A Question of Gifts

Wilkinson: Part of maturing in the faith through discipleship in church is discerning spiritual gifts. Part of discerning spiritual gifts is sifting one's strengths over weaknesses. Why is that not judgment? I have known individuals who wanted to teach but were terrible at it. They were, however, great small-group, spiritual-growth leaders. Believers must be able to find what they do well for God, and, while they can still enjoy what they are not good at (me and singing), they need not force it on the congregation proper. Our goal is to mature and sharpen rather than preserve feelings (though we don't want to be harsh just for the sake of it).

Coppenger: I'm glad you brought up gifts. I remember an "Equipping Center Module" the SBC Sunday School Board published back in the 1980s, a tool designed to help you discover what yours might be. It had a good study guide and a sheet we spread out on the floor with markers by which we indicated what gifts we thought we might have, and those which the other participants thought we might have. I think it was helpful.

One of the big questions concerned the difference between talents and gifts, and we settled on the distinction between craft and anointing, between what the world would recognize as skill and what the people of

God could recognize as fruitfulness. Of course, there if often great overlap. Billy Graham was a well-spoken orator, but he also had the touch of God on his messages. Spirits were quickened. Lives were changed. His off-stage behavior preached the authenticity of his spoken words.

We discussed the case of evangelist David Ring, who has won many to the Lord despite difficulty in speaking, the effect of cerebral palsy—an instance of giftedness where talent is not so clear. Then there are other instances where the sermon or performance came off as cold even though the accomplished deliverer crossed all the t's and dotted all the i's. (And, yes, one can be fooled by counterfeit anointing through formulaic means for eliciting warm approval). So, the question is whether or not the church is built up or spiritually cleansed by what they offer, the same thing you would ask about committee work, landscaping, hospital visitation, or mission trip leadership.

The Excellence Idol

Stark: I agree that not everyone should preach. Not everyone should paint. But I am also concerned about falling into another trap, the one where we use code words like 'excellence' and 'distractions' to mask our pride and idolatry. Don't get me wrong. I am all for excellence in the church, and I want to eliminate distractions and do everything as unto the Lord. But we are also called to equip the saints. Yet, I fear that in many cases we have made excellence an idol and consequently have missed out on the opportunity to develop artists in our churches.

We all have stories about that tone-deaf forty-year-old woman who thinks she is Mariah Carey or that college kid who does those awkward interpretive movements like Napoleon Dynamite. I don't think any of us want them on the platform. But what about that young man who has been learning guitar? His rhythm is off from time to time, and, every now and then, his voice gets a little pitchy, but overall, he shows potential as a worship leader, both in skill and in spirit. He may not be great now, but is there not a place for him to lead in some capacity so he can grow as a leader and as an artist?

I was a part of an itinerant vocal ensemble in college. We traveled around the state to many churches on behalf of the college, leading those churches in worship. One Sunday, we were at a very small church in the middle of nowhere. Before our ensemble got up to sing, the music minister

called up a middle school student to play her violin for the church. She was very shy about the whole thing. If I remember correctly, she played *The Lord's Prayer*. It was terrible. There were lots of squeaks and start-agains. Had I been the music minister, I would have never put her on the platform to play. But something beautiful happened that day. The beauty may not have been in the music itself, but it would not have happened without the music. As the young lady finished playing, the congregation "Amen-ed" and applauded her as if she were a master violinist. She quietly went back to her seat. She was embarrassed; she knew it was not that great. Yet, at the same time, as the applause continued, I think I saw a little confidence grow in her, a desire to keep striving to become better. That, in and of itself, was beautiful. But more importantly, I believe the church was edified by her playing that day—again, not because she was great, but rather because she was one of their own who was seeking to honor the Lord with the best that she had. She was still a novice, and she had much room to grow. But she made it through a difficult piece, and she would be better the next time she played. I wonder where that young lady is today and if she is still playing the violin. If she is, I think it might very well be, at least in part, because of what happened that day.

 We definitely need to protect our churches from artistic disasters, but perhaps in our discipleship of artists, we need to make room for the not-so-great to happen so that growth can occur. My first sermon was terrible, but I needed to preach in front of the church for the first time in order to grow as a preacher. I am thankful that someone gave me the chance to preach and that many have poured into me since then. If my sermons are not terrible today, it is because I was given the opportunity to mess up and to be corrected. We need this kind of culture in our churches as we minister to artists and cultivate their talents, and we must play more the role of a shepherd and less the role of a talent show judge.

Coppenger: Thanks, Richard. I'm having troubling flashbacks to the early sermons I "supply" preached when I was still a Wheaton prof, but on my way to seminary. I remember my "flop sweat" when one song director in a little church near O'Hare Airport handed the pulpit over to me with forty minutes to go in the service, and I discovered that I had only a 15-minute sermon. Or the time I preached a very strained "sermon" on safe-driving from Titus or somewhere. (Thank God for my subsequent preaching cours-es.) Were it not for the forbearance of the poor souls in that dying church

on the Far South Side of Chicago (about twenty gathered for an evening service in an auditorium that could seat three hundred), I would have been disqualified from subsequent preaching, for the sake of the Kingdom.

Shepherding

Warnock: We've spoken of gatekeeping, but spiritual shepherding is a big thing too. If we tell out-of-tune Tina or off-pitch Pete they can't sing in church, the reaction we get will say a lot about their spiritual maturity. They may pout or scream or pitch a fit, but if so, it will also show that they aren't mature enough to lead worship. Further, it presents an opportunity (if we're not afraid to take it) to invite them into biblical humility and godly character. A patient and loving hand is required. This, incidentally, is why the church needs worship *pastors*, not just good lead musicians. Many leaders try to avoid these conversations, and I completely understand why: they're draining and difficult. But if we love our people as Christ loves them, we will engage rather than avoid these issues.

Coppenger: I'm reminded of something I heard in a Wheaton faculty meeting one day. A New Testament prof spoke up when we were complaining a bit about faculty salaries. This fellow assured the president that he was happy to teach for free, but that he still wasn't paid enough to grade. That struck a chord, for we all knew the pain of determining and defending our grades. In this vein, you have to feel for the church staff member who has to gently turn down the offer of a parishioner who wants display his skill at hamboning and eephing (cf. *Hee Haw*) while you all sing *There's Power in the Blood*. But it comes with the territory.

Back to grading, the prof needs to see himself as both gatekeeper and shepherd. If you give out A's like candy, then graduate schools can get an inflated impression of their candidates for admissions, can misdirect scholarship money, and can waste their efforts on people who don't show promise of contribution to the profession. But you also need to have a pastoral heart in grading. The student is some mamma's baby, and she's been praying that he or she would grow up to be great, or at least less disappointing. Besides, the family has likely put big bucks into this education. So, you need to attend to stack of papers the way you'd attend to a congregation needing pointed ministrations from the pulpit.

Of course, the sort of shepherding the grader provides is often ignored or attacked. It can be right frustrating to know that you spent fifteen to thirty minutes marking up an essay (noting bloviation, non-sequiturs, run-on sentences, misuses of 'its', etc.), only to have the student either not bother to pick up the paper or to scan the notations for appeal-springboards if they don't like the grade. Now and then, one will offer humble thanks (as when a very bright international student was relieved to hear he didn't have to use five-dollar words—'eleemosynary' for 'charitable', 'numerous' for 'many'—to make a splash. But then there was the student who was livid when I circled his misspellings and included them on the handout list of all the misspellings from all the papers (without attribution). Only he and I knew which ones were his, and I would have thought he'd appreciate my attention to the sort of detail that could help him in the future. But he had his sensitivities, and he took my markups as an affront to his dignity. So, worship pastors, we graders feel your pain.

A Sense of Decorum

Farris: Let me bring up decorum. Proper corporate worship usually requires a certain level of it, depending on what the congregation is used to. This, of course, can vary a lot. I once went to a fairly-high-brow church, where one family began bringing their severely mentally and physically handicapped child into the main worship service. The child would scream out several times during the service, and, while sympathies were always felt, after several months it began to wax uncomfortable in unavoidable ways. It usually disrupted flow and atmosphere to where, finally, something had to be done. Over time, there was little to be gained, with the law of diminishing returns kicking in for the congregational humility factor, and everything to lose.

There are many ways to support such families, and every care should be extended. While it can be appropriate to have children perform at any level, it is no excuse to not promote the very best that can be mustered in whatever public endeavor the church pursues. Toward that end, my home church is holding an art school, seminars, and workshop one weekend this April, where there will be judging, and everyone must maintain an understanding that fresh learning is always possible, no matter how good or bad you are; that talent comes in enormous variety; and that, if you are not particularly good, with work, at least, improvement can be expected.

Part of the school is teaching spiritual background, where our aesthetic senses are lauded as part of God's nature and creation. After the workshops, certain art will then be displayed for a period, even for sale, but no one should be presumptuous enough to think that they should have their particular work displayed without professional approval. This reflects a personal decorum without which, in a Christian setting, one should not be involved in any artistic activity. Artistic temper tantrums, even if accompanied by a level of genius, have no place in the Kingdom. When such formal avenues are provided, many of these conflicts, I would think, are avoided.

19

Taste Is So Subjective. How Would You Ever Decide What to Choose for Presentation?

Coppenger: In this context, I'm reminded of Evelyn Waugh's take on a striking landscape:

> I do not think I shall ever forget the sight of Etna at sunset; the mountains almost invisible in a blur of pastel grey, glowing on the top and then repeating its shape, as though reflected, in a wisp of smoke, with the whole horizon behind radiant with pink light, fading gently into a grey pastel sky. Nothing I have ever seen in Art or Nature was quite so revolting.

It's meant as edgy humor, a poke in the eye of Romanticism, but it underscores a problem we have in the arts. What you love, I may hate, and vice versa. While we can agree over the doctrinal soundness of a hymn or the economies of a new heating system, we splinter when it comes to evaluating the arts. And who's to say who's right and who's wrong? Why take on the impossible task of honoring the taste of our members when taste is so subjective, mercurial, and surly?

Rotation

Addington: Well, this is one reason I'm in favor of rotating exhibitions: By the time somebody gets up enough gumption to lodge a formal complaint, the artwork is gone!

Seriously, though, this is true of *ev-ery-thing!* The same complaints happen when a church chooses a carpet color or style of podium, or even evaluates the preaching style of a pastor. Mature adults have learned how to navigate these waters and negotiate them, and immature ones haven't. And yet, while I'm sure questions like these are based on some real life experiences, I have not seen that in the churches I've been involved in. Honestly, I really do think that those who are interested appreciate, and those with no interest barely see the stuff; they don't remember the song; they don't remember the painting; it's just all beside the point.

Coppenger: I like your rotation model and grant your point about appreciation-vs.-indifference rather than appreciation-vs.-disdain. But I've still heard snarky comments (some of them warranted) about particular flower arrangements, graphics, portraits, and such. A lot of critics out there.

Of course, rotation won't work so easily with architecture. You may not like the current storefront look or the "modern" style they chose in the 1960s. You might wish it looked more colonial and less like Dulles or the old TWA terminal at JFK. But, unless you can come up with a bunch of money, you're stuck. Everybody has to be somewhere, enjoying or suffering decor.

Choices must be made.

The Impossible Radio Station

Warnock: As a worship pastor, I have now endured seventeen years of being unable to please everyone's taste. Sometimes I think this challenge is underappreciated. I defy anyone to find a radio station whose music pleases people from age eight to age eighty, and yet this is what worship pastors and church artists are asked to do. It calls for variety, to be sure. I have joked for years that my job has been to make sure that nobody is completely happy.

There are several ways to address this problem. Some churches build entire services around people's taste: a country service, a traditional service, a rock service, etc. This approach works at the cost of fracturing the church

and indulging members' preferences, probably to their souls' detriment. Personally, I'm not fond of this approach.

Coppenger: Taste/congregational fragmentation is a real issue. Of course, in many cases, you're just piggybacking on a solution to overcrowding— multiple services. Once you chop things up, so the thinking goes, you might as well offer different styles to help folks self-select. I've done "pulpit supply" at some big churches that had three services, and I remember one where I was prompted to wear coat and tie at the early service (with traditional hymns and an anthem-singing choir) and a sweater at another (with a bit of a jazz band). And yes, you get more "bodies life" than "body life."

Tables at a Family Gathering

Warnock: The solution I have been pursuing is to begin by regarding the church as a family. In a family, no one expects the teenagers to like grandpa's music, or vice versa, but we can love and be patient with one another. I learned this from Ross Parsley, worship pastor at New Life Church in Colorado Springs: In big family gatherings, you often have a kids' table and an adults' table, with different food, values, and conversations. To bring these two together, as we should in the church, it takes humility. It takes humility for the adults to sit at the kids' table, and it takes humility for the kids to be invited to sit at the adults' table.

Worship pastors and church leaders can model that humility by inviting all kinds of artistic expressions, even those that don't personally resonate with them. Frequently, however, church artists have modeled elitism and arrogance by how they program things. I certainly have.

Elephant Man

Coppenger: Nice. And I think there are all sorts of variant styles to appreciate or learn to appreciate. (And yes, I'm going beyond the club manager who told the Blues Brothers, "Here, we like both kinds of music—country *and* western.") When I hit a museum, I make sure to check out whatever works I can find by Sargent, Van Gogh, and Durer, as well as medieval altar triptychs and ancient sarcophygi. There are many engaging genres, but there are standards of aesthetic excellence within those genres. It's not just a relativistic matter of "beauty in the eye of the beholder."

Way back in 1980, I read a paper at the American Philosophical Association comparing "aesthetic goodness" with "redness." To say something is red is essentially to said it appears red to most people when viewed in the proper light. Some people are color blind, and, to them, the fire engine looks gray. Or it looks black under sodium vapor light. But it's still red.

David Hume said something like this. The experience of red may be subjective, but the experience is *intersubjective* or widely shared. He says art works this way. For those who know how to attend to a piece, a commonality of appreciation will surface, and so we make the *objective* judgment that it is good.

Look, no matter how much personal preference may be in play in our everyday judgments, very few would say that Joseph Merrick ("Elephant Man") was more handsome than George Clooney; that Anne Ramsey ("Mama" in *Throw Mama from the Train*) was more fetching than Taylor Swift; that soured milk is more refreshing than a cold Coke; that fingernails on the blackboard are more pleasing than Debussy's *La Mer*; that a stick figure from a game of hangman is more gratifying than Constable's *The Hay Wain*. There are standards, grounded in our wiring in Creation.

By the way, in an aesthetic theology seminar, I went around the room, asking the all-male class what their ideal of feminine beauty might be (spouses excepted), and all but one reponse got understanding nods. One student said, "Virginia Woolf," and we had to think about that a bit. But close enough.

Taste Making

Raley: Taste is formed socially. Traditions are laid down by groups over a long time, like the traditions of a seeker-sensitive worship service inspired by Willow Creek. There is a tone, an atmosphere, a kind of humor, and a flow that characterize good taste within this tradition. The tradition is now almost fifty years old. I think this may have been the last time anybody did the hard work of taste-making in relation to evangelical worship. Most of the time, ministry leaders are reacting to the tastes of people in the congregation, trying to appease people's sense of what is attractive rather than to lead it.

Lucas and Spielberg were taste-makers: They reworked B-movie formulas, and people loved it. Starbuck's was a taste-maker. Sting was a taste-maker. Ministry leaders need to see this work as important to their

communication strategies, so that people can bond together in groups across the usual boundaries. The work involves careful thought about who needs to be brought together in our churches, how existing practices can be reworked and combined in new ways,

During Advent in 2017, we focused on angels. Who are these beings that played such an important role in the coming of Jesus? In order to preach effectively about angels, our arts team decided we needed to change our angelic tastes. No more naked babies with wings, or lovely, non-threatening young women in white. One of our painters made six, larger-than-life, full-length angel paintings. These figures stood and stared at us during worship, flanked by more faces in ultraviolet paint. It was abstract and unsettling. At first, many people didn't like them. But in combination with preaching about angels, these same people came to love the paintings because they embodied what we were learning together. That's a small bit of taste-making.

Coppenger: Nice examples. I agree, but with the qualifications I just suggested for aesthetic goodness. No matter how hard and long you press, it's hard to arouse community appreciation for the smell of vomit, the sound of snoring, or the sight of an autopsy.

I think of taste makers as tour guides of a sort. Raised in the SW Arkansas/NE Texas "piney woods" region, I'd given little or no thought to the Flint Hills in Chase Country, Kansas, but having both read William Least Heat Moon's *PrairyErth* and made the Kansas City-Wichita drive repeatedly in the 1990s, I long to visit them again. Who knew? (Just as with the angels at Matthew's church.)

Objective Impact of Aesthetic Choices

Dittman: *"And they were all of one heart and mind, sharing everything between them"* (Acts 4:32).

Many of us have already thrown up our hands and surrendered in the name of subjectivity. Yet while everyone must concede that a portion of his aesthetic taste is determined by his personal and individual experiences, one must also recognize that each and every aesthetic choice produces an objective consequence. In regards to Lord's Day worship, leaders make aesthetic choices, and congregations experience objective consequences;

the unity and strength of the flock relies on the persistent vigilance of its shepherds, the continual wisdom and skill of those charged to guide and nurture by the power of the Holy Spirit. But have we neglected to consider how our aesthetic choices impact the vigor of the fold? Have we neglected to scrutinize that which holds the power either to quicken or to kill authentic worship and praise?

Do not write off all aesthetic decisions to subjectivity. But instead we must test the objective results, holding on to that which unites, casting off that which divides. For as Jesus assures us, "Any house divided against itself shall not stand," and as the Psalmist entreats, "O magnify the Lord *with* me, and let us exalt His name *together*." As we gather together each Lord's day, it is right to desire the manifestation of both beauty and relevance in our worship. It is right to determine in our hearts to sing a new song to the Lord. Even so, the complete abandonment of the songs of centuries past impedes the church from lifting up a unified and joyous praise to God and facilitates the headlong dive into the shallow waters of stage performance and passionless worship.

Coppenger: With so much emphasis put upon the artist's creativity, expression, and authenticity, we can lose track of the Christian's responsibility to edify. Tolstoy said good art builds community (and he's roundly criticized for this by those disgusted with the "herd" that gathers around a Norman Rockwell illustration while shunning Francis Bacon's "screaming Pope" series). Well, certainly, provocation and discomfort have their place in Christian art, much as it does in Christian preaching. But fellowship is, indeed, a big church value.

Classics for a Reason

Dittman: Do we truly believe a church's relevance to its younger generations relies on a songbook composed entirely of twenty-first century hymns and praise choruses? The century is but a decade old! And how did our fathers and grandfathers fare when they were led to sing songs of the nineteeth century? And how did they prosper when led to sing songs over a century old—songs such as *Amazing Grace, Holy Holy Holy, How Great Thou Art, Just a Closer Walk with Thee*, and *What a Friend We Have in Jesus?* In this matter, time is not our adversary but our ally. As decades pass, the songs which speak most deeply to our spiritual need, the songs which nourish

most richly our spiritual health, live comfortably in our minds and in our hearts. The very best in worship must be proven through patience. The body of Christ sings with greatest zest the praises which have penetrated to the very marrow of our bones.

As a singer of Americana in secular clubs and taverns, I have witnessed firsthand how patrons who may never darken the doors of a church, nevertheless recognize and enjoy the traditional American and English hymns. The songs of the nineteenth century have been so securely woven through the fabric of American culture, that the unchurched and recent converts to secularism still recognize the melodies. Will the hymns alone draw the profligate back to the fold? Probably not. But they may provide a touch of familiarity in an otherwise wholly foreign modern church culture.

Are not the Psalms of Scripture, both songs and prayers, a model for our own present-day worship? In one sense, if we do not sing together, we do not pray together. In the name of musical innovation, would the leaders of our churches deprive God's people the privilege to pray as the corporate body of Christ in the very buildings which function as modern houses of prayer?

Who do we serve when we abandon our hymnbooks? Have we stumbled upon some golden age of composition, such that every enthusiast who picks up a guitar must also feel compelled to add a limp bridge to the stout hymns of the faith? Not many of us were innovators when we were called. Not many of us were highly skilled. And even the most experienced musicians spend countless hours with a song before truly knowing the spirit of a melody or lyric. Let us then not overburden our congregations with new worship songs week after week, pushing the flock to the brink of a cliff, over which they may lose any hope of truly worshiping. Let us not create unwilling students and joyless spectators in our congregations. Let us progress more deliberately into our musical future, standing firmly on the foundation of our traditional hymnody, without dismissing the truly best of all that may be called new.

Coppenger: I can testify to this effect. In Chicago, following Joe's group, the Blind Anabaptist Blues Band, I found myself in some interesting venues, including a smoky one where a lesbian couple was dancing amidst tables groaning under pitchers of beer—not the typical stomping ground for a teetotaling Southern Baptist preacher. But when his group broke out a

classic hymn, the room got quiet and people turned respectfully and even wistfully toward the stage, some singing along.

In *An Experiment in Criticism*, C. S. Lewis said that an indicator of quality in literature is the reader's interest in rereading it. You could say the same about movies. There are some that stop my channel-surfing and draw me in for an nth viewing (my own list including *The Searchers*, *The Bourne Identity*, *The Three Amigos*, and *Fantasia*). So, too, with hymns and gospel songs that have stood the test of time, including *A Mighty Fortress* and *Just As I Am*.

Stranding Congregants on Separate Islands in the Dark

Dittman: As the most loved hymns of the past two centuries have been abandoned by our contemporary congregations, so have we abandoned the simple piano and organ accompaniments in exchange for guitars and drum kits and all the preferred trappings of popular music ensembles and secular stage acts? And here we collide with a dangerous dividing wall, the wall that divides a performer from his or her audience. In many of our evangelical congregations, the house lights have dimmed, the stage lights have brightened, and the Sunday worship moment has become a contemporary Christian concert in microcosm. With light so low, my fellow brothers and sisters fade from my periphery, and I am alone, staring at projected words hitherto unknown, straining for unrecognizable melodies concealed by the wall of worship sound. Each man is an island. And tell me, if you can, how the church can lift up a praise and prayer of worship in oneness of heart and mind, with no knowledge of the words nor familiarity with the melody, each member standing alone in such a sea of literal and figurative darkness? And who will be served by a worship repertoire selected primarily by virtue of its newness or a presentation model which imitates theatre?

To further hinder our unified worship, the newly adopted performance style drags in tow all the amplification technologies of stadium-sized concert rigs. Thus, the worship leaders take the stage and gaze out on their audience to observe a darkened mob of faces unable to hear the sounds of their own praises. Many will fail to sing at all, failing to overcome a mounting inhibition, failing to offer any praise to our most Holy God. We have constructed a true disservice. As leaders, we have denied our own flock the joy of participating together in worship to God, who alone remains most worthy of our highest praises. In a mad rush to introduce the newest songs

and newest technologies to congregations who still cherish the melodies and prayers of the past, we have rehung the crudely stitched curtain and veiled anew the throne room of God.

Coppenger: I think this perspective took on new life for Joseph when he enrolled in a course on black gospel music at Northwestern, one that assigned attendance at variety of African-American churches where the whole house was alive in song. He ended up singing with at least one of them. For him, there was no coming back, at least in terms of exuberant, congregational involvement.

I think also of one of the most consuming worship experiences I've had, when singing (yes, the fairly contemporary) *In Christ Alone,* a capella, with hundreds of Evangelical Ministerial Association members in London's sixteenth-century, St. Helen's Church, Bishopsgate. No lonely island singing there. We were all in the same happy boat.

Pulse

Dittman: I would argue that the beat is the soul of worship. We do not worship as disembodied spirits, nor do we transcend physical reality during worship, but instead, we worship corporeally and our bodies must worship in concert with our spirit and mind. We are admirably focused on the theological truthfulness of our worship content, but flagrantly negligent toward the basic mechanics of communicating this truth in our physical environment.

God has endowed humanity with sensitive physical bodies and powerful physical minds, and these endowments do not function independently from the soul (though as Paul reminds us, they may be frequently in conflict). If there be conflict, it is civil war among factions under the same jurisdiction. We do not subscribe to the Gnostic notion of duality, pitting soul against body, mind against matter, and consequently, we must not overlook the beat and the pulse of our worship.

Does not the heartbeat accelerate with excitement? How then can our worship inspire the joy and excitement in our risen Lord, if its pulse remains at sixty beats per minute, if its beat never exceeds the slow end of our normal resting heart rates? Though the congregation may stand, it is as though we stand in a dimly-lit gallery, gazing leisurely at the stage, as if pausing before a large canvass to take in the sights on a guided tour.

Or if we do strive to be something other than mere onlookers, we raise our voices but our noise remains placid. We come weekly to celebrate life and resurrection— undeniable victory of our Savior over death, over the grave—yet we are routinely invited to join the slow march of the second line, singing only dirges to our King.

Coppenger: I think of the plodding monotony I've suffered in some song services. (I heard once that the uniformity in tempo among the songs allowed the leaders to transition seamlessly from one to another.) And I remember gratefully the way that you and Dan (Addington) would kick up the tempo (including a bluegrass sound) on a variety of songs, e.g., *These Are the Days of Elijah*. A joy.

Of course, you don't want everything hard driving or perky. Bach's *O, Sacred Head Now Wounded* and Watts' *When I Survey the Wondrous Cross* ask for something more stately or reflective. But I agree, we've slighted the allegro option.

Volume Not the Answer

Dittman: Merely raising the dynamic volume of our worship will do nothing to stir up greater joy in praise. Dial up the loudspeaker mains to plus 10db. Make our eardrums bleed. The beat and soul have not been elevated simply by playing louder. It is a common fallacy embedded deep in the subconscious of our stimulation-starved generation: the louder the music, the more excited an audience will become. But from where does the fallacy derive?

For any of us who has ever been in a stadium, theater, auditorium, or large sanctuary filled with even as few as a thousand other persons, we are familiar with the palpable buzz created by many bodies in close proximity. And when the performers, or dignitaries, or keynote speakers step out onto the stage, the collective applause and cheer of the multitudes can be deafening. Consider an event like the Super Bowl. Even if we only watch the game on television, we can still feel the electricity of the cheering crowds. And though very few of us will ever attend a Super Bowl, most of us will attend an event of similar magnitude with comparable crowds, and all us who have access to the Internet will likewise have access to countless hours of video footage of crowd-packed venues.

Herein lies the fallacy: We observe the energy of large crowds and believe energy to be a product of dynamic volume. We do not walk away with the memory of multitudes so much as we walk away remembering it was *loud*. So, in our smaller churches (of a hundred, or two hundred or three hundred), we cannot magically multiply bodies, but we can nudge a couple faders on the soundboard, we can make the music in the room a little louder. Unfortunately, the technologies which are innocently meant to augment, are too easily employed to overpower and overwhelm the true energy of worship emanating from the hearts and mouths of individual worshippers. Worship does not pour solely from the amplifiers of worship leaders. We innocently desire to recreate the energy we have experienced in so many concerts and sporting events and conferences, but in our zealousness to amplify our worship, we have substituted something artificial, something loud, but more like a clanging cymbal, than a chorus of sincere praise.

My appeal is quite simple and direct, addressing a purely mechanical issue: Accelerate the beat and pulse of our worship repertoire, and the joy and energy of our congregations' praise will likewise increase. Inspire in our congregants' greater exuberance; make rejoicing more manifest; fear not the joyful noise of the heavenly host.

20

But Nobody Got Saved at Christmas.

Coppenger: My first church out of seminary had a huge Christmas season program—Advent candle lightings; a platform covered with poinsettias; choir presentations by all age groups; wreaths and ribbons and banners; handbell specials; Sunday school class parties with the full range of goodies, including, in one elderly ladies' class, Jack Daniels sausage balls; food deliveries to needy families. I think we had a Christmas eve service by candlelight, with the Lord's Supper. It was wall-to-wall celebration, with the arts and crafts in full play.

But, nobody got saved in December. It was the oddest thing. Now, I know that some churches have singing Christmas trees with an evangelistic appeal, but we weren't set up for that.

I have to say it was a grand time, but I came to think that perhaps we so filled the air with beauty and adoration and commemoration that the feel-good of celebration overwhelmed the feel-bad message so necessary for the repentance part of conversion. Which got me to thinking about whether the music program ever really joined with the hard prophetic work of the pulpit, or simply focused on glad worship and consolation, leaving tougher topics to the pastor.

What about hymns warning of judgment, such that the singer might tremble at the prospect? What about a probing hymn at Christmas, asking the congregant whether he might be falling prey to materialism, neglecting the Lottie Moon Christmas Offering for International Missions? What if we

had a present-day John the Baptist write a rude song or two for the holiday season?

The simple answer is that the pastor and the music leader might be run out of town on a rail for pouring cold water on the festivities and provoking relatives who might be in town for the week. But I think it's worth a look, not only at Christmas but throughout the year. What if, for once, the music program played Amos and then the pastor had to soothe things with a Barnabas message? Just asking.

Edgy Advent

Ahrens: When Charles Jennens, the librettist for *Messiah*, sent his work to Handel to be scored, he stated that he hoped the composer would "lay out his whole genius and skill upon it, as the Subject excels every other Subject." Although few, if any, would argue with Jennens, the desire to fully explore that subject has, in a way, been lost, giving way to joyful hymns and carols, and "feel good" celebrations which turn a blind eye to the darkness into which Christ came. This is not to say there is no room for joy at Christmas, for certainly there is! However, an exploration of Jennens' libretto reacquaints us with the darkness that necessitated Christ's coming as it traces through Old Testament stories and prophecies. Granted, taking on the whole of *Messiah* is too immense a task for the average choir or music team, but its themes should, nonetheless, be explored if listeners are to fully grasp the reason for Christ's coming.

Thus, I believe it is important to emphasize the meaning of Advent, to adequately focus on the darkness and sinfulness into which Christ came, so that we can even begin to grasp and celebrate the wonder and meaning of his birth. The opening recitative of *Messiah* captures this ancient call to "prepare ye the way of the Lord," a call the church must continue to hear and heed. Advent, after all, is a period of waiting and expectation, of participation in Kingdom work and reconciliation. New hope and rejuvenated faith can result from realizing anew that God knew not only our sinfulness, but also our suffering, and that Christ's suffering, death, and resurrection were his loving assurance that his Kingdom was coming, that help was on the way.

Perhaps "nobody got saved at Christmas" because, in our effort to capture what has come to be known as the "spirit of the season" through celebration and gift-giving, the "back story" has somehow been lost. As

Sibley Towner wrote, "Somber doesn't sell," but it sure can give us pause as it shines the light on our sin. There is no need of a savior if there is no comprehension or admission of sinfulness. Maybe someone would get saved at Christmas if our current and persistent sinfulness and Christ's grace-filled coming were equally held in tension? Perhaps we could vulnerably share stories of the darkness before conversion, and the resulting wonder of living redemptive lives? Perhaps we could share how the Gospel touches our lives in a new and unique way each day. Throwing our energies behind telling this part of the story helps us to see that Christ is, *indeed*, the "Subject which excels every other Subject." Sitting with our sorrow and avoiding a rush to rejoicing is possibly just the prescription we need. This is, after all, the pattern of tension and release, of dissonance and consonance, found throughout Scripture. Not only might someone get saved, but those who are believers could experience anew the glorious meaning of the gospel. Acknowledging the darkness, speaking the truth *about* it and *to* it, makes the light something we can barely comprehend, and certainly cannot resist.

Coppenger: Well said. But let me add, that, in my experience, the use of literal darkness in meetings is more picturesque than convicting. I think of candlelight services, some of them for Tenebrae, some of them on youth retreats (where we pushed little Styrofoam blocks bearing candles out onto the lake to show how the gospel goes out in darkness), but most of them in auditorium settings, where we turned to our neighbors down the row and watched the room slowly fill with a dreamy glow. There's a sort of frisson to the darkness and the squirmy anticipation of the light show, hoping the pastor will just wrap up his remarks.

I'm not gainsaying these justifiably memorable moments, but I think it takes more than flip-the-switch darkness to get at the edgy witness Ann suggests, rather, a clear-eyed focus on what the darkness really means, even close to home. What about a testimony from a parishioner who used to get drunk and hit his wife before he got saved? What about a word from the college senior who "hooked up," "binge drank," and wrecked his grades before a campus minister led him to the Lord his junior year? Put some darkness in the darkness.

An Outdated Evangelistic Paradigm

Warnock: Evangelism is not one-dimensional. If we regard someone's coming to Christ as a ten-step process, then getting a person inside the church building for the first time could be a major step forward. Seasonal productions can serve this end.

Some churches are known in their community for big Christmas or Easter presentations. That reputation can serve the gospel if—and this is a big "if"—the church and its leadership leverage it correctly. Church members have to be trained to invite people far from God to come to these things, and to have personal conversations about Jesus with their friends over dessert afterward. It is quite common for seasonal productions to take on a life of their own, and to divert energy and resources away for legitimate Kingdom tasks. Especially in the South, I've seen them become ends in themselves, the kind of show that attracts busloads of Christians from other churches.

A decade ago, my church was spiraling into bankruptcy, but they kept putting on a Hollywood-scale Christmas presentation (birthed in the 80s) that busted the budget, exhausted the members, and, by all reports, did not result in new disciples. The tail was wagging the dog. Part of coming back from the brink was the hard realization that we could not do it any longer. One county south of us, the sad story echoes: another large, dying legacy church is killing itself to keep up a huge Christmas production that mostly attracts very churched Christians, even as their membership dwindles.

The problem, of course, is not Christmas programs; the problem is that institutionalized churches think their productions will do their evangelism for them, like they did decades ago. In the heyday of "church growth" and "seeker sensitive" and "purpose driven" approaches, churches tried to get people into the building so they could find Christ. But today, lost people aren't coming—not for our programming, anyway. America is more post-Christian in attitude every day, and people celebrate Christmas (or Festivus, or Kwanzaa, or "the holidays") without the church or its services, and do not appear to miss it much at all.

The new vision we are waiting for will show how the church can take the gospel-driven artistic energy we once poured into productions into the neighborhoods and apartment complexes and trailer parks and barrios where people far from God live, work, and play.

A Pebble in the Shoe

Stark: I've definitely witnessed this tendency in churches. The celebration of Christmas can become a strange mash-up of saccharinity and insider politics. Who's going to sing the contemplative Mary solo? Whose grandson (or granddaughter for that matter) is going to play the Christ child? What high-profile family is going to light the advent wreath candle while in their "donned, gay apparel?" It's no wonder no one got saved at Christmas. That's not what this was ever about.

On the other side of the spectrum, I've witnessed other churches with well-meaning evangelistic zeal actually get in the way of their own efforts. As with the obligatory "pray the sinner's prayer" moment in the middle of most "Christian" films, musical holiday productions are often interrupted with awkward, if not cringe-worthy, altar calls that can ironically distract from the work that the Holy Spirit may have already been doing through the beauty of the artistry and truth presented in the program itself. What if we trusted the beauty and truth of the gospel in the narrative of the Christmas story (that hopefully is being presented with clarity in artistic form) to have the desired effect of leading audience members to Christ? In other words, I think we need to be careful that we not confuse artistic presentations with sermons. We may desire the same end with both, but the process and execution are going to look very different.

I was recently at a writing seminar led by author Jonathan Rogers. He was pointing out that good creative writing avoids spelling out inner states (e.g., he was scared; she was sad; they were elated) and instead describes the concrete elements of a scene, allowing the reader to experience the emotions of fear, sadness, and elation herself based on the descriptions offered. Rogers asked, "Do you believe the world is shot through with meaning?" We said we did. He then inquired, "Do you have the faith just to show what you've seen and let the meanings of the world God has made to come through?"

That would be terrible advice for sermon preparation, because the primary purpose of a sermon is pedagogical and instructive. I would not want those listening to a sermon leaving without understanding what was meant. But narrative and artistry allow us to grapple with truth in a different way—indirectly—permitting the audience to experience the world through a borrowed lens. What if we utilized the arts in the church to allow an attendee to experience the Christian approach to reality in juxtaposition to the naturalistic and secularistic ideology pervading our culture, trusting

the Holy Spirit to work through the inherent power of the artistic process as we would trust him to work through the message of a sermon? What if we let the arts in church (to Mark Warnock's point) be a "step one" in our evangelism process, allowing questions and epiphanies to arise and sit in someone's consciousness? What if, as Gregory Koukl recommended in his approach to apologetics and evangelism, we don't always come in with a hard sell—and risk coming across as badgering—but instead have the "modest goal" of "put[ting] a stone in someone's shoe?" Just as a tiny pebble in a shoe can nag at a pedestrian until he stops, removes the shoe, and addresses the problem, Koukl explained, "I want to give [someone] something worth thinking about, something he can't ignore because it continues to poke at him in a good way" (*Tactics*).

Obviously, I am by no means suggesting that an explicit evangelistic presentation/invitation is inappropriate at a Christmas program! But I do think that an artistic presentation that functions as a "stone in a shoe" can be one component of a church's overarching evangelistic strategy in a post-Christian society like ours. In that sense, it's okay if no one got saved at the Christmas program, *if* we are utilizing this program as one step in the journey of building relationships and cultivating dialogue within our community *in order then to* share the gospel more overtly and explicitly and call for a response.

Coppenger: Of course, some consider all "sinner's prayer invitations" and "altar calls" to be "cringe worthy" (I, not being in that company), but, indeed, the soft sell/indirect approach can reap benefits. In her biography, *Now They Call Me Infidel*, Muslim convert Nonie Darwish tells about being flabbergasted by two things when she moved from Egypt to Los Angeles—a rich man, with a luxury car in his driveway, doing yardwork (something you wouldn't see in her homeland); and a radio preacher's remarks on loving your enemies. These manifestations of humility and love were new to her and helped lead her to the Lord. (She'd been primed by a variety of things back in Egypt—the humanitarian behavior of Israeli commandoes; the baleful way polygamy impacted her widowed mother; the fact that the best schools and jobs were tied to Westerners, many of them Christian.) God uses a lot of things to break down our walls to the gospel, and some of them come through Christmas pageants. But I think these encounters are usually more like lozenges in the mouth than pebbles in the shoe.

Easter and Funerals

Westerholm: My twenty years of full-time music ministry in local churches has left me much more excited about Easter ministry than Christmas productions. This discussion has helped me understand why.

Many people in our churches have been inoculated to Christmas. That is, they've been exposed to a weakened version of it (commercialized or sentimentalized) that has left truth of the incarnation powerless to grow their faith. Perhaps this is why many, younger, low-church believers are so interested in observing a season of Advent; it can help blow the dust off of these over-realized celebrations. Easter, in contrast, feels all the more powerful, especially if a person has recently lost someone that they love.

I would make the same comparison with weddings versus funerals. Weddings require a lot of effort for very little ministry impact; funerals require relatively little production work but make a big difference growing people's faith. At this point in my ministry, I almost never provide music for a wedding (unless the couple are personal friends), but I will provide music for every funeral at our church if I am in town. It's a privilege and a great chance for prime-time ministry.

Coppenger: I can particularly "Amen" your comment on funerals. My first year in the pastorate, I performed thirty of them (and I don't think it was my preaching that was killing them; there were a lot of elderly people in the church). The next year, I was talking with one of my old Wheaton students, Kevin Miller, who now edited *Leadership* magazine, and he wondered if I might write on the transition from the academy to the church. We settled on "Funerals for Those You Barely Know," and I had good occasion to reflect on the powerful opportunity the services brought. (Yes, there were slips, as when I forgot the fellow's name and had to do the service in pronouns; and the time I grabbed my NIV, only to discover that Psalm 23 works best in the KJV.)

The main thing was the juncture of a good many attendees who were virtual strangers to church and the gospel and the opportunity to talk very plainly about the only hope we had for salvation. It provided a poignant opportunity for a "come to Jesus" talk, where everyone was focused on both the hereafter and the prospects for their own edifying (or thin) eulogies. I just wish that Christmas and Easter could force the issue as readily as a funeral.

Body Life

Coppenger: Let me mention a good insight from my aesthetics-course colleague, Joseph Crider. While insisting that these holiday programs do, in fact, reach many in affecting ways, he said that one big by-product is the growth of community among the fellowship. Lifelong friendships are formed within the cast and crew, and you can count on all sorts of friends and family to come and watch their colleagues, kids, etc. on stage. And spiritual things happen.

Of course, there's the danger that some will substitute this work for the one-on-one practice of evangelism and that long hours in rehearsal will stress out families, turning them and their loved ones into Christmas Scrooges. But the overall takeaway is of a good thing done together with brothers and sisters in Christ, a testimony to the world that Jesus is Lord and his people are winsome and connected because of it.

Contributors

Mark Coppenger is Professor of Christian Philosophy and Ethics at Southern Baptist Theological Seminary, where he leads doctoral studies in Christianity and the Arts. His own contribution to and involvement in the arts has been modest. Raised in a church's graded-choir program, he eventually found himself singing in a range of productions, from *Amahl and the Night Visitors* to C. P. E. Bach's *Magnificat*. As a trumpet player, he joined in the same all-state band with Bill Clinton; worked in the orchestra pit for community theater productions of *Sound of Music* and *Music Man*; sat in with church orchestras in Nashville, sometimes on treble baritone alongside real musicians. In college, he appeared in plays by Sophocles, Arthur Miller, and Edward Albee. And thanks to the solicitude of parents, the patronage of a grandfather, and the privilege of traveling far and wide on mission trips, he's been able to visit hundreds of museums and performance venues, from Jakarta to Cairo to Vienna; from Los Angeles to Boston to Ft. Worth; from the Baths of Caracalla in Rome (*Aida*) to the Lyric Opera in Chicago (*Pirates of Penzance* and *Porgy and Bess*) to a Kabuki theater in Tokyo; and from Stratford on Avon (*Merry Wives of Windsor*) to the Guthrie in Minneapolis (*Sense and Sensibility*) to the Kalita Humphreys in Dallas (*Caucasian Chalk Circle*). He's taught aesthetics at Wheaton, Midwestern, and Southern; read papers on aesthetics at the American Philosophical Association and the Evangelical Theological Society; and provided chapters on aesthetics to books by Eerdmans and Baker. Now and then, he's tapped to dust off the old Bach Strad for a "gig" (e.g., with the Blind Anabaptist Blues Band) or borrow a C trumpet for "The Trumpet Shall Sound" in *Messiah*.

Dan Addington is an artist and gallery owner who lives and works in Chicago. He grew up in the American West, living in Colorado, Montana,

and Alaska. He has a B.A. in art and theater from Northwestern College (IA), an M.A. in art and art history from Arkansas State University, and an M.F.A. in painting from Illinois State University. He is known for his work with wax and tar, and often lectures on encaustic painting, an ancient technique utilizing molten beeswax. His work has been exhibited in group and solo shows across the country and is represented in numerous public and private collections. Dan's paintings often include combinations of anatomical imagery, memorial sculpture, romantic symbolism, and religious iconography. Through a mixed use of painterly languages, his works explore the nature of mortality, express a sense of loss, and address mankind's desire to locate spiritual meaning.

Dan has worked as curator and director of various galleries since 1995, and is owner and director of Addington Gallery in Chicago. He has served as visiting artist, exhibition juror, and workshop instructor for art centers, museums, and colleges throughout the U.S. He has spoken on the intersection of art and faith at venues including CIVA, Karitos National Conference on Art and Spirituality, Loyola Museum of Art, John Brown University, Judson University, Bethel University, and Dordt College. He loves to sing and play guitar, and has served as worship leader in Chicago-area churches since 2002. In 2016, he helped found the Sanctuary Exhibition Series at First Free Church, Chicago, which seeks to explore and reconcile the role of visual arts in worship by bringing contemporary art into the sanctuary. He is married to artist/educator Steph Roberts Addington, and has a ten-year-old son and budding paleontologist, Aedric.

Ann Ahrens serves as Professor of Worship Studies at Urshan College and Urshan Graduate School of Theology in St. Louis, Missouri. In addition to worship studies, Ann has taught music courses and private piano (classical and gospel) at Urshan College, for over twenty years. Her past teaching experience includes private and group piano at Missouri Baptist University and The Community Music School at Webster University in St. Louis. Ann also works as a gallery attendant at the St. Louis Art Museum, where she gets paid to walk around, look at art, meet some interesting people, and ask folks to "please stand behind the security line" about a hundred times a day.

Ann started her artistic journey at age twelve, when she started taking piano lessons at Wilson Music in tiny Camdenton, Missouri. About six months later, her mother graciously emptied her savings account to purchase an old clunker piano that was probably a better boat anchor than

suitable instrument. The piano sat just inside the front door of her house, and, many days, Ann wouldn't make it past this point when coming home from school. She endured deep persecution from her brother, who regularly taunted and teased about her studies in "Batch" (Bach) and "Choppin'" (Chopin).

Ann earned a B.A. in church music with concentration in piano from Missouri Baptist University, an M.A. in piano pedagogy and performance from Webster University, an M.T.S. from Urshan Graduate School of Theology, and a Ph.D. in Christian Worship from Southern Baptist Theological Seminary, where her dissertation examined lament and soul care needs in the context of corporate worship. She has written commentary notes for the *Apostolic Study Bible*, various articles for *Reflections* magazine (a publication for Christian women), and adult Sunday school lessons on corporate worship for Word Aflame Press.

Daniel Blackaby is an author and lifelong lover of the arts. He follows in a rich literary heritage that traces back at least four generations to his great grandfather, who was a published poet in Canada over 100 years ago.

Daniel has always been a bookworm and music lover, but, after stumbling upon the writings of Francis Schaffer, he felt inspired to study aesthetics on a deeper, more philosophical level. To that end, he is currently pursuing a Ph.D. in "Christianity and the Arts" at Southern Baptist Theological Seminary, in Louisville, Kentucky.

While both a lover and student of art, Daniel's greatest passion is as a creator of it. After dabbling with music for several years as the guitarist for a local rock band, he discovered his true passion as a writer. One week after graduating from college with a B.A. in English, he published his debut novel, *Legend of the Book Keeper*, the first entry in a young adult, fantasy trilogy. He has gone on to publish several more novels, and has recently teamed up with his wife, a visual artist, to create an illustrated children's book. His books have been featured in *Publishers Weekly*, at the International Christian Retail Show, and at the American Library Association convention.

Chris Bolt became fascinated with performing arts magic and escape artistry at the age of six and performed for years in a variety of venues inside and outside of the church. He found "gospel illusions" helpful for illustrating biblical principles concerning the character of God, the sins of

humanity, and salvation through Christ. Chris learned enough bass guitar to play the background for basic songs in a praise band, and is a large consumer of art both high and low. He took courses in aesthetics, including the philosophy and theology of art, during his undergraduate, graduate, and doctoral studies but is still trying to figure out what is meant by studying aesthetics.

Chris double-majored in philosophy and religion for his B.A. at Lynchburg College in Lynchburg, Virginia, before pursuing his M.Div. and Ph.D. at Southern Baptist Theological Seminary in Louisville, Kentucky. For his doctorate, Chris majored in Christian philosophy and minored in systematic theology and world religions, writing on the relationship between divine providence, laws of nature, and the scientific contributions of world religions.

Chris serves as pastor-teacher of Elkton Baptist Church in Tennessee. He also teaches theology, apologetics, and whatever else is needed at Birmingham Theological Seminary (Huntsville Extension) and Legacy Bible College in Alabama. He is married to Kerri and has three children—Karis, Zoe, and Christian—all of whom appear to be much more musically gifted than he is. His wife taught herself to write songs and play the guitar, and the church regularly enjoys hearing her beautiful singing voice.

Ryan A. Brandt is Assistant Professor of Christian History and Theology at Grand Canyon University. His interest in the harmony and beauty of creation has found multiple expressions over time. As a teenager, he was an astronomy enthusiast and trumpet player. After his parents bought him a small telescope, he became enamored with the ordered beauty above and, thereafter, he spent much time in the company of the stars. As a trumpet player, he enjoyed both classical and jazz expressions, reveling in the splendor and complexity of musical composition.

These interests in harmony and beauty led him towards the theological and philosophical domains as he sought to understand how things work together on a metaphysical level. Later, while obtaining a Ph.D. in systematic theology, specializing in theological methodology, he found himself in the academic world teaching philosophy and ethics at a community college as well as theology, church history, and apologetics at a local Christian college.

Since the completion of his degrees, his interests have expanded to the area of spiritual formation. He has published on a theological understanding of contemplation, the spiritual reading of Scripture, and historical

and theological developments regarding the beatific vision. He is also editing and contributing to an upcoming book with John Frederick, *Spiritual Formation in the Global Context*. In his spare time, he enjoys gazing upon the beauty of the heavens with his wife, Laura, through their 11" Schmidt-Cassegrain telescope in the deserts of Arizona.

Daniel Cabal has directed a feature film, a web series, and numerous promotional videos in business, fashion, and non-profits. He says he was interested in video for many years, making shorts to show his friends and family since he was a boy, but never realizing that it could be anything more than a hobby because of his call to ministry. In the meantime, he earned a B.A. in biblical studies from Boyce College and an Advanced M.Div. from Southwestern Seminary. Yet, with a strong desire not just to enjoy movies but to make them, Daniel found a film director and asked him what film schools to consider. The director responded that instead of spending $100,000 on film school, it would be better to raise that money and shoot an independent movie. So, beginning as an assistant director, Daniel worked his way through various crew roles, learning how each job contributes to the production of a great movie, until he felt confident to raise the funds and direct the feature film.

Daniel's subsequent experience has often overlapped film/video production, Christian ministry, and education. Although the film director was right about the need for a degree in film education, Daniel says he still desired to pursue a terminal degree in Christian theology, aesthetics, philosophy, and film. When he learned that Southern Seminary was offering a doctorate in Christianity and the Arts, Daniel moved his family from Texas to Louisville, Kentucky, where he is currently writing his dissertation on a Christian view of Tolstoyan aesthetics. In addition to generous scholarships, Daniel has self-funded his degree by working at IBM—and, after his department was sold, at Tangoe, where he is a professional auditor by day. Daniel claims his family is the best in the world, and he certainly adores his wife Mendy and their two children, Sophie and Jet.

Stephen DeKuyper: Most of Stephen's twenty-five years of business experience was in the commercial real estate industry, with stints in Toronto, Hong Kong, Beijing, and Shanghai. He spent seventeen years helping foreign companies set up, relocate, or expand offices, manufacturing operations, and R&D centers in Mainland China.

For the last five years of his time in China, he ran his own commercial real estate brokerage firm in Shanghai, affiliated with Cresa, the largest tenant-representation-only firm in the United States. He was primarily involved in agency and project management in China, but he also helped to coordinate client requirements throughout Asia.

After leaving China, Stephen took a break from the business world and moved to the United States to study. He received his M.Div. and Th.M. from Southern Baptist Theological Seminary in Louisville, Kentucky before returning to the marketplace.

Stephen lives in Toronto and has spent the last few years working in the health insurance industry. He is currently a co-founder of an "insurtech" start-up, which is using a new technology and business platform to help small businesses get simple, flexible, and affordable group benefits and insurance. He is also active in marketplace ministry as a group and city leader with LeaderImpact, an international ministry focused on helping marketplace leaders explore the relevance of faith in God in their personal and professional lives.

Joseph Dittman began a life of musical pursuits in a simple Baptist church perched on a hill overlooking small-town, Wisconsin dairy land. On summer Sunday evenings, distant train whistles and chirping crickets hummed through open, screened windows, as a solitary piano and two dozen voices sang from the hymnal. At age six, he began piano lessons and dreamt he'd one day be that pianist in the Sunday hot seat, pounding out all the congregation's favorite hymns.

A decade and a half later, his dream yet unfulfilled, he gained acceptance into Northwestern University's creative writing program and redirected his creative energies to crafting English verse in the style of Coleridge, Whitman, and Frost. But even after a handful of writings were published in small-press literary journals, he became disillusioned, perceiving that the twenty-first century lacked a significant poetic audience. Thus, like many of the young and emotional men of his age, he succumbed to a temptation almost impossible to resist—he became a singer/songwriter.

Now in his late thirties, Joseph can look back fondly on a decade of performances in many of Chicago's finest dives, night clubs, studios, theatres, and universities—Hideout, Morseland, Duke's, Experimental Sound Studio, Viaduct Theatre, Columbia University, and Art Institute of Chicago.

Thankfully, only a handful of obscure recordings and YouTube videos remain for future generations to retrieve this dubious musical legacy.

By God's grace, his time in Chicago also opened his ears to the world of gospel music. Experiencing the great joy of Albertina Walker in concert inspired Joseph to join the Evanston North Shore Community Mass Choir, a gospel choir that, in its decade of existence, performed in countless churches, concert venues, and festivals throughout Chicagoland. No other experience has yet matched the musical satisfaction of singing Gospel at full voice with twenty other exuberant singers!

Benjamin G. Edwards is the pastor of discipleship at Inter-City Baptist Church in Allen Park, Michigan, and serves as academic dean and instructor in pastoral theology at Detroit Baptist Theological Seminary. He received his M.A. from Northland International University and his M.Div. from Detroit Baptist Theological Seminary. He is currently a Ph.D. student in world religions with a full minor in Christian philosophy at Southern Baptist Theological Seminary.

Ben, a West Virginia native, grew up around the arts, with a father who loved to sing (including a stint with a traveling Southern gospel quartet) and a mother who taught high school art. His personal experience in the arts has always tilted more toward appreciation than ability, but it does include a modest involvement in music and theater. Through high school, he learned at least the basics of piano, trombone, violin, and cello, and participated in school choirs, chorales, concert bands, and plays. The summer before he started university, he traveled with a Christian music-and-drama ministry to dozens of churches across the Northeast, performing a musical drama portraying the life of Jesus Christ based on the Gospel of John. While in university, he minored in music, was president of the men's glee club, and participated in productions of *Cyrano Bergerac* and *Mefistofele*. Currently, his role in the arts is primarily as a consumer and theologian who loves to see God glorified as his beauty and creativity are reflected by those made in his image.

Ben and his wife, Jo (who is also an amateur musician) have two young boys who are already expressing a great love for music.

Will Farris, currently a doctoral student in philosophy and apologetics at Southern Baptist Theological Seminary, has a professional background in science and technology. He has served in the U.S. Navy, taught science and

mathematics in a Christian high school, and lived in Denver and London as a telecommunications training specialist and systems engineer. Originally from Birmingham, Alabama, Will currently lives near Franklin, Tennessee, with his artistic, painter wife Lynn. Not known himself for contributing much to artistic endeavors, but certainly acting as an avid consumer, he is an committed jazz fan and prefers older school movies, television, and musical productions. (He recently attended the Montreal Jazz Festival.) Were he to study music formally, his instrument of choice would be the flute, at least to start. (Are you listening, Jethro Tull?) He did perform as a percussionist in marching band while in high school in the 1970s.

He was educated in microbiology at Auburn University and also in electrical engineering at cross-state rival, the University of Alabama, before attending Beeson Divinity School and Denver Seminary as a full-time, working student. He is well-traveled and has been to the British museums, Louvre, Rijksmuseum, Chicago Art Institute, Metropolitan, Getty, Boston Fine Arts, National Gallery, and many others in America, Europe, and Asia.

For him, in order for art to be art, it must convey true beauty and meaning in a memetic sense, for art in so many various ways necessarily resonates through imitating some aspect of humanity or nature in ways that connect. Purposeless or ugly "art" is an oxymoron. But, as a techie, his favorite type of art is industrial design and art that has an intense practical purpose—airplanes, weapons, cathedrals, and horse tack, for example. Not one able to articulate significantly sophisticated aesthetic theories, although quite interested in them, he assumes that, for anyone with any measure of artistic IQ, good art appreciation comes intuitively and naturally without necessarily understanding more than that natural *je ne sais quoi* that quickens the spirit in resonating with portrayed beauty from the human (and Creator's) hand.

Amanda Jenkins currently works as full-time faculty at Grand Canyon University College of Theology and Seminary, where she teaches classes ranging from Christian Worldview to Christian Character Formation. Her main areas of academic interest are in beauty and theological aesthetics as well as theology for the church. She was born and raised in Southern California, and began in the performing arts at the age of five with voice lessons, followed by a later-childhood shift from vocal to instrumental (with service as a percussionist through the end of her undergraduate days).

Music is just one of her many passions, and Amanda has spent her adulthood pouring into the church and studying theology. She has served as a young adult, youth, and children's minister these past few decades, and she currently enjoys membership in New City Church in Phoenix, where she teaches a small group and helps organize outreach with a local foster care non-profit. Her church is in the center of the arts district of Downtown Phoenix and has a monthly art show that corresponds with Phoenix's First Friday Art walks. Her undergraduate degree is in theology from California Baptist University, and she earned both an M.Div. and an M.A.E.L. from Golden Gate Baptist Theological Seminary. Her time living overseas in both the Middle East and Southeast Asia was served by an M.A.I.S. from Union University. Her Ph.D. is in theology from Gateway Seminary, with a dissertation on *The Beauty of Holiness*.

Matthew Raley started his artistic journey when his dad was doing music theory homework. As a baby, Matthew would sit on his dad's lap while he listened to recordings of Bach, Bartok, and Stravinsky for college classes. Starting violin at five, Matthew went on after high school to major in violin performance at Willamette University in Salem, Oregon. He plays in the North State Symphony, a regional orchestra based in Chico, California, and in chamber music festivals.

He went to Western Seminary in Portland, Oregon, earning his M.Div. in 1996 with a focus on expository preaching. As pastor of the Orland Evangelical Free Church, Matthew was part of starting Providence Christian School, a K-12 ministry, and Westhaven Assisted Living, an elder care ministry. Currently, Matthew is the senior pastor of Living Hope Fellowship in Chico, California, where he has served since 2011. His novel *Fallen* (2008) and his non-fiction book on evangelism, *The Diversity Culture* (2009), were both published by Kregel.

Matthew received his Ph.D. in May 2017 from Southern Seminary in Louisville. His dissertation focused on reconciling artists and audiences after modernism, using Bach's work for solo violin, the *Chaconne*, as a model. Matthew and his wife Bridget have two boys, one who loves making video games, and the other who loves playing guitar.

Richard Reichert might have followed in the artistic footsteps of his father, whose first job was drawing shoes for local newspaper ads. After his dad explained that art was no way to support a family, Rick took a job at the

Lion's eye bank, where he harvested donor tissue for transplant surgeons. If beauty is in the eye of the beholder, then Rick has literally beheld God's masterpiece of the human eye. In fact, it was so compelling that Rick attended the University of Florida medical school and ended up practicing the art of medicine, specializing in cornea transplantation. After marriage, four daughters, and nearly thirty years in practice, Rick retired and went to seminary. After earning masters degrees at Dallas Theological Seminary and Gordon-Conwell Theological Seminary, he began his Ph.D. work at Southern Baptist Theological seminary, currently completing his dissertation on human-enhancement technology.

Rick lives in Lake City, Florida, about the last uninhabited part of the Sunshine State. He has taught Christian ethics as an adjunct professor for the Bible College of Florida, Gateway College, and Liberty University. He has also served as an interim pastor, elder, and Bible study teacher for Celebration Community Church, in addition to playing the guitar with his pianist wife, Jill, in their worship service. On occasion, he gives lectures on the philosophy of aesthetics to the local art league. Rick and his wife still serve in the medical mission field with Samaritan's Purse at Hospital Loma de Luz in Honduras.

Timothy Scott is currently the pastor of Salem Baptist Church in Florissant, Missouri, and a Ph.D. candidate in the field of church history and historical theology at Southern Baptist Theological Seminary. He also holds degrees from Detroit Baptist Theological Seminary (M.Div.) and Northland Baptist Bible College (B.A. in biblical languages).

Raised in churches and educated in institutions commonly associated with American fundamentalism, Timothy has spent a great deal of time wrestling through various aspects of the "worship wars" that have engulfed that particular movement. Though he has since moved into other ecclesiastical circles, he owes most of his admittedly cursory knowledge of the arts to the churches and educational opportunities of his youth.

The church in which he grew up afforded him informal arts training though participation in cantatas, the church choir, and children's puppet shows. The Christian school he attended for the entirety of his elementary and secondary education taught him how to read music and play the trumpet. During high school, he also took it upon himself to learn how to play rhythm guitar. Today, he uses many of these skills to aid the music program

at his church, where he plays guitar for congregational singing and occasionally participates in special music.

Timothy's interest in the arts focuses primarily on the philosophical and theological history of art. He especially enjoys identifying theological expressions in church architecture and religious painting. Therefore, it is not uncommon to find him admiring the vaulted ceilings and stained glass in old church buildings.

In domestic life, Timothy and his wife, Jennifer, spend most of their time trying to keep up with their three energetic sons—Ryan, Zachary, and Adam.

Na Young Seo has studied piano from the age of five. Since her father was a senior pastor of a Presbyterian church, she grew up in church and naturally became familiar with church music and theology as well. Her experiences in a recorder ensemble and orchestra in her school days helped her to build her musical philosophy as she contemplated harmony, unity, and the variety of colors as God's gift. And this became a huge part of her whole life.

She went to Bethesda Christian University in Los Angeles and earned a B.A. in piano and church music. From there, she went to Austria, where she earned a Piano Diploma from Vienna Conservatory. Later, she earned am M.A. in church music at Southern Baptist Theological Seminary in Louisville. Here, she completed the M.Div. equivalency program and the Ph.D. in Christianity and the arts. Her dissertation focused on Michael Tippett's philosophy of musical and eschatological time and its implications for Christian theology. She is now staying in South Korea, serving Sarang Church with her husband, pastor Joseph. They have a six-year-old daughter, Lilly.

Richard H. Stark III has served as a youth and education pastor in both median and large church contexts for over a decade and is currently minister of students at Berea First Baptist Church in Greenville, South Carolina. He has also taught in the School of Christian Studies at Anderson University (SC) and at his alma mater, North Greenville University. He has a Ph.D. in philosophy from Southern Baptist Theological Seminary, where he focused on theological aesthetics.

Richard's love for the arts began in early childhood, and he grew up singing in both church and school choirs and performing in various musical theater productions at school. In college, he was part of an itinerant music

ministry known as Joyful Sound, and in seminary, he sang with the oratorio chorus. In addition to appreciating music, Richard has long enjoyed the study of literature—so much so that, while he majored in Christian studies in college to prepare for ministry, he decided to minor in English just for fun.

While working on his M.Div. at Southern Seminary, Richard met Dr. Jim Parker and took his Christianity and the Arts class. For the first time, Richard's passion for theology and love for the arts came together. Subsequent courses taught by Dr. Steve Halla and Dr. Mark Coppenger further opened Richard's eyes to the robustness of the arts in the Christian tradition and ultimately led him to write his dissertation on the implications of the concept of Sabbath for a Christian aesthetic.

Currently, Richard enjoys utilizing the arts to help his students engage their worldview and the worldviews of others. He also makes a point to go to at least one art gallery in each major city he visits—most recently the Gemäldegalerie in Berlin and the National Gallery in Washington, D.C.

Andrew T. Walker serves as the Director of Policy Studies for the Ethics & Religious Liberty Commission of the Southern Baptist Convention.

He makes no pretense to be an expert in art or aesthetics, but over the last few years, has undergone a personal renaissance in his appreciation for beauty, and particularly music. He grew up as an "emo" kid in the central Illinois punk rock scene, and music has always been a central fixture in his life. Only recently, he's begun to understand how central music really is for his understanding of God's nature. He has an eclectic taste in music, and you can always find him in his office cycling through Spotify and Apple Music.

His writing and commentary have appeared in such outlets as *National Review, Public Discourse, The Federalist, The Gospel Coalition, TIME, and The Resurgent.* He serves as the director of the ERLC's Research Institute. His first book, with co-author Eric Teetsel, was entitled *Marriage Is: How Marriage Transforms Society and Cultivates Human Flourishing* (B&H, 2015), and he the co-editor, with Russell Moore, of the *Gospel for Life* series (B&H, 2016). His most recent book, *God and the Transgender Debate: What Does the Bible Actually Say About Gender Identity?* (Good Book, 2017) won *The Gospel Coalition's* 2017 Public Theology Award.

He graduated from Southwest Baptist University in 2008. He received his M.Div. from Southern Baptist Theological Seminary in 2010. He earned

a Th.M. and Ph.D. in Christian Ethics from Southern Baptist Theological Seminary in 2018 under the supervision of Russell Moore. Married to Christian and father to Caroline, Catherine, and Charlotte, he's an avid distance runner. He's a member of Redemption City Church in Franklin, Tennessee.

Mark Warnock serves as the administrative pastor for the worship ministry of Family Church, a network of churches in South Florida. There, he herds cats . . . er, coaches worship leaders for their 11+ campuses, and builds systems for worship leader training. Mark serves as executive producer for albums of worship songs written by his team. He teaches church music at Palm Beach Atlantic University, serves as a connector with Worship Catalyst, trains church planters for Family Church, and writes practical counsel for seminary students at seminarysurvivalguide.com and in his book, *The Complete Seminary Survival Guide.*

Mark started his artistic journey at six, begging his parents for piano lessons. Somewhere a fading snapshot shows too-big headphones flopping on his red hair and wide collar as he listens to the Tchaikovsky Piano Concerto on vinyl. (His mom bought it for $3.35 at Publix.) Classical piano lessons and chorus class were anchors for him growing up, although he stepped out as an actor in high school, earning a nod for best supporting actor at district festival for the role of Thump in *Cagebirds.* He has played the Mozart Piano Concerto #20 with a symphony, recorded albums, and played innumerable concerts.

Mark came to faith at eighteen while earning a music ed. degree at Florida State, and he added an M.Div. and Ph.D. in philosophy along the way. His dissertation was on the role of religious arguments in political discourse. Reading philosophy and history has convinced him that Western culture and its art are in decline. Descartes cast the rudder into the sea, and the ship has been listing and adrift ever since. Visiting museums in St. Louis, Chicago, Paris, Washington D.C., and Philadelphia cemented Mark's conviction that, unmoored from Christian truth, art drifts into the inane, the ugly, the violent, and especially, the political.

Mark's hope is that the church, as custodian of the truth, will add new artistic treasures to the old and foment a renaissance of truth-born art of all kinds, for the good of the church, the good of the world, and the glory of God.

Harrison Watters sold his first piece of art—an eight-year-old's rendering of a locomotive—for one dollar, to the entrepreneur next door who wanted to teach him a lesson in economics. Harrison is now an undergraduate student at Boyce College and is halfway through a group major in politics, philosophy and economics, with the hope of doing creative leadership in the future. He is a film technician for the video department of Southern Baptist Theological Seminary and specializes in directing live stream events such as chapel and various conferences. He is an illustrator who has contributed artwork to Southern Seminary's quarterly newsletter *Veritas* and has created a map of the best spots to read, study, or think on campus. He is a musician who leads a homegrown band called Concerning Hobbits and plays ukulele in the worship band at his church. He is a writer who is currently scratching out a novel called *The Desolation of Charbory*, that takes the plot of the Wagner opera Götterdämmerung and sets it in an alternate galaxy, running it at light speed. Harrison has always been an avid reader of everything from *Animal Farm* to *War and Peace*, but he currently has a hankering for science fiction, especially the kind that is really science fantasy. Most importantly, he is a committed Christ-follower who sees his own weakness and daily need for God's grace, especially as a creature working to be creative.

Matthew Westerholm serves as the pastor for worship and music at Bethlehem Baptist Church in Minneapolis, Minneapolis. The son and grandson of Free Church pastors, Matthew studied church music and music performance (trombone!) for his undergraduate degree at Trinity International University. His M.A. in systematic theology from Grand Rapids Theological Seminary included a master's thesis on Karl Barth's use of the metaphor of repetition to describe the Trinity. Matthew received his Ph.D. from Southern Baptist Theological Seminary in Christian worship, where his dissertation examined the eschatology of contemporary worship music.

He has served as a worship pastor at Harvest Bible Chapel in Rolling Meadows, Illinois, as an adjunct music professor at Trinity International University, as dean of the chapel at Cornerstone University in Grand Rapids, Michigan, and as associate professor of music and worship at Bethlehem College & Seminary in Minneapolis. His original congregational songs have been published in *Lift Up Your Hearts: Psalms, Hymns, and Spiritual Songs* (Faith Alive, 2013) and recorded by Vertical Church Band and other local churches around the country. With Dr. Joel Beeke, Matthew has

co-written a chapter on the Lord's Supper for *A Puritan Theology: Doctrine for Life* (RHB, 2012). He has published in the *Puritan Reformed Journal* and *Themelios*. He has contributed online articles for DesiringGOD, the Gospel Coalition, and Doxology and Theology. Matthew has presented workshops and panels on worship for the StraightUp conference, Calvin's Institute of Christian Worship symposium, the DesiringGod national conference, the Canvas conference, the Doxology and Theology conference, and Together for the Gospel's 2018 conference. Matthew loves classic and modern jazz, comic books, and Chicago sports. And while he feels comfortable behind a piano, he only feels at home with his wife Lisa and their three boys, Ethan, Owen, and Levi.

Paul Wilkinson is not sure how he landed with this aesthetic crowd and work. He's fairly sure he's tone deaf and has such an analytic personality that the general beauties of sunsets and mountains are, to him, more neat than sublime. Yet, he found an aesthetic outlet through logic and sciences. With an undergraduate degree in chemical engineering, Paul found elegance in nature's grand system—played out in chemical mechanisms and physical equations. Moving from chemical engineering to philosophy was not as dramatic a shift for him as one might think; one still finds grand systems beautifully connected as one pins down their metaphysics, epistemology, and axiology, tracing all of the interrelated consequences and outcomes in philosophy, not to mention the elegant delight to be found in the logic of proofs and paradoxes. Paul simply traded one set of questions for another while keeping the same techniques and methodologies of discovery.

Now he finds himself working with grand systems of people as one of the discipleship groups ministers at Brentwood Baptist Church in Brentwood, Tennessee. All of the connectivity and relatedness of the chemical and philosophical systems are present in the local community of faith as different contextual, discipling groups, full of diverse, creative people, vary in their efficiencies and aims, with a plethora of on-ramps and outputs. Paul craves connecting the various departments within his local community, and having a multi-campus model has only given him more materials to reflect upon and tinker with. Paul lives in Nashville with his wife, Shelly (a high school math teacher) and two dogs (Dingo and Zoey). Shelly brings a profound aesthetic into his life by "forcing" him on nature walks and to symphonies, while unpacking the magnificence he would be seeing if he weren't so obtuse. She's his compass.

Eric Williamson teaches ethics, philosophy, and theology at Saint Leo University in Atlanta. While he relishes every course, one of his favorite classes introduces theology in popular culture. Along with looking at the theological messages of film, celebrities, and musicians, the course also discusses the nature of church architecture. This discussion draws students into the history of architecture as well as the modern influence on church design. While Eric acknowledges the value of several different art forms, he's more captivated by architecture. He agrees with the late architectural critic, Gavin Stamp, who said that architecture is the one art you cannot escape.

Eric was not always intrigued with architecture. In his younger days, music was the main priority. He was more interested in the performances at live shows (e.g., by Bob Dylan, the Allman Brothers, and Phish) than with studying the design of the venues. Eric also began playing acoustic guitar, mandolin, and banjo. After dedicating his life to Christ, he found these instruments were put to better use in the church setting and praise bands. (Later, Eric picked up the bass guitar because no one really wanted to play it in the praise band.) His musical tastes have also changed to the sacred music of John Rutter and Arvo Pärt. While he no longer plays music in church, he currently teaches classes on apologetics, culture, and theology at Biltmore Church in North Carolina. Two of his four children play the piano, thus the live shows are now in living rooms and recitals.

In May 2018, Eric received his Ph.D. in philosophy and ethics from Southern Seminary. His dissertation was on the epistemology of disagreement applied to apologetics. His research also looked at the challenge of disagreement with experts and the problem of religious diversity.

Made in the USA
Middletown, DE
30 November 2018